PAINTING & DRAWING SKIES

*The landscape painter who does not make
his skies a very material part of his
composition – neglects to avail himself of
one of his greatest aids!*

John Constable (1776–1837)

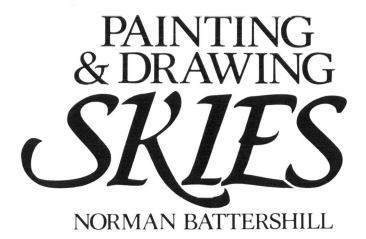

PAINTING & DRAWING SKIES

NORMAN BATTERSHILL

With illustrations by the author

Pitman House · London

Pitman House Limited
39 Parker Street, London WC2B 5PB

Associated Companies
Pitman Publishing Pty Ltd, Melbourne
Pitman Publishing New Zealand Ltd, Wellington

© Norman Battershill 1981

First published in Great Britain 1981

ISBN: 0 273 01392 0

Text filmset in 11 on 12 pt Monophoto Bembo
by Northumberland Press Ltd,
Gateshead, Tyne & Wear;
printed by Fakenham Press Ltd,
Fakenham, Norfolk; and bound by
The Pitman Press, Bath.

Contents

Acknowledgments

My thanks for valuable information and assistance with this book go to: Keith Shone of *Weather* (published by the Royal Meteorological Society, Bracknell, Berkshire) who took on the task of checking my manuscript; Sir John Mason, Director-General of the Meteorological Office, Bracknell, for giving his valuable time to write the foreword; Walter Gardiner of Walter Gardiner Photography, Worthing, Sussex, who photographed the majority of my paintings and drawings that appear in the book; Dennis Moore, who photographed the remainder; the staff of the Meteorological Office Library; and to the Victoria and Albert Museum, and the Science Museum in South Kensington, London.

I would also like to express my gratitude to the following individuals and organizations for permitting the reproduction of their copyrighted material: Dr J. T. Bartlett for the photograph on page 131; the trustees of the British Museum, London, for *Folkestone from the Sea* by J. M. W. Turner on page 152; Granada Publishing Ltd, for the table on page 48 taken from *Instant Weather Forecasting* by Alan Watts; the Controller of Her Majesty's Stationery Office for the Crown copyright photograph on page 50; F. Hollands for the photograph on page 151; David Lewis for the back jacket-flap photograph; Marlborough Fine Arts Ltd, London, for *The Sailing Club* by Edward Seago on page 129; the trustees of the National Gallery, London, for *Dardagny, Morning* by Jean-Baptiste Corot on page 94; the Royal Academy of Arts, London, for *Cloud Study* by John Constable on page 39; the Royal Meteorological Society for the photographs on pages: 51 (both), 52 (both), 53 (top), 54 (both), 55 (both), 56, 57, 141 (top); and finally to W. K. Young for the photograph on page 53 (bottom).

Foreword

It is not by chance that the paintings of Constable and Turner give especial pleasure and satisfaction to the meteorologist. It is because these great artists make the sky appear an integral, vital part of, not just a background to, the landscape. Constable's point that 'the sky is the source of light and governs everything' is made with great force and effect in Turner's later paintings and in equally convincing if less spectacular manner in the Dutch landscapes of Ruisdael and Cuyp. Here the artists capture not only the subtleties of light and shade, tone and texture, but also the source of the illumination; the effect and the cause, the art and the science, are caught and unified.

Constable's best lesson 'Remember, light and shade never stand still' is particularly relevant to the rapidly changing skies of Britain where it must be very difficult to achieve synthesis and compatibility of landscape and sky-scape on the spot; while back in the studio memory is often fallible. It seems important, therefore, to understand how and why changes in cloud cover, thickness and texture can produce dramatic changes in the intensity and quality of the light, and why these can be so ephemeral. At first glance a cloudy sky may appear chaotic, but the perceptive observer will discern some semblance of order, the existence of recognizable patterns and of distinctive cloud types, all of which, in their infinite variety of shape and form, are expressions of the way in which the air has risen to fashion them.

Since the whole mood of a landscape may be dominated by the weather, and the mood may change quite suddenly, it may be useful for the artist to know that the approach or clearance of a storm is usually heralded by a sequence of cloud changes spread over several hours. The approach of a depression is foretold by the appearance of thin, high, fibrous cirrus clouds, followed by the gradually thickening shield of cirrostratus merging to form a mid-level layer of altostratus, and finally by the lowering dark-grey nimbostratus or raincloud—all of which the reader can learn to identify with the aid of the photographic reference section in Chapter 2. A little understanding of these changes, of the formation, structure and evolution of clouds in relation to the weather will help artists to anticipate the changes that may occur during the execution of their work outdoors.

In this book Norman Battershill not only describes and illustrates the techniques of painting and drawing skies in different mediums and with different materials, but has drawn on his experience of watching and studying clouds to describe their shape, texture, arrangement and development, all of which should enhance the reader's insight and feeling for the subject he or she is trying to capture on canvas.

I have no artistic ability myself, but I have greatly enjoyed reading *Painting and Drawing Skies* and believe that it ought to add to the quality and enjoyment of landscape and seascape painting by generating a greater awareness of how clouds interact with the direct and scattered sunlight to produce kaleidoscopic changes of illumination and colour as we progress from dawn to dusk, from season to season, and even from minute to minute.

Sir John Mason
Director-General
Meteorological Office
Bracknell

Introduction

Certainly if the sky is obtrusive, as mine are, it is bad, but if it is evaded as mine are not, it is worse, it must and always shall with me make an effectual part of the composition. It will be difficult to name a class of landscape in which the sky is not the key note, the standard of scale, and the chief organ of sentiment.

John Constable (1776–1837)

There is no better way to approach our subject than by drawing. Selecting the right drawing medium for freedom of expression is essential. In this book I show cloud studies drawn with pencil, conté, pastel and crayon; and the technique of drawing clouds in charcoal is fully illustrated with step-by-step demonstrations.

Drawing and painting clouds outdoors with so many distractions – changing light, moving cloud and fickle weather – is a challenging and exhilarating experience that demands a special approach. This is discussed and illustrated with examples of outdoor studies in pastel, oils, acrylics and watercolour.

Skies must not be looked upon as just background to landscape painting. In the words of Constable: 'the sky is the source of light and governs everything.' All the greatest landscape artists gather their knowledge of skies, atmosphere and landscape by observing nature; but it is in the studio that their masterpieces are painted. Being able to develop a studio painting using an outdoor sketch as a reference is a great asset; you are encouraged to draw outdoors and develop a painting indoors.

Working from photographs is an accepted practice but often misused. There is a section showing you how to use a photograph as a starting point for a painting. Photographs of clouds are a useful source of reference; some hints and tips are included to help you take your own photographs.

A well-conceived sky adds a great deal to a picture, but to achieve it the landscape artist must appreciate the essence of cloud and atmosphere. What are clouds? How are they formed? At what heights do the different shapes appear? Understanding elementary cloud physics increases our pleasure when painting clouds or just watching them go by. A section in this book introduces you to the fascinating basics of cloud physics, and another shows you how to tackle painting different types of cloud formation.

The general colour of clouds is grey, in fact subtle greys are the colours essential for adding depth to skies, so knowing how to mix a wide variety of greys is of paramount importance to the landscape painter. As a guide a number of different tints and shades are illustrated. That cloudy skies require as much attention to composition as landscape, is often overlooked; I have included several examples of sky composition in diagrammatic form to show some of the basic principles involved.

Finally there is a chapter to guide you through the problems posed by the weather's variations: sunsets, mist and rainbows, among others. As you will learn, even painting a blue sky is not as simple as it might seem.

But before learning these techniques, the first thing to consider is what sort of equipment and materials you are going to use; this is where we shall start.

Fair Weather

Size: 9½ × 8 in (241 × 203 mm)
Medium: Charcoal
Paper: Bockingford 140 lb (300 g/m²)
watercolour paper

Charcoal on Bockingford watercolour paper
produces a coarse texture. On a small scale this
is too pronounced for the kind of subject I have
drawn. I have blended and softened the charcoal
with paper tissue, and taken out the lighter parts
with a putty rubber. The untouched charcoal
mark is just below the horizon across the water,
and shows the coarse texture.

1. Materials and Equipment

*So, if a great painter with questions you push,
'What's the first part of painting?' he'll say,
'A paint-brush.'*

William Blake (1757–1827)

DRAWING

Cloud effects can change shape very quickly and necessitate drawing with a broad medium that does not hinder expression – spontaneity is more likely to capture the outdoor atmosphere than a laboured drawing.

The size of the drawing will determine which medium we choose. A small sketch may be done with a pencil or thin charcoal; a larger drawing with pastel or charcoal. Each medium has characteristics which we can explore and develop to advantage.

Charcoal
Apart from pastel, charcoal is the most versatile and expressive drawing medium. Ideal for rapid impressions it has a full tonal range and also a very sensitive line. Generally regarded as a broad medium only suitable for

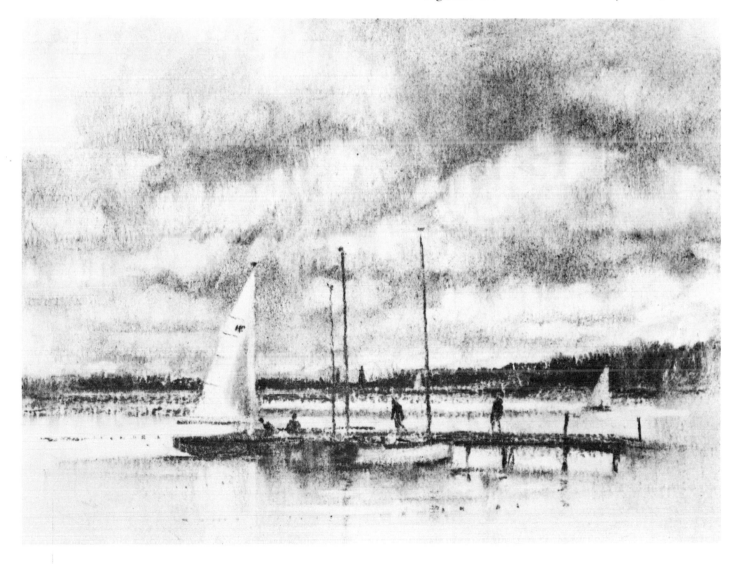

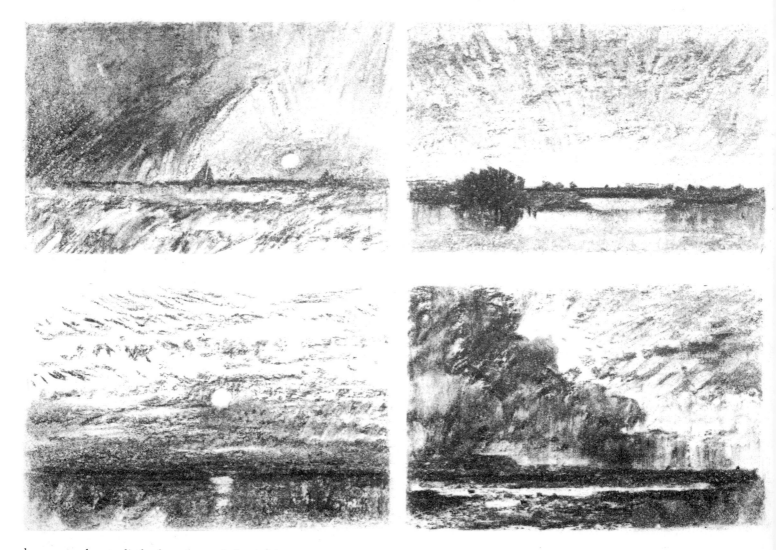

larger work, my little drawings of $3\frac{3}{4} \times 2\frac{1}{2}$ in (95 × 64 mm) reproduced here actual size prove otherwise. Willow sticks are thin and snap easily but this helps you to develop a light touch by trying not to break the stick. Charcoal used by scenic artists is much thicker and gives a broader mark. I do not consider it necessary to sharpen charcoal to get a point but if required, a thin drawing edge can be obtained by lightly rubbing the end of the charcoal on a piece of sandpaper. Any paper is suitable for charcoal drawing provided it has a slight texture for the charcoal to adhere to. Pastel paper is ideal. I use inexpensive drawing paper, either white or tinted; watercolour paper is also suitable for charcoal drawing. To erase lightly applied parts of a charcoal study use a kneaded putty rubber.

Charcoal smudges very easily and practice is necessary to keep your hand off the paper

Sky Sketches

Size: $2\frac{1}{2} \times 3\frac{3}{4}$ in (64 × 95 mm)
Medium: Charcoal
Paper: Drawing paper

These small sketches were a very good exercise to develop the imagination. Before I began I had a rough idea of the theme for each drawing, no preliminary sketching-in was done, and if an idea did not work I scrapped it and started again.

My purpose was to get a different effect of atmosphere in each of the small rectangles.

when drawing. The complaint about charcoal being a grubby medium is unfounded, once the technique of handling is mastered.

Soft conté, soft chalk pastel, and charcoal are a very expressive combination for drawing clouds on tinted paper. By gently rubbing-in charcoal a range of soft gradations is easily

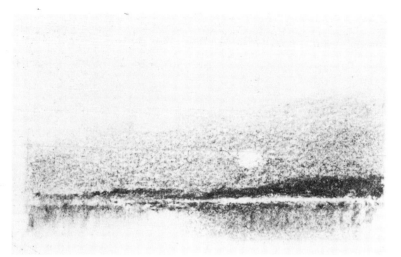

Morning Sun

Size: $3\frac{3}{4} \times 2\frac{1}{2}$ in (95 × 64 mm)
Medium: Charcoal
Paper: Drawing paper

A simple tonal study concerned with shapes and atmosphere.

The sky is firmly rubbed-in with charcoal, then the sun and upper part erased with a putty rubber. Slight smudging along the water blends and creates reflections.

Detail of Morning Sun (below)
A characteristic of charcoal is its vibrant textural quality, as the enlarged detail shows. The paper is 70 lb (150 g/m²) cartridge (drawing) which I have used for most of the charcoal drawings in this book.

obtained, but some restraint must be exercised because the technique of smudging is easily overdone.

Because charcoal smudges and comes off the paper so easily it must be fixed with an aerosol charcoal fixative. Care must be taken when fixing otherwise spots from the spray may appear on the drawing, and the fixative can blow off some of the heavily applied charcoal. You can restrengthen these areas after the fixative has dried.

With very little practice this medium is capable of great expression.

Charcoal Techniques

Charcoal is a lovely, expressive medium capable of delicate blending and strong contrasts, as these illustrations show.

Illustration A: This drawing is 4 × 3 in (102 × 76 mm) on cartridge paper (drawing paper). It is an imaginary scene. Drawings B and C show you how I achieved the effect.

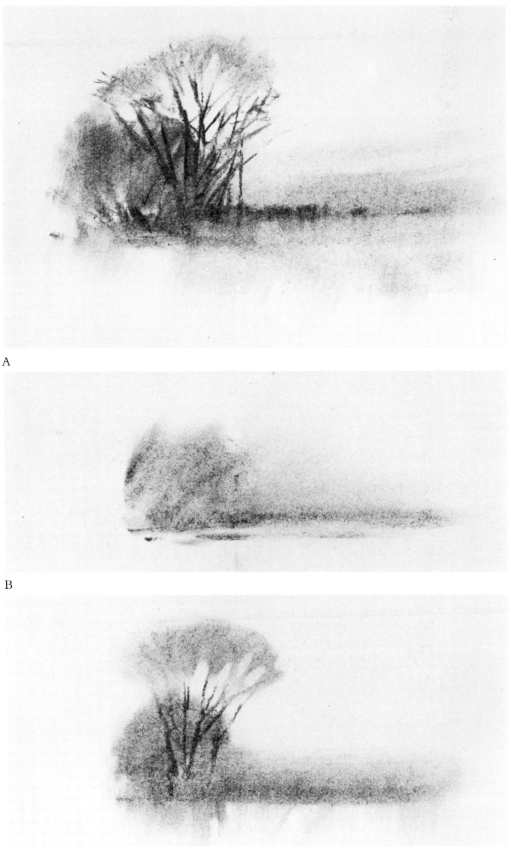

A

Illustration B: The charcoal was drawn-in loosely, similar to illustration F. Then I blended and softened by rubbing the charcoal with a soft paper tissue.

B

Illustration C: Next I drew in the tree trunks and foliage. I rubbed the foliage with tissue to soften and get a flat tone. For the sky showing through and the reflections I used a kneaded putty rubber.

C

Illustration D: I have drawn a line with charcoal and smudged part of it to show you the effect.

D

Illustrations E and F: These two sketches were drawn direct without any smudging or lifting out with a putty rubber, and illustrate the rich density of tone.

E

F

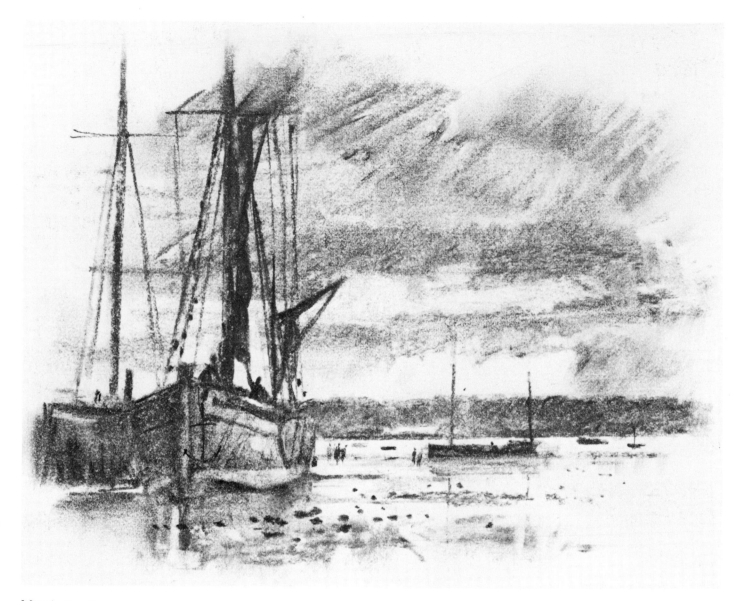

Manningtree, Essex

Size: 8 × 6 in (203 × 152 mm)
Medium: Charcoal
Paper: Drawing paper

The theme for this charcoal sketch is a rainy sky
and wet mud-flats. The light over the hills
reflects into the river and links together the
landscape and sky.

I have rubbed charcoal all over the paper
except for the highlight on the river, and then
lifted out the lighter tones with a kneaded putty
rubber.

I worked again over the rubbed-out areas to
lower the tone of the sky. The mud-flats are
lighter and therefore reflections of light and dark
register clearly. Success of this atmospheric
subject depends entirely on getting tone values
right.

Notice how the line of dark hills joins up to
the barge. The barge joins the dark clouds
linking sky and landscape. The principle of
relating landscape to sky is a common factor and
a key to successful drawing and painting.

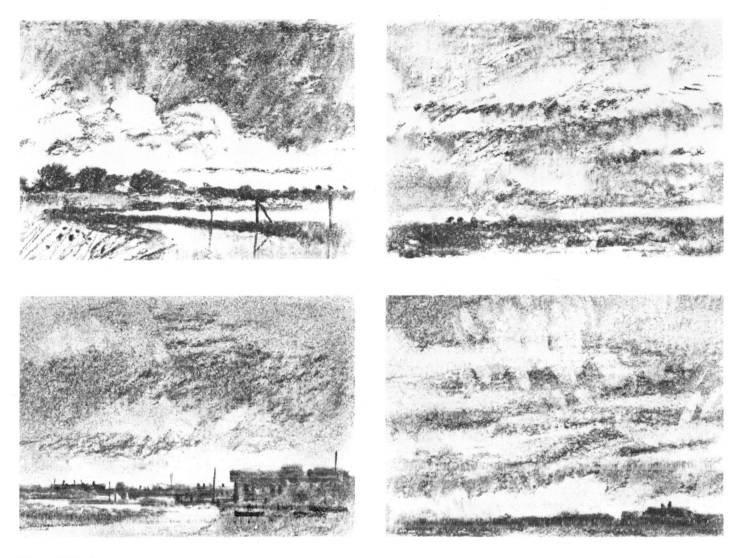

Charcoal Sketches

Size: $3\frac{1}{2} \times 2\frac{1}{2}$ in (89 × 64 mm)
Medium: Charcoal
Paper: Drawing paper

These charcoal drawings illustrate how complete a small sketch can be. They were done in the studio from imagination. A few preliminary charcoal lines can suggest a possibility for a landscape.

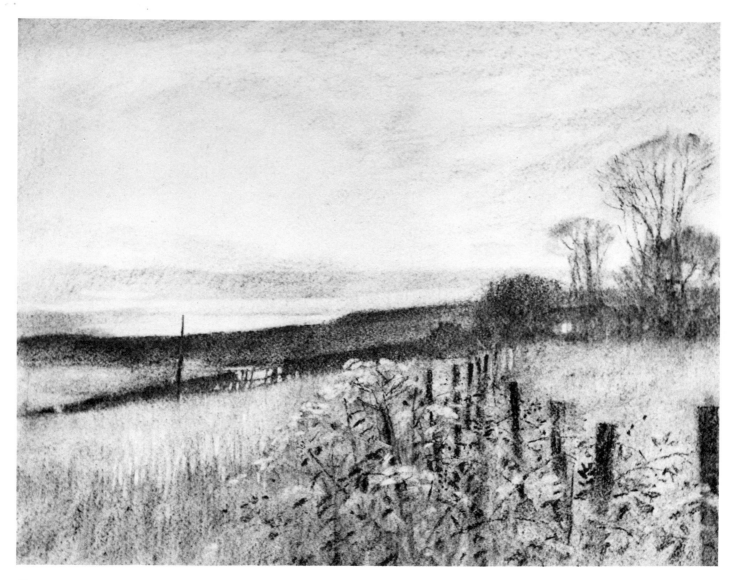

Dawn

Size: $17\frac{1}{2} \times 14$ in (445×356 mm)
Medium: Charcoal and white soft chalk pastel
Paper: Bockingford 140 lb (300 g/m²)
watercolour paper

My subject is imaginary. The effect of sunrise
always has a fascination for me.

For the darker part of the sky I have used
charcoal. To get the effect of luminosity white
pastel was applied over the charcoal.

Notice how the pole and fence are positioned
to lead into the point of interest on the
horizon.

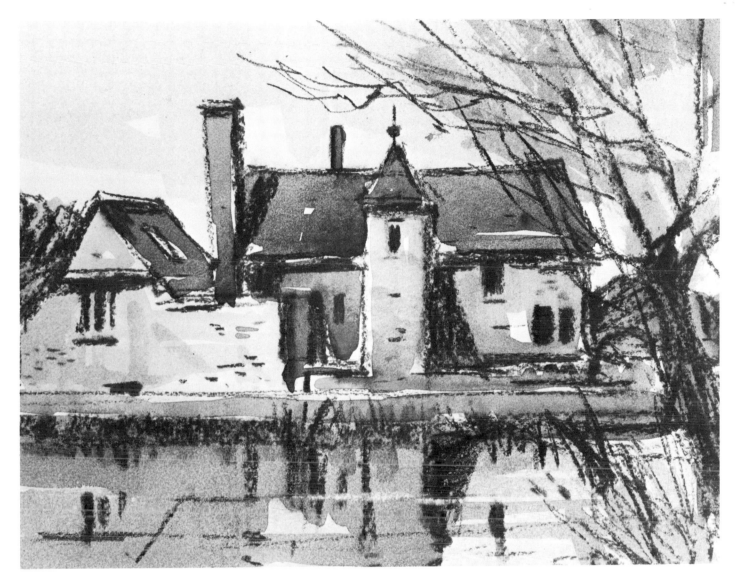

Mill House

Size: 8 × 6 in (203 × 152 mm)
Medium: Charcoal and watercolour
Paper: Watercolour board

Charcoal and wash is an excellent combination for rapid sketches. The watercolour board has a slight texture, and is ideal for charcoal.

I have indicated just a blue tone for the sky, leaving patches of white. Drawing-in the shapes of clouds in charcoal would have been much too assertive for this small outdoor sketch.

Oil Pastel

I personally prefer to draw in monochrome with oil pastel rather than a range of colours. Normally I use dark brown which gives a good range of tone values.

The medium is capable of a broad expression ideally suited to drawing skies. It can be used on smooth or textured paper, but its wax-like mark cannot be erased or blended with the fingers.

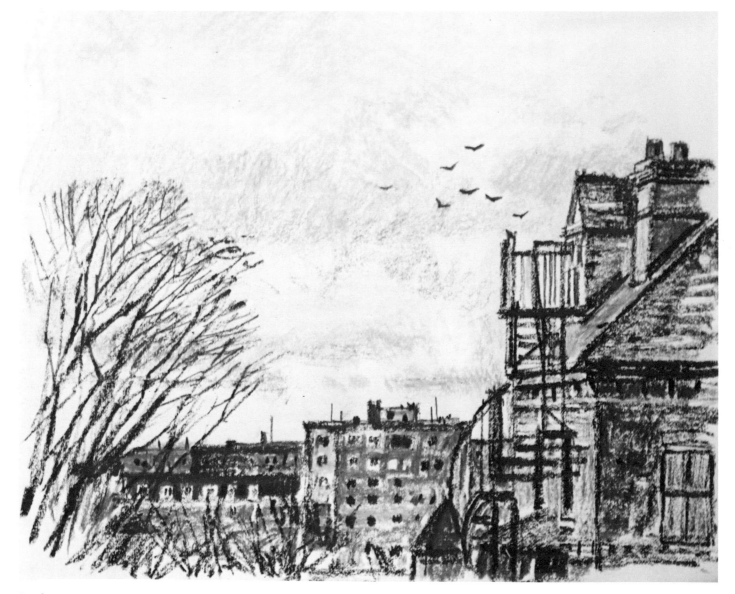

Roof-tops

Size: 11 × 9 in (279 × 229 mm)
Medium: Oil pastel
Paper: Drawing paper

I started this outdoor drawing with the fire-escape on the right, drawing direct with oil pastel.

The sky is blue overhead, becoming paler towards the horizon where it blends into a dusty yellow. Clouds are low and formless. I put these in after I had almost finished the drawing. The trees and birds were drawn last of all.

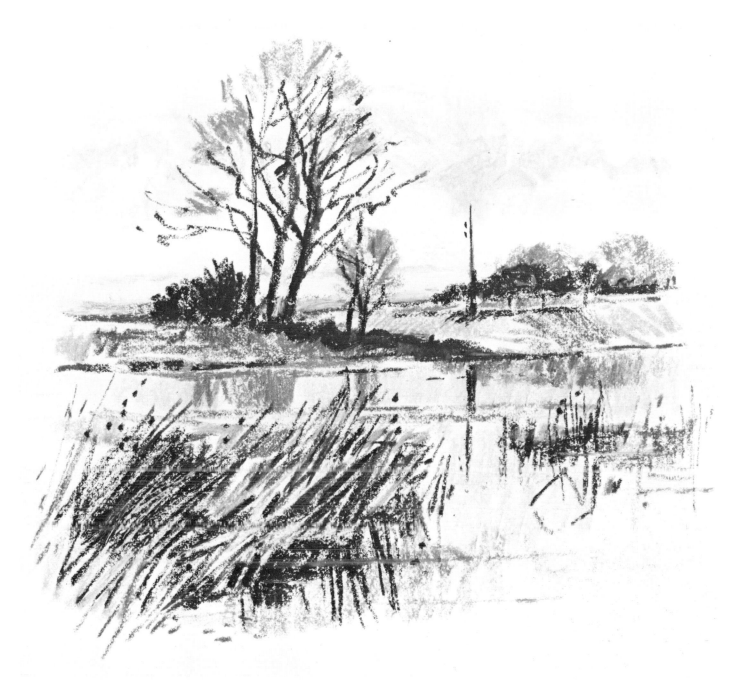

Reflections

Size: $7 \times 6\frac{1}{2}$ in (178 × 165 mm)
Medium: Oil pastels
Paper: Cartridge paper

There are various techniques which can be used with oil pastels, such as scraping out and thinning with turpentine.

But I have illustrated direct drawing on paper. Oil pastel does not have the same range of expression as soft chalk pastel. It cannot be rubbed and blended except by the addition of turpentine.

Chalk Pastel

This underrated medium is one of my favourites: excellent for quick impressions or more finished work, soft pastel has everything to offer the artist. It is easy to use and with such a wide range of delicate tints and shades is particularly suitable for painting landscape and skies. If you buy a boxed set of pastels make sure they are suitable for landscape: the necessary freshness of colour is achieved by having a good range of many colours – I have several hundreds.

Chalk pastel has a density similar to oils and acrylics so the transition from a pastel sketch into either of these two mediums is reasonably accurate. Neutral coloured paper with a slight grain is best suited to pastel.

When working outdoors clamp the paper between two boards in transit to prevent rubbing.

Like charcoal, pastel smudges easily but with care this will not happen and in any case the areas are easily reinstated by reworking over the top after surplus pastel has been removed. Aerosol fixative darkens pastel, particularly if applied too heavily.

Hilaire Degas (1834–1917) exploited the medium to an unprecedented extent bringing out all its beauty and colour. His $40\frac{3}{4} \times 38$ in (104×96 cm) pastel painting *Après le Bain* in the National Gallery, London, is just one that testifies the durability of pastel. If you have not considered soft chalk pastel for sky studies I recommend it without hesitation.

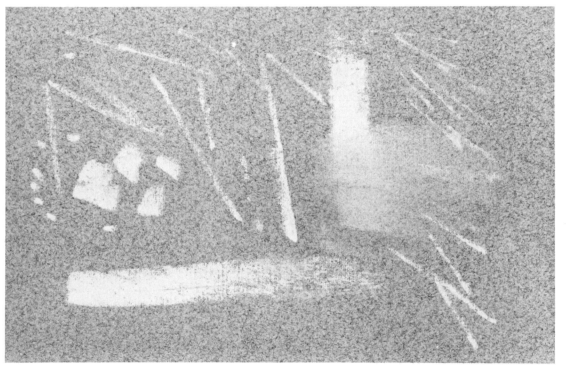

Pastel Marks

I have used one piece of chalk pastel $\frac{1}{2}$ in (13 mm) long to make all these marks. Below, by varying the pressure, I have made a full-scale tonal mark from light to dark. Paper tissue was used to soften the thick vertical pastel mark.

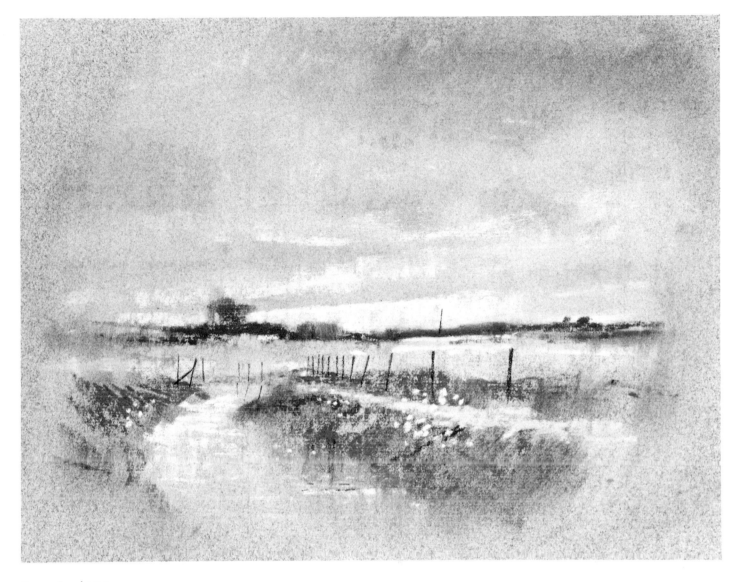

Sussex Landscape

Size: 9 × 7 in (229 × 178 mm)
Medium: Soft chalk pastels
Paper: Fabriano Ingres Mid-grey

This sketch done in the studio from imagination illustrates the versatility of pastel. Positive marks contrast with blended areas. I have used dark grey, yellow ochre, pale green, and silver white. The posts were drawn-in lightly with a soft carbon pencil and a lot of softening and blending was done with a paper tissue.

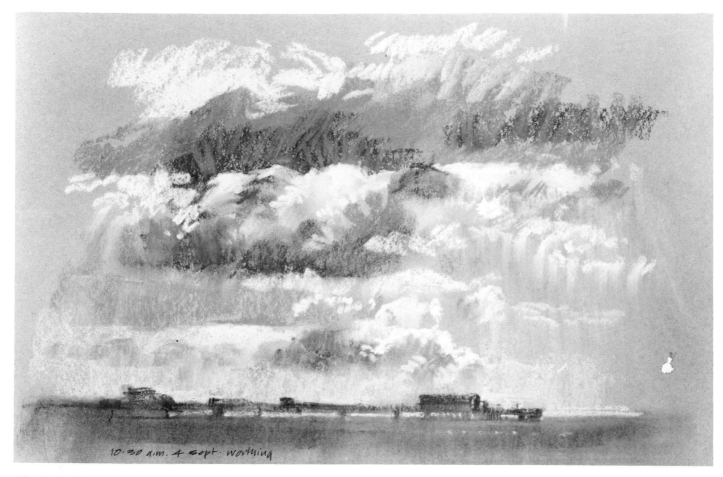

10.30 a.m. 4 sept. worthing

Clouds, Brighton

Size: 12 × 7 in (305 × 178 mm)
Medium: Dark grey pastel
Paper: Grey scrapbook

An outdoor sketch on Brighton beach on a June
morning.

The single pastel is ideal for rapid drawing.
I have not done any rubbing or blending at all
and have left every mark as it is.

Drawing skies outdoors on a beach is a very
great pleasure. The best way to start is to
determine in which direction the clouds are
moving. Select an area which has the most
interest and place it in the centre of your
paper. Work outwards, only looking for the big
shapes and principal tonal contrasts. Remember
to leave the paper showing. Filling it all in
will result in your drawing becoming dark and
heavy.

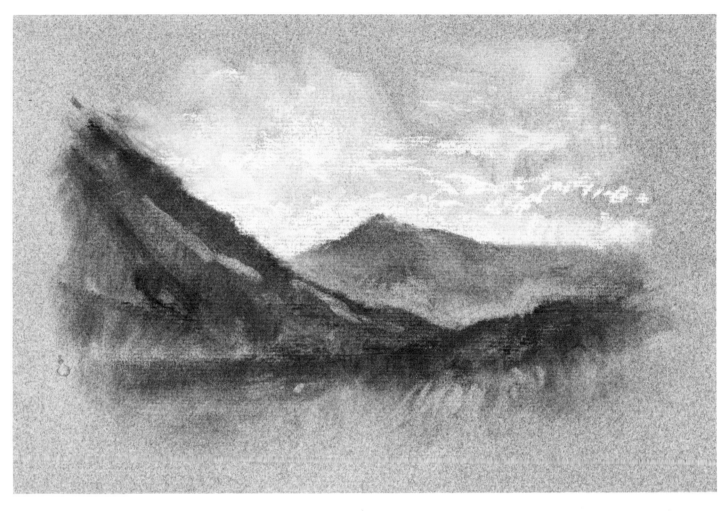

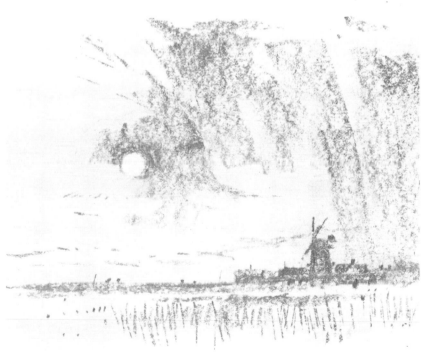

Scottish Highland

Size: 8 × 6 in (203 × 152 mm)
Medium: Charcoal and pastel
Paper: Canson

Charcoal and light-blue soft chalk pastel were used for this sketch. The combination of the two mediums is ideal for rapid sketches, because a full tonal range is easily achieved.

For the distant mountain the charcoal was lightly rubbed off with paper tissue; then a putty rubber lifted out the lighter tones.

Cley-next-the-sea, Norfolk (left)

Size: 7½ × 6 in (191 × 152 mm)
Medium: Grey pastel
Paper: Drawing paper

I used one grey pastel for this drawing. After masking-off the edges of the rectangle the pastel was firmly rubbed into the paper with tissue, producing a pale grey tint. The sun disc was lifted out with a putty rubber. I drew boldly and directly into the grey ground; no alteration was possible because erasing would have spoiled it.

Pencil

Some artists like to use pencils of varying grades when drawing landscape, but for drawing skies one soft pencil is usually sufficient. On a small scale, soft pencil is well suited to drawing clouds outdoors. If not overworked it gives an effect of light and life on textured paper; but rubbing-in should be avoided because this will render the texture flat and lifeless.

I often use carbon pencil because it gives a tonal range from black to the lightest grey without an unpleasant shine; it is also difficult to smudge.

Charcoal pencils are sometimes gritty and, like conté pencil, give a strong black mark. Clutch pencils have needle-thin, retractable leads and have a great advantage over wooden pencils because they do not need sharpening.

Providing they are not too smooth or coarse in texture most papers are suitable for pencil drawing. Do not use a rubber except to lift out light tones.

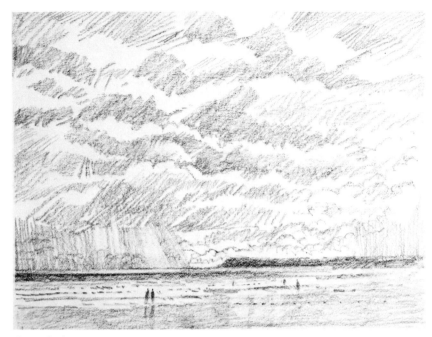

Coastal Sky

Size: 7 × 6 in (178 × 152 mm)
Medium: 2B pencil
Paper: Drawing paper

If pencil lines are left open, the texture of the paper retains its sparkle. Soft pencil is more suitable for this effect than a hard grade.

The diminutive figures give a tremendous effect of space; without them there is no indication of scale. Positioning is important because attention is immediately drawn to them. Except for clouds on the horizon, no outline drawing is used. Dark against light indicates shape and form.

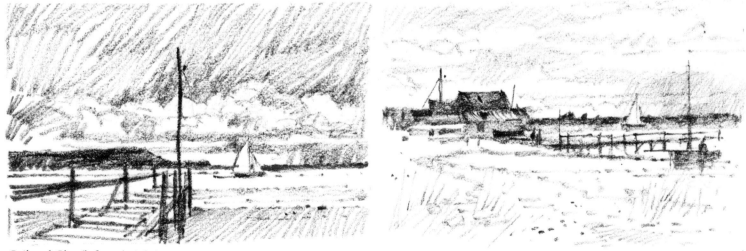

Sail and Sky (left and right)

Size: 3¾ × 2¼ in (95 × 57 mm)
Medium: Soft carbon pencil
Paper: Drawing paper

Both sketches were drawn direct without preliminary drawing: a good exercise to develop surety of hand.

The positive drawing of the darker sky gives it vigour and a sense of movement. In contrast, the other drawing is quieter and still.

These drawings graphically illustrate how a sky effect can impose a mood and atmosphere. I do not erase a pencil drawing; if it does not develop satisfactorily I scrap it and start again.

Outdoor Sketch

Size: 5 × 5 in (127 × 127 mm)
Medium: 2B Pencil
Paper: Drawing paper

A rapid sketch in pencil done outdoors. The sketch has no artistic merit, but I enjoyed doing it, and learnt from the experience.

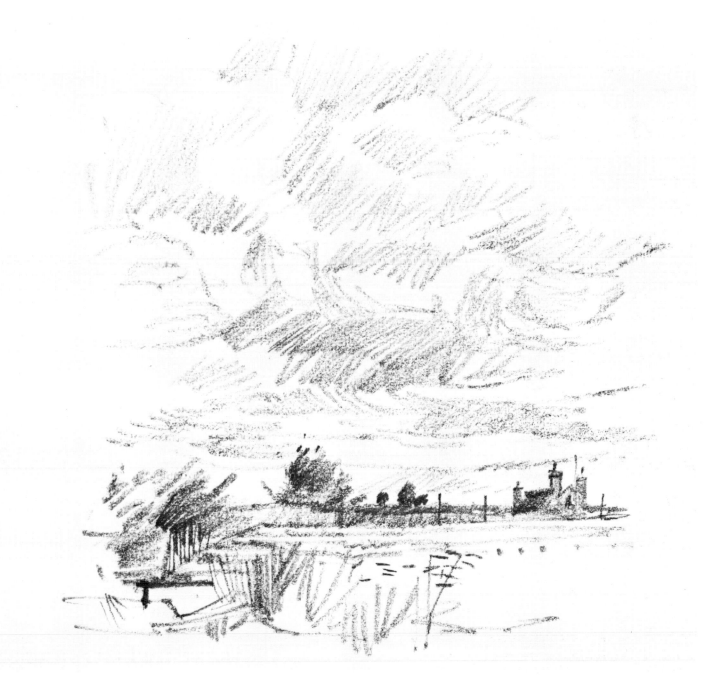

Conté

Soft black-and-white conté crayon on grey pastel paper is a good combination for drawing skies; grey conté on white or cream coloured textured paper also works well.

Soft pastel can be combined with soft conté, particularly for rapid studies outdoors.

Wax Crayon

Black wax crayon is very suitable for broad and quick sky studies. On white textured paper it has sparkle and life, and because mistakes cannot be erased it develops directness. There is a wide range of colours in wax pencils and many artists produce full-colour sketches with them. I often use a children's wax crayon on slightly textured cartridge paper, and some of the monochrome drawings in this book are done with black wax crayon to show its effect on smooth and textured paper.

Pen

A fine steel nib is unsuitable for quick tone drawing outdoors because shading takes time to build up, so use a fountain pen with interchangeable nibs. Tone can be built up more quickly by smudging the ink when wet or using a sable brush and water.

Tone washes can be put on top of a waterproof ink drawing without it lifting. A delightful atmospheric effect is achieved by using a non-waterproof ink and then brushing over it with a wet brush.

Writing ink flows well but Indian ink soon clogs most pen reservoirs and should not be used unless specified by the pen manufacturer.

Felt-tip and nylon pens are very useful for broad, simple impressions; they are available in an assortment of colours but some of these pens have ink that eventually fades or discolours.

Brush

Drawing with a brush is very pleasurable and expressive. Capable of a variety of marks the brush-and-ink technique is essentially broad and bold; fine detail can be drawn in with a smaller brush or pen. You might like to experiment by gradating tone with the dry-brush method but this does not have the same versatility of tonal range as pencil or charcoal.

I have a cleverly designed Chinese brush pen that is a delight to use. Designed on the principle of a fountain pen it has a brush instead of a nib; the ink in the barrel flows into the brush and keeps it charged all the time when drawing. You can see its effect illustrated on pages 32 and 33.

Paper

It is unnecessary to use expensive paper. Cheap cartridge paper with a slight texture will suit all drawing mediums. I am always on the look-out for children's drawing books: many have a pleasant, slightly coarse paper ideal for sketches.

Watercolour and pastel papers are popular with many artists because of their pronounced grain. Watercolour paper, pastel paper, writing paper, duplicating paper, brown paper and layout paper are all suitable for drawing on in different mediums, but I would not advise using cheap coloured paper as it can fade or change colour in the course of time.

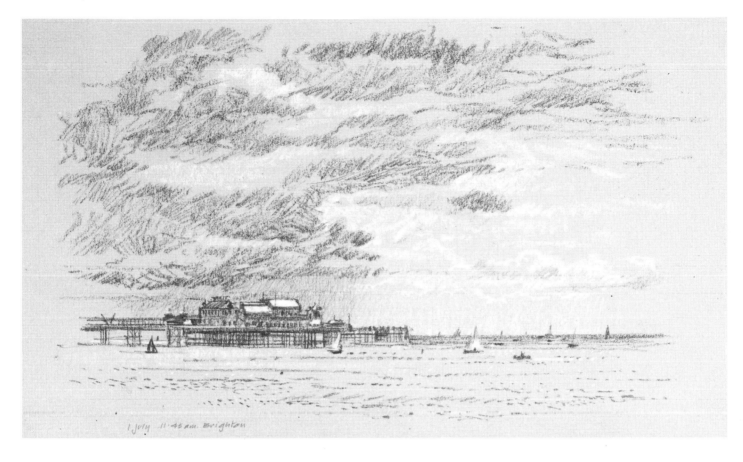

Outdoor Sketch, Palace Pier, Brighton

Size: 14 × 9 in (356 × 229 mm)
Medium. Soft black and white conté
Paper: Grey scrapbook

I enjoyed doing this outdoor drawing despite an extremely chilling wind. The clouds moved quickly, but I began by roughly indicating the pier to get the scale correct. Then I completed the sky. A few touches of soft white conté give a subtle hint of sunlight to the sky, pier, and sails.

The studio painting I did from the sketch is illustrated on page 86.

Fountain Brush Drawings

Size: 6 × 4 in
(152 × 102 mm)
Paper: Bockingford
watercolour paper
and drawing paper

Four drawings using
the fountain brush pen
mentioned on page 30.

Drawings A and B
are drawn on
Bockingford water-
colour paper. The
brush is more effective
on textured paper
because the dry-brush
technique can be
exploited.

I use black writing
ink for all my pen and
brush drawings.

To lighten the sky
in drawing B I have
lightly rubbed it over
with a putty rubber.

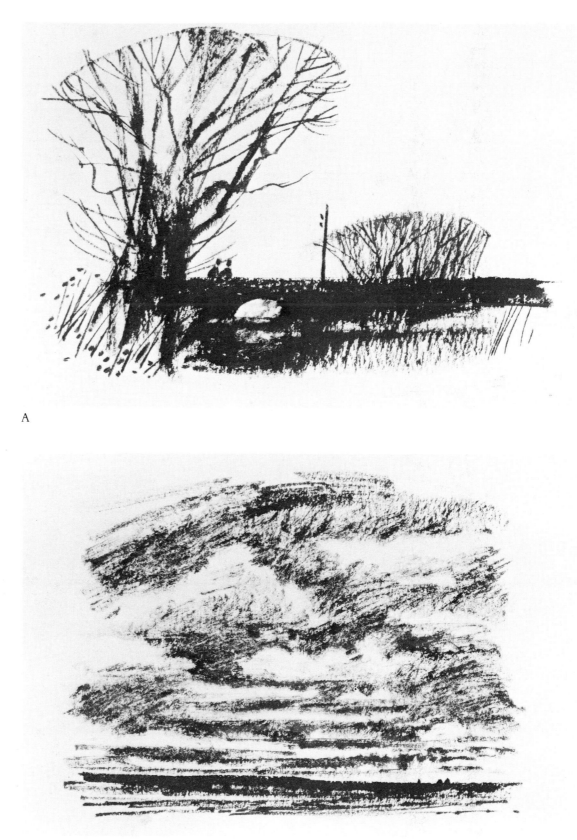

A

B

C

D

PAINTING

Acrylics

When varnished, acrylic paints are virtually impossible to tell apart from oils. They are comparatively modern but in no way inferior to the traditional medium of oils; I have been painting with both for a long time and hold them in equal regard.

Acrylics consist of pigmented colour of artist's quality bound with clear synthetic resin which, unlike linseed oil, does not have a tendency to discolour. They are thinned with water and by diluting the medium to transparent washes a watercolour technique can be adopted. When the colour is dry it cannot be lifted by subsequent washes of colour. Without thinning, they can be

Coastal Sky

Size: 24 × 18 in (610 × 457 mm)
Medium: Acrylic
Support: Hardboard (Masonite)

A blustery sky with intermittent patches of sunlight is my theme for this acrylic painting. The subject is imaginary.

The harbour wall, sails and figures give scale to the big cumulus clouds whose characteristic flat bases aid the feeling of recession. On the horizon the sunlit cumulus clouds are typical of a coastal sky. The dark band of sea is a strong division and gives contrast to the sky and beach.

My colours were cadmium red, burnt umber, ultramarine, yellow ochre and titanium white.

applied like oils using the opaque and impasto techniques. Beautiful glazing effects are also possible with acrylics. They dry very quickly enabling subsequent layers of paint to be applied sooner than with oils. Working outdoors can cause problems but the answer to quick drying is to use much more water to dilute the paint. I paint outdoors a great deal with acrylics.

The medium is suitable for any oil-free surface. Boards and canvases primed with acrylic primer are obtainable from most art stores, or you can purchase the primer and prepare your own supports. Nylon brushes are manufactured specially for acrylic painting; I also use hog-hair oil-colour brushes, but they do seem to wear out more quickly with acrylics.

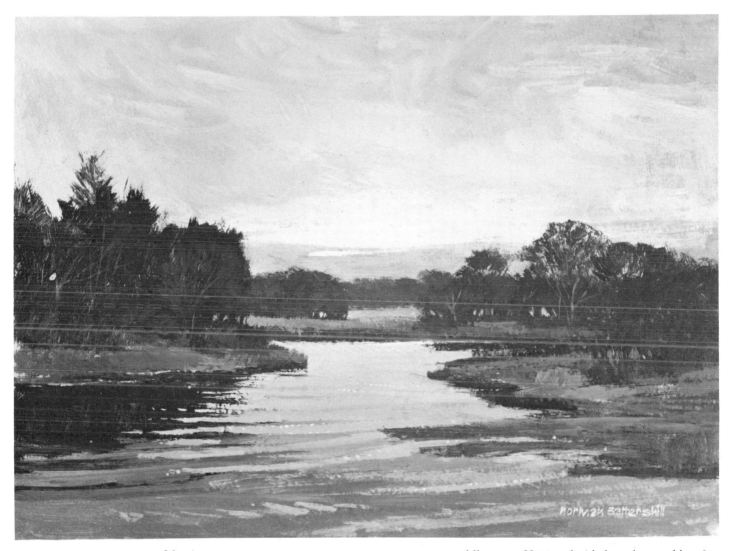

Morning

Size: 30 × 24 in (762 × 610 mm)
Medium: Acrylic
Support: Canvas

For this studio painting I used a black-and-white photograph as a starting point. The sky effect and atmosphere are imaginary. At the time of taking the photograph I also did a pencil sketch.

The point of interest is the streak of light towards the horizon. First of all I laid-in all the darks of the landscape and water, then the

middle tones. Having decided on the tonal key I painted the sky straight off and completed it. The effect of atmosphere fortunately came right first time.

If a painting does not go as I want it I let the paint dry, and then reprime the area. With acrylic it soon dries, and I can begin the sky again. It is not always necessary to obliterate with solid white paint. A diluted application is enough.

The colours I used here were burnt umber, ultramarine, cadmium red, yellow ochre, cadmium yellow and titanium white.

Watercolour

Landscape has long been the main interest of the watercolour painter. The early twentieth century saw a preoccupation with the effect of light and atmosphere, no doubt inspired by the work of J. M. W. Turner (1775–1851). Hercules Brabazon Brabazon (né Sharpe, 1821–1906) painted with a dash and verve so well suited to watercolour. His *Ischia* is a small sketch measuring $11\frac{5}{8} \times 7\frac{5}{16}$ in (297 × 187 mm) but has a breadth which is a delight. The versatile John Absolon (1815–

1895) also painted atmospheric impressions of a similar quality.

The transparency of watercolour is ideally suited to painting the misty forms of clouds; and delightful, rapid effects are obtained by experienced watercolourists.

Being quick drying, watercolour is excellent for outdoor work, but you will need a certain amount of practice before you can expect to start producing satisfactory results. This is because watercolour dries to a much lighter tone than when wet, and its

Step 1

Distant Church (step-by-step, above and opposite)

Size: 8 × 5 in (203 × 127 mm)
Medium: Watercolour
Paper: Bockingford 140 lb (300 g/m²) watercolour paper

Step 1: Alizarin crimson and ultramarine are mixed for the preliminary wash of colour. Then a darker tone is brushed into the wet colour, letting it run freely. Before it dries I lift out patches with soft paper tissue.

Step 2: The landscape, a mixture of ultramarine and Payne's grey, is painted on top of the sky colour when it is dry. The blue-grey is an even dark tone. Here and there I lift out the dry

colour with a wet brush and blotting paper to suggest light tones.

To get the effect of distant heap cloud I wetted the shapes with a small brush, and then blotted it with clean blotting paper. A few more touches of colour and lifting out of patches completed the sky.

The edges of the painting looked untidy, so I took them out with a small sponge and clean water.

Step 3: I extended the foreground to give a better balance in relation to the sky.

Process white was mixed with watercolour for the foreground and touches of light in the distance.

It is fun building up a painting from imagination like this.

Step 2

Step 3

transparency makes it difficult to paint over mistakes. If absolutely necessary you can take out errors with either a wetted sponge, blotting paper or a wet brush.

Opaque white cannot resemble the translucency of cloud in the same manner as a transparent wash of colour on white paper, but it has its uses for painting skies: it is effective when diluted and painted on tinted paper. Turner used bodycolour white on blue paper for some of his watercolours. I prefer to use designer's gouache which has more strength and brilliance.

I would suggest using a watercolour paper of not less than 140 lb (300 g/m²), the avoirdupois measurement being calculated by the paper's weight per ream— traditionally the old ream of 480 sheets. The heavier the paper, the easier it is to take out mistakes.

Incidentally, if your watercolour picture turns out to be a disaster, don't throw it away. You can go over it with pastel and make it a pastel painting, or prime the paper with acrylic primer and when it is thoroughly dry, paint in acrylics or oils. Alternatively, use the other side of the paper.

Sussex Fields

Size: 12 × 8 in (305 × 203 mm)
Medium: Watercolour
Paper: Bockingford 140 lb (300 g/m²) watercolour paper
Palette: Cobalt blue, ultramarine, yellow ochre, chrome deep, cadmium red

I did this watercolour in the fields near my studio at 6 pm on an August evening. First of all I laid-in the sky and almost completed it before beginning the landscape. I used a sponge to wipe out the blue sky to indicate a layer of cirrus cloud. After the trees had absolutely dried the clean sponge was used again, lightly dragging down the sky. The same technique was applied to the immediate foreground, to soften the edges and suggest grass.

Gouache

Many famous artists have painted with gouache, notably Turner, Brabazon, Peter De Wint (1784–1849), and Paul Sandby (1725–1809). It is an expressive medium particularly suited to atmospheric painting. Like watercolour, gouache dries quickly and appears lighter than when it is wet but it differs in one important respect: one layer of colour will conceal another. This makes it an ideal medium for beginners as mistakes can be corrected. It can be used either on paper or watercolour board.

Watercolour brushes are normally used for gouache but you may like to experiment using oil-colour bristle brushes and poster colour, painting in the oil colour manner.

Oils

Admirably suited for outdoor or studio work, oils are the most popular painting medium. They are particularly suitable for skies and atmospheric paintings on any scale, as many large and small works of Constable and Turner testify.

When you are working outdoors and need a shorter drying time mix underpainting white, or alkyd white or a gel-medium with your colours.

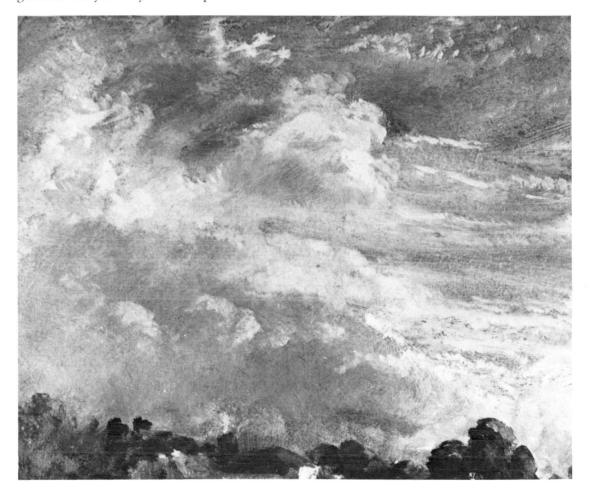

Cloud Study: Horizon of Trees
John Constable (1821)

Size: $11\frac{1}{2} \times 9\frac{3}{4}$ in (292 × 248 mm)
Medium: Oil on paper on panel
'*I made about fifty careful studies of skies tolerably large to be careful.*'—John Constable

Constable's first oil sketches of skies without any land are assumed to date from 1822. Earlier studies in crayons on blue paper are small, measuring $7 \times 4\frac{1}{2}$ in (178 × 108 mm). When Constable took a house in Hampstead, London, he turned increasingly to sky studies. Of twenty such studies only one had a vestige of landscape. His twenty pencil drawings of cloud types are copies of schematic engravings made by Alexander Cozens in his landscape treatise, c1785.

Alkyds

Alkyd colours are pure pigments ground in alkyd resin solution. They are 'touch dry' within eighteen hours and paintings of average paint thickness are ready for varnishing one month after completion. Painting techniques are similar to oils, and all forms of conventional oil colour materials and mediums are suitable for alkyds.

Petroleum distillate is suitable for retarding the drying time.

Mediums and Varnishes

One of the most popular mediums for oil colour is a mixture of half turpentine and half linseed oil. Sometimes I use sun-thickened linseed oil but any of the proprietary brands specifically manufactured for oils and acrylics are suitable. With acrylics I do not use a medium at all, except occasionally for glazes. Retouching varnish may be used when an oil painting is dry to the touch, and the final varnish in approximately twelve months. Acrylic varnish can normally be applied to an acrylic painting within twenty-four hours.

Autumn

Size: 24 × 20 in (610 × 508 mm)
Medium: Alkyd
Support: Hardboard (Masonite)

The sky has a tonal gradation to give the effect of a passing light shower.

The colours are mostly russets and greys. Although the tone is darker to the right of the painting it is balanced by the small tree.

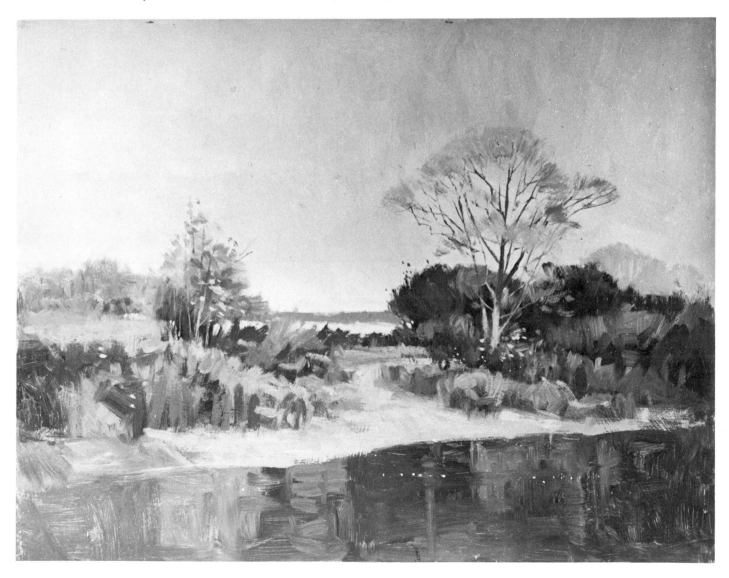

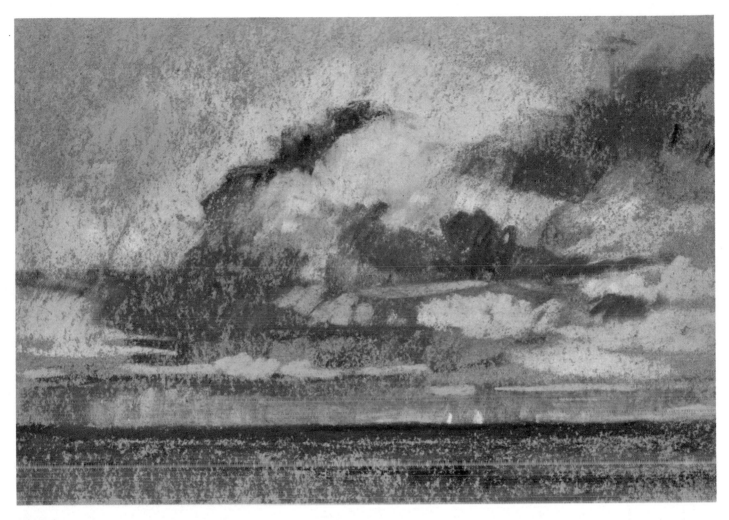

Winter Sky, Cromer

Size: 9 × 6 in (229 × 152 mm)
Medium: Pastel
Paper: Grey-brown pastel paper

I did this pastel sketch on a chilly December afternoon from the balcony of a Cromer hotel. The sky was full of subtle colour and tone. I had to work fast because the heap clouds altered very quickly. In fact I did three pastel sketches one after the other without moving from my chair.

The hotel room was warm and comfortable but looking through a window was not the same as sitting outside, absorbing the atmosphere – and the cold!

I began with the darkest part of the cloud, and then the lightest, so that contrast was the first statement. My intention was to keep the sketch broad in treatment to suggest the rugged winter sky.

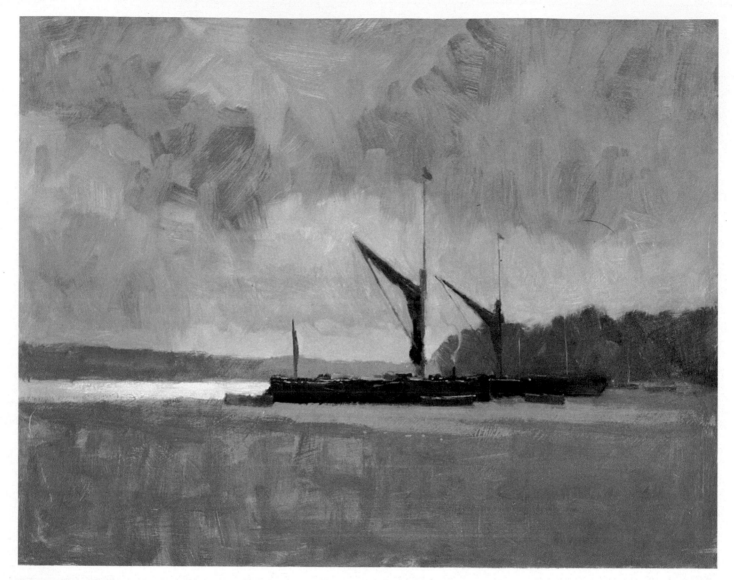

Barges at Manningtree

Size: 24 × 18 in (610 × 457 mm)
Medium: Oil
Support: Hardboard (Masonite)

Thames barges on the mud-flats under a rainy sky is
a subject I like to paint.

The sky occupies a large area of the painting.
Cloud form and the quality of light create
atmosphere and mood. I do not start a painting
without some preconceived idea of how it will
look when completed, particularly with regard to
the feeling of light and atmosphere.

I chose a cloudy sky to relate it to the
movement of the sailing barges.

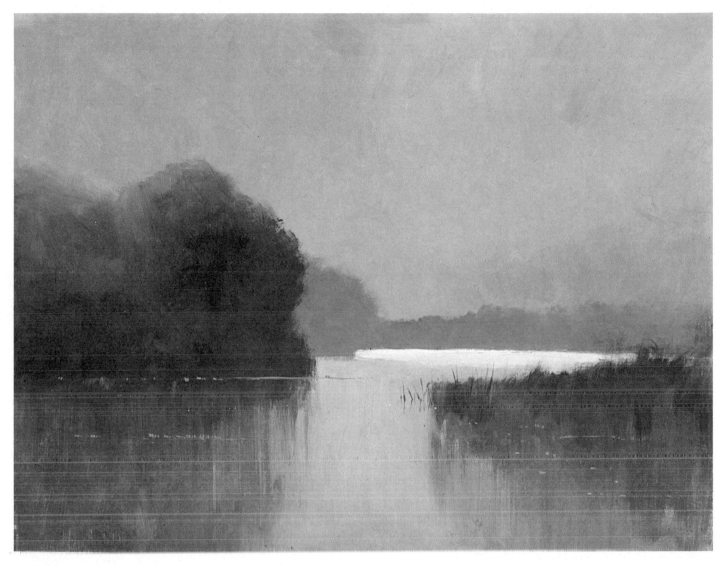

Early Morning

Size: 24 × 18 in (610 × 457 mm)
Medium: Acrylic
Support: Hardboard (Masonite)

A simple subject divided into a few planes can
make an interesting painting. Flat areas of colour
and minimum detail add to the atmosphere of
stillness. The accent of light across the water
sharpens the tone values and aids recession. I built
up the painting with thin washes of acrylic. When
the general tone and key value appeared pleasing,
opaque areas were carefully laid-in. The sky was
added last of all. If the tone of the sky is wrong the
rest of the painting will also be wrong; leaving the
sky until last lessens the chance of this happening.

The colours on my palette were ultramarine,
cadmium red, Winsor orange, yellow ochre and
titanium white.

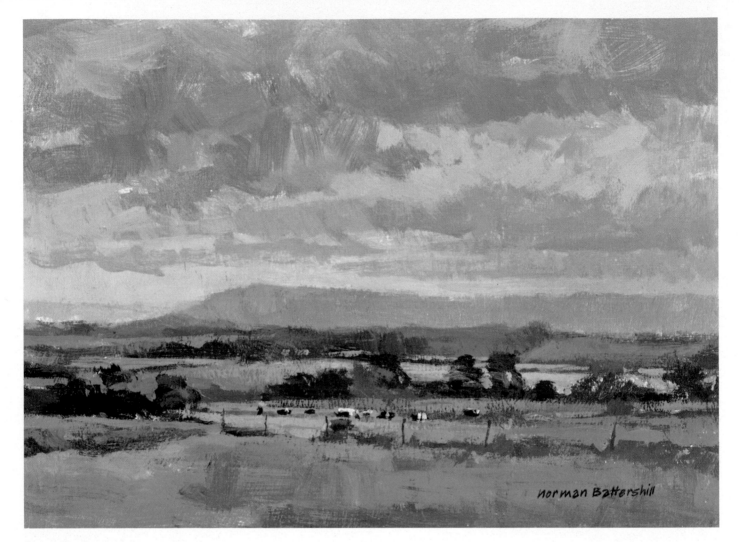

Sussex Downs

Size: 10 × 7 in (254 × 178 mm)
Medium: Acrylic
Support: Illustration board

An acrylic pochade done outdoors. The landscape is within walking distance of my studio, and you probably recognize some of my drawings as being of the same area.

I consider this a successful example of the sky fitting the landscape. The quality of light is very soft and diffused by the low layer cloud. I left the sky until almost last because in the words of Corot 'it is easier to fit a sky to a landscape than a landscape to a sky.' In this painting it was advantageous to follow his principle.

The acrylic colours on my palette were ultramarine, cadmium red, yellow ochre, sap green, cobalt blue and titanium white.

EQUIPMENT

Stool
For sketching you need a strongly constructed folding stool. Some artists prefer to paint sitting down; I prefer to stand because it is not so restricting, except perhaps when using a pochade. It is a matter of personal choice.

Easel
Painting outdoors demands a sturdy, practical easel that is easy to assemble and carry around. One of the most useful items I have is a Mendip pochade: a wooden box measuring 12 × 10 in (305 × 254 mm) which holds brushes, paints, two containers for oil and turps, a palette, and can hold painting panels, easel-fashion. Because it is compact the pochade is ideal for small paintings outdoors.

The larger French box easel which I have used for many years is extremely stable even in a strong wind. When full up with brushes, paints and boards it is a bit heavy to carry over any great distance so I carry only the minimum number of colours I am going to need; it is, however, the most compact of outdoor box easels. Light, wooden outdoor easels can easily be adapted to hold a paint box at waist level by the simple fixing of easel brackets. The extra weight of the paint box adds to the stability of the easel.

For studio work I have an old-fashioned oak wind-up easel, and I also use the very convenient and practical radial easel.

Drawing-board
I use a lightweight but rigid ply board for drawing and watercolour painting outdoors. In the studio I have a draughtsman's adjustable drawing-board on a stand.

Canvas and Hardboard (Masonite)
Canvas of all grades has a pleasant textural surface. The resilience of canvas on a stretcher is preferred by many artists to the rigidity of a panel. If you like the firmness of a panel and the texture of canvas, mount the canvas on hardboard with heavy-duty, fungus-resistant decorator's paste. You can paint direct on to hardboard although the rough side is unsuitable for anything except impasto painting. It is widely used because it is cheaper than canvas on stretchers, and also less prone to damage by accidental knocks.

Rubbing down the smooth side with coarse sandpaper and then applying two coats of acrylic or oil primer provides a pleasant, slightly textured surface. But be careful not to make the scratch marks too obvious.

Primer
It is preferable to use artists' quality primer for oils and acrylics. Prepare hardboard by rubbing the smooth surface with medium-grade sandpaper and then apply primer in two or three thin coats as recommended by the manufacturers. It is inadvisable to paint with acrylics on an oil-primed base, but an acrylic-primed base is suitable for oils.

Watercolour Box
My favourite is a box that is held in the hand by a thumb-hole in the palette which has adequate mixing space and enough compartments to hold a range of colours from tubes. If you like painting outdoors this kind of watercolour box is ideal.

Many artists prefer pan colours. Again it is a matter of personal choice; I like to use tube colours.

Brushes
For watercolour, a large sable brush with a good point is versatile and aids a broad style of painting. For laying large areas of colour, and a good substitute for a more expensive sable, there are a range of wash or sky brushes. A shaving-brush is popular with some watercolour painters.

Whichever medium you use, good quality brushes are a very wise investment and add greatly to the pleasure of painting.

Water
Acrylics and watercolours are thinned with water and it is important to take enough with you if you intend to paint outdoors. Large plastic lemonade bottles make excellent containers – some artists prefer to use a hot water bottle!

Palette
I use paper palettes for oils and acrylics; plastic panels are also practical for acrylics because the paint comes off easily in warm water. I would not recommend a wooden palette as the adhesive quality of acrylics makes them difficult to remove.

2. Cloud Facts

Clouds that love through air to hasten
Ere the storm its fury stills,
Helmet-like themselves will fasten
On the heads of towering hills.
William Wordsworth (1770–1850)

Forecasting the weather by looking at the clouds has long been a pastime of yachtsmen, fishermen, farmers, glider pilots, and anyone whose activities are dependent upon the weather. Ability to forecast is a useful asset for outdoor artists too, and some knowledge of why and how clouds form is essential for everyone who wants to paint or draw skies.

Clouds are formed by rising air carrying invisible water vapour. Because atmospheric pressure decreases with height, rising air expands and cools – like air rushing from a tyre. This cooling may lead to condensation of the water vapour on minute airborne particles called atmospheric aerosols which can be mineral dusts, soot, waste tar products, sulphates or even sea-spray. A cloud is an agglomeration of countless tiny water droplets. These droplets grow initially by condensation; to grow to a size large enough to fall from the cloud processes of coalescence, accretion and aggregation are necessary. Precipitation often starts as snow but melts as it falls through warmer air to reach the ground as rain.

Types of cloud formation are the result of different ascending motions of air. These motions are described as follows:

Widespread Vertical Ascent

Widespread layer clouds are formed by a slow and prolonged ascent throughout a deep layer of air. High cirrus clouds are formed primarily by vertical ascent, and their pattern is determined by the variation of wind velocity with height.

Irregular Stirring Movement – Turbulence

Layer clouds are also formed by irregular stirring movements of the air by radiational cooling or advection. These processes may take place at ground and sea level, or within the cloud itself.

Convective Movement

Convective movement is caused by rising masses of warm air called thermals. They can transform small and scattered cumulus clouds into massive, towering clouds that can reach an altitude of over 30,000 ft (10,000 m).

Orographic Movement

Lenticular, or wave clouds, because of their distinctive saucer or cigar shape, resemble UFOs and can often be observed as if flying in formation. This phenomenon – called lee-wave cloud by meteorologists – occurs where air rises to flow across mountains. Cloud forms above the mountains at the crest of the wave of air. If conditions are favourable, a wave-like oscillation may continue downwind on the lee side of the mountains. One or more similar cloud forms may be produced at the crest of each wave. Sometimes several wave clouds form vertically to form a stack or 'pile of plates'.

Clouds can be divided into three height decks:
1 The region of low clouds – cloud bases between land surface and 7,000 ft (0–2,100 m)
2 The region of medium clouds – cloud bases between 7,000 and 25,000 ft (2,100–7,600 m)
3 The region of high clouds – bases between 16,000 and 45,000 ft (4,900–13,700 m).

These divisions are generally applicable, but medium and high clouds sink below their lower limits in winter and with increasing latitude. In the tropics all clouds tend to rise

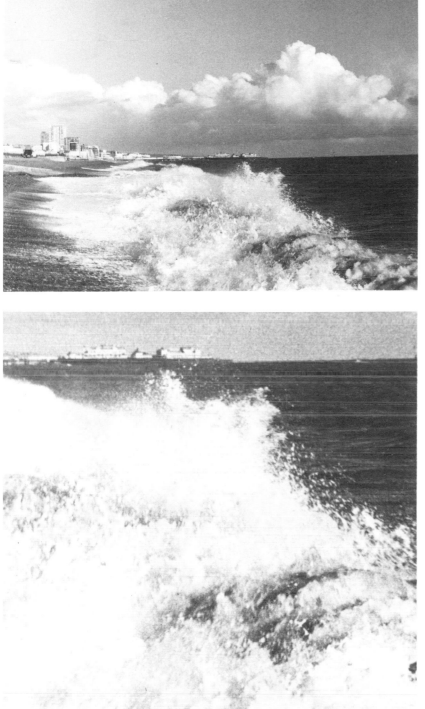

above the upper limits for their type. Thus the divisions are only a guide.

Clouds are further classified by shape:
a) Heap clouds (cumuliform)
b) Layer clouds (stratiform)
c) Feathery clouds (cirriform)

Having established the general cloud divisions the table overleaf gives the major types. This international visual-classification system was originated in 1803 by Luke Howard, a London-born pharmacist. Height and shape numbers refer to the divisions given above.

Cloud Droplet Nuclei

My photograph (above) taken on Brighton beach shows how a disintegrating wave forms a myriad of water droplets. Smaller droplets are formed by the bursting of the bubble film (as shown in the enlarged detail below). Rising air lifts the salt moisture particles, which may become involved in the growth of a cloud. But the concentration of salt nuclei may not exceed one-tenth of those involved in the formation of cloud. The other nine-tenths are assumed to be combustion nuclei from natural and man-made fires.

Important discoveries about the types of droplet and particle emitted when bubble films burst were made by Dr B J Mason, now Sir John Mason CB DSc FRS, Director-General of the UK Meteorological Office.

CLOUD CLASSIFICATION

Height and Shape	Name	Abbreviation	Description
1a	Cumulus	Cu	Low heap clouds of varying vertical extent
1ab	Stratocumulus	Sc	Low heap-layer clouds either broken or covering the whole sky
123a	Cumulonimbus	Cb	Heap clouds of great vertical extent producing showers and thunderstorms
1b	Stratus	St	Low, or very low, amorphous layer clouds covering coasts and hills, often ragged or in shreds
123b	Nimbostratus	Ns	Layered, often solid, clouds of great vertical extent associated with bad weather
2ab	Altocumulus	Ac	Medium-level heap clouds in 'islands' or 'rafts' seldom covering the whole sky. The normal form is often associated with the term 'mackerel sky' but other forms are lenticularis (lens-shaped), and castellanus and floccus (chaotic clouds of thundery skies)
2b	Altostratus	As	Medium level layer clouds associated with the term 'a watery sun'
3c	Cirrus	Ci	High clouds mainly formed by more-or-less dense heads from which fall trails or streaks (fallstreaks). Associated with the term 'mares' tails'
3ab	Cirrocumulus	Cc	High heap clouds ranged together in sheets of dappled and rippled appearance. Also associated with the 'mackerel' sky
3b	Cirrostratus	Cs	High amorphous cloud often covering the entire sky and sometimes only revealed by the presence of haloes about sun or moon

Cloud Classification

The chart describes the shape of the main cloud types and defines their height decks. The photographs on the following nine pages illustrate all these types and variations in their form.

Cumulus Cloud Growth

My photographs on this page show cumulus clouds of moderate vertical extent – cumulus mediocris. Notice the slight raggedness and the darkness of the cloud base at the top of the first picture.

The photographs were taken at very short intervals.

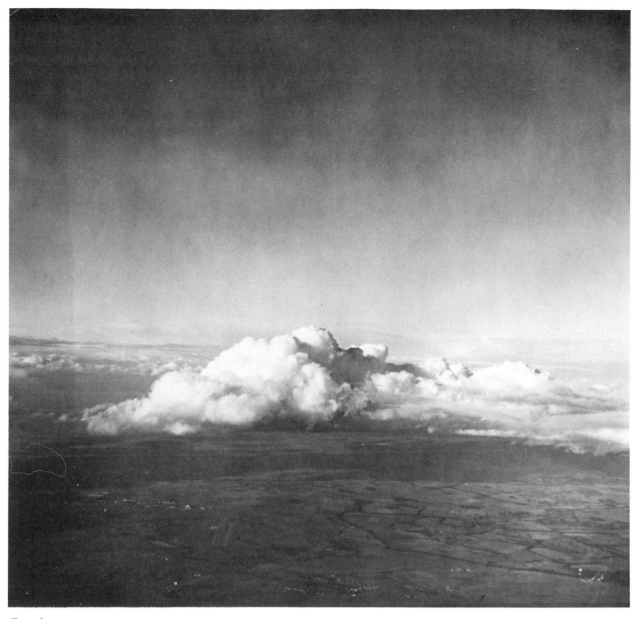

Cumulus

This aerial photograph
clearly illustrates the
rounded heap-like
form and flat base of
cumulus.

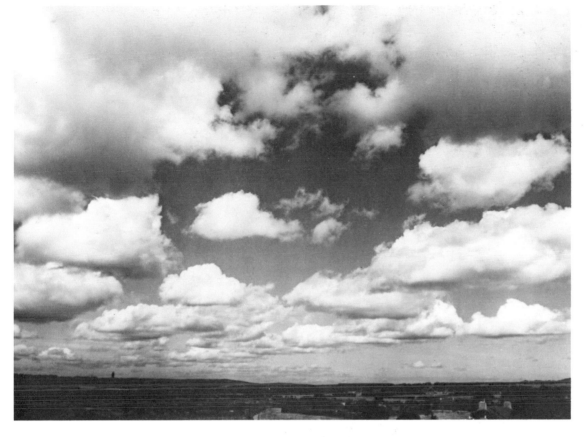

Fair-weather Cumulus.

The tops are well defined and the bases flat. Small clouds with woolly edges suggest that the cloud droplets of water evaporate as rapidly as the cloud forms. This process can be seen in the middle of the photograph. The smallest cumulus clouds are called cumulus humilis.

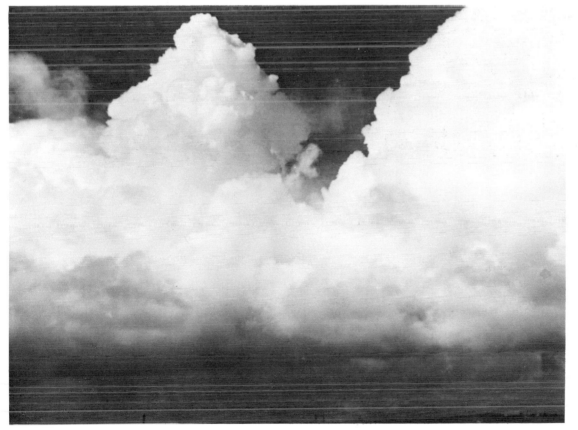

Cumulus Congestus

Sometimes the small fair-weather cumulus of early morning develop vertically so that their height far exceeds the width of their base. The atmosphere is said to be unstable, allowing bubbles of warm air from the surface to rise many thousands of feet.

The greater the vertical extent of the clouds the larger grow the water droplets within them. To the left of the photograph is a characteristic vertical development. Notice that the flat bases extend unbroken across the horizon.

Stratocumulus

Stratocumulus can cover the whole sky and may be formed by the spreading out of cumulus cloud as the latter's vertical growth is limited by changes in the stability of the atmosphere. The low cloud develops into featureless sheets, rolls – as here, undulating sheets or broken layers like crocodile skins.

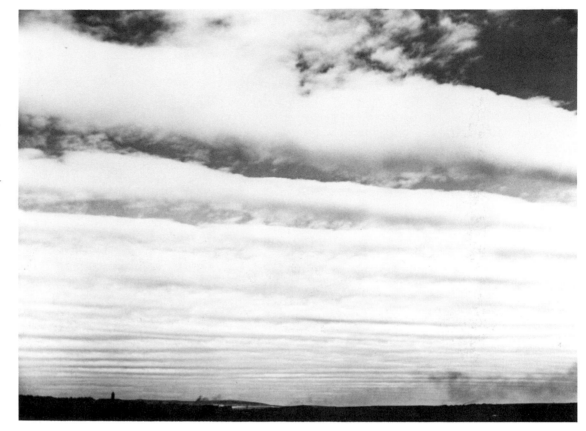

Cumulonimbus

The largest cloud has the characteristic fibrous top known as the 'anvil'. This occurs when ice crystals formed at the top of the cloud are swept aside by the high-level wind.

Heavy rain can be seen falling from the dark base of the clouds. This cloud form is one of the most dramatic optical phenomena in nature.

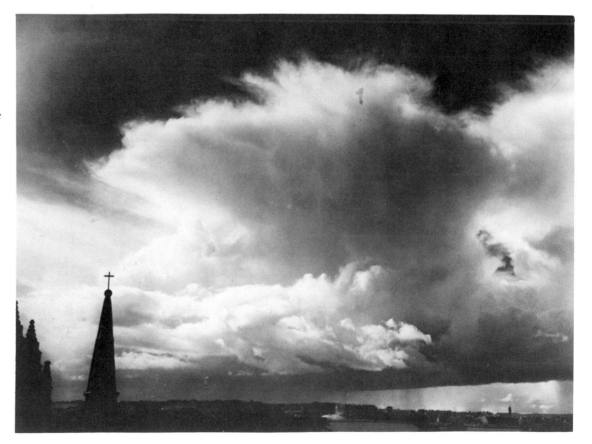

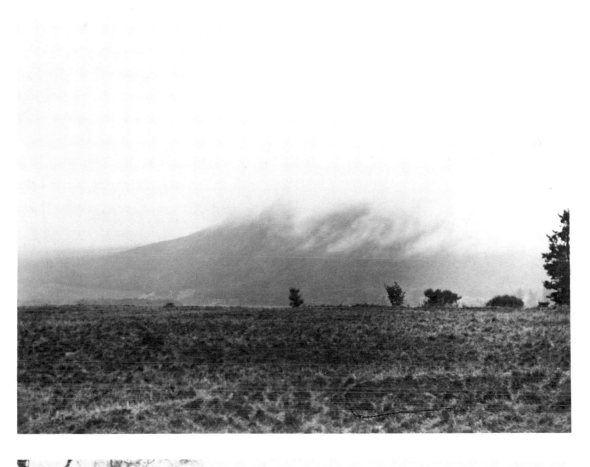

Stratus Fractus

These are clouds in the form of irregular shreds, which have a clearly ragged appearance. Fractus is a term applied only to stratus and cumulus. In this photograph the sky is covered by a layer of stratus which also covers the high ground – producing hill fog patches.

The pastel monochrome studies of Scotland in this book show some dramatic examples of stratus fractus in the Highlands.

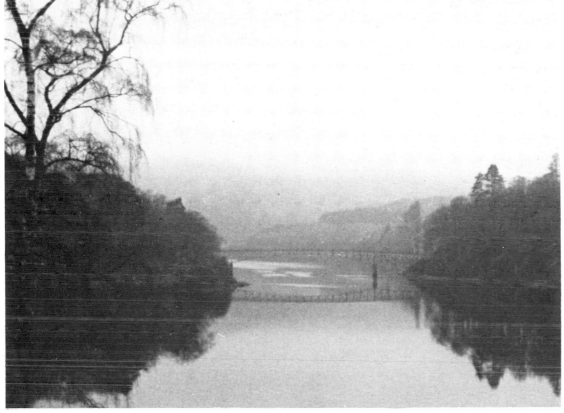

Nimbostratus

Low-level, shapeless nimbostratus covers the hills around a reservoir in Scotland. Rain can be seen falling into the water on the far side of the bridge.

Altocumulus

An extensive dappled layer of cloud composed of flattened globules, often referred to as a 'mackerel' sky. The other forms are lenticularis (lens shapèd), castellanus (turreted, like castle battlements) and floccus (tufted). The last two named often contribute to a chaotic sky characteristic of thundery conditions. The lenticular form dominates this photograph with some cirrus visible through openings.

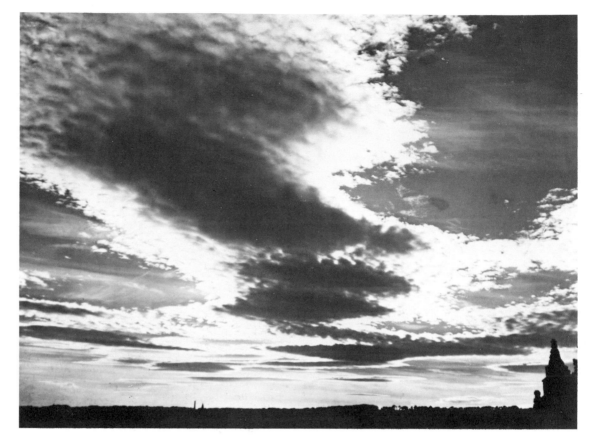

Altocumulus Lenticularis

A UFO-shaped altocumulus lenticularis cloud (right centre) surrounded by cumulus.

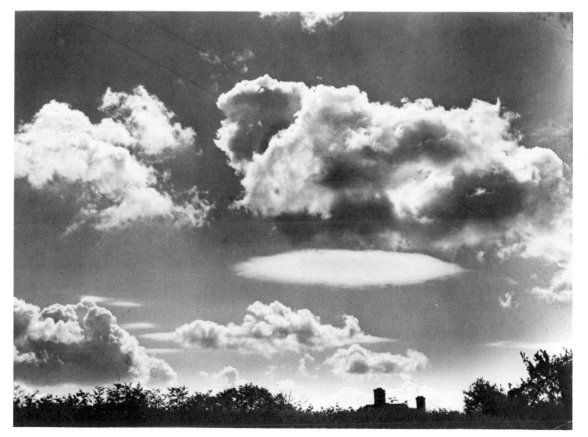

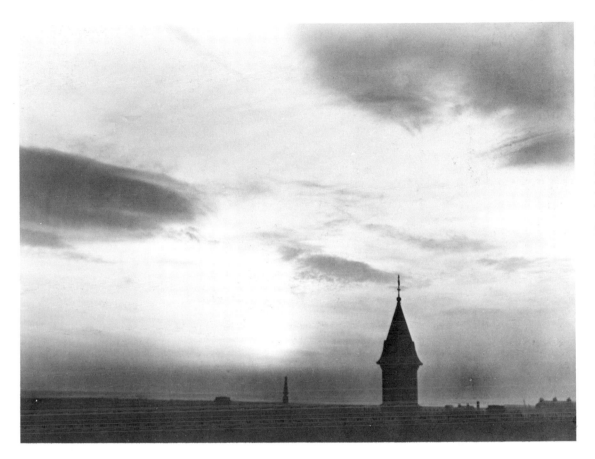

Altostratus

The diffusion of sunlight through altostratus often produces subtle effects of atmosphere and colour, particularly at dawn or dusk as this photograph shows. Sometimes these clouds have parts thin enough to reveal the sun at least vaguely, as through ground glass.

The cloud may thicken and completely obscure the sun, and is then known as nimbostratus, which is associated with bad weather.

The dark cloud patches in the middle and upper parts of this photograph are altocumulus.

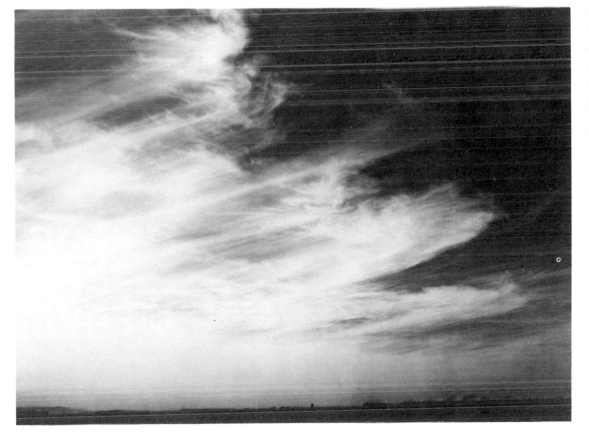

Cirrus and Cirrostratus

This photograph shows cirrus in the foreground and a sheet of cirrostratus in the background. These are high-level clouds formed of tiny ice crystals.

Often prism shaped, they may, by refraction of the sun's rays, cause a coloured halo or ring of light around the sun. Sometimes other patches of coloured light and a parhelion or 'mock sun' may appear in the sky.

Cirrostratus with
Sun Pillar

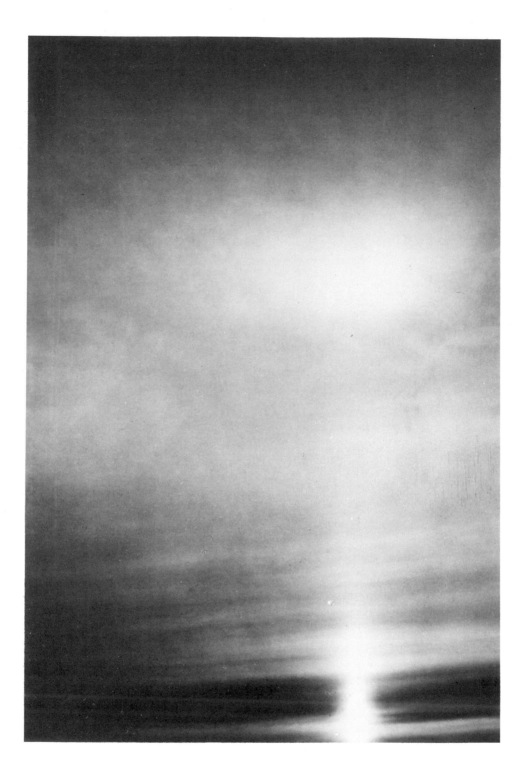

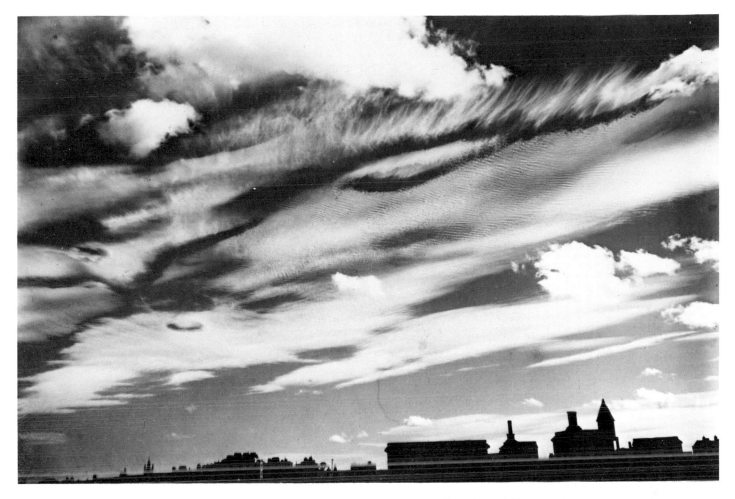

Cumulus and Cirrocumulus

One of the most beautiful cloud forms is
cirrocumulus arranged in ripples, like a sandy
shore after the tide has receded. Patches
spread across the sky as in this photograph where
the dappled layer has formed among cirrus.
The small tufts of cumulus at low level look
like suspended pieces of cotton wool.

3. Drawing Skies Outdoors

Drawing is the probity of art.
J. A. D. Ingres (1780–1867)

There is as much pleasure in drawing skies as painting them. To get the most from drawing, a worthwhile method is to devote a complete sketchbook to the study of skies: it will become an invaluable source of knowledge.

My basic materials for drawing outdoors are a spiral-bound $11\frac{3}{4} \times 8\frac{1}{4}$ in (29·9 × 21 cm) sketchbook secured by a bulldog clip and protected by a plastic envelope, a soft carbon pencil and a small sharp knife, both of which fit easily into an old spectacle case. I either take a small stool or sit on the ground.

For charcoal drawing I use a larger sketchbook, putty rubber and spray fixative. Recently I have fixed a drawing-board to a photographer's tripod which adjusts from the horizontal to any angle.

HOW TO START

When you start drawing skies outdoors it is best to choose a day when there are heap clouds (cumuliform). The shapes are usually well defined and sometimes soar to great heights in dramatic towers. I would recommend using pencil for a first attempt as it is a medium familiar to everyone, and working in monochrome simplifies problems of colour and tone.

Before you begin to draw just relax and watch the changing patterns above you – ignore the landscape and give all your attention to the sky. Two things must concern you even before pencil is put to paper. The first is to determine which side the light is coming from; the second, which way the clouds are moving. If the intensity of light is bright the shape of heap clouds is clearly defined by the contrast of dark and light on the rounded forms. Don't be in a great hurry to begin drawing – a

workmanlike and methodical approach goes a long way to producing good results. It may be that the clouds are moving quite quickly so your reaction is to draw rapidly before they change shape or disappear. This is unnecessary; select a part of the sky which has the most interest and simplicity of arrangement and concentrate on that one area. Trying to include all that you see from horizon to horizon results in confusion; if an interesting cloud formation appears somewhere else then start another drawing.

Using a soft pencil, begin drawing in the middle of your paper. The reason for this is that whichever way the clouds are moving you can add to your drawing with ample space to extend it in any direction without being cramped. At this stage you should not be at all concerned with getting the clouds into a balanced composition, this comes later when you are more experienced in drawing the individual cloud shapes. Just because you are drawing only a small part of the vast expanse of sky there is no need to do a microscopic sketch. Allow freedom of expression but do not be over ambitious.

Lightly indicate the main cloud shapes first, either by a hatched or continuous line. The hatched line is easily disguised when shading is added. Get the main bold pattern of shapes first, detail is the icing on the cake and should come last.

Before you begin shading make a comparison of the darkest tone in the sky with the darkest on the landscape. The sky is seldom as dark as the landscape except perhaps during a storm. Careful comparison of relative tone values between landscape and sky must be observed, otherwise the drawing will be unbalanced.

If you find it difficult to judge the tone values a useful technique to help make accurate comparisons is to hold a piece of dark grey card and white card against the sky and landscape. It is better to err on the light

Stillness of Morning

Size: 11 × 9 in (279 × 229 mm)
Medium: Charcoal and pastel
Paper: Canson

I have used charcoal and silver-white soft chalk pastel for this monochrome sketch.

Blending was done by lightly smudging paper tissue across the charcoal and the pastel.

I began by drawing-in the trees and reeds with willow charcoal, and then white pastel. I did not want the texture of the pastel paper to appear too pronounced, so I blended and softened to get the atmosphere I wanted.

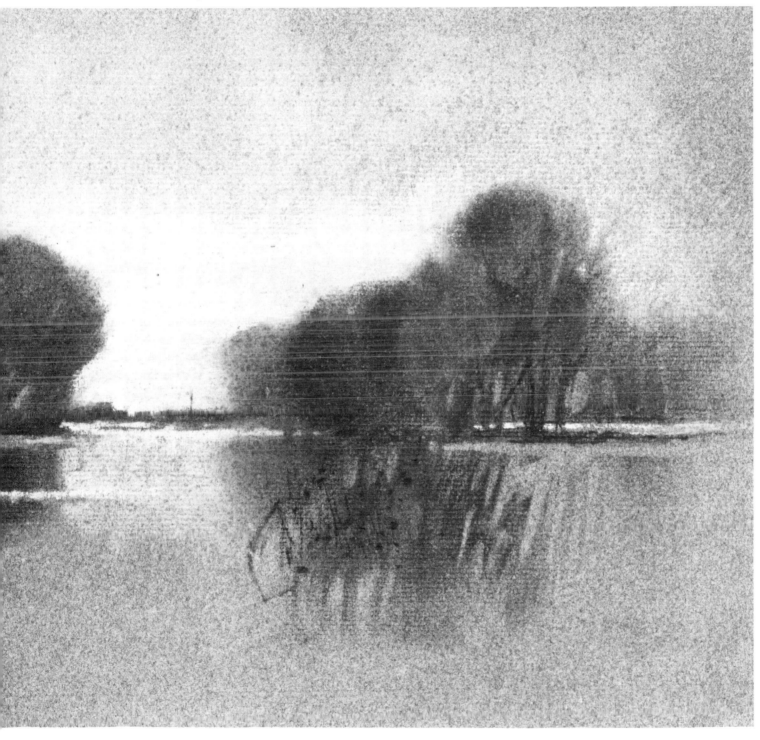

side when shading clouds; white paper shining through emphasizes their luminosity and gives you greater scope for dark-toned accents. A low-tone drawing is restricting but can have atmospheric qualities. At the beginning it is quite enough to be concerned with three values: light, medium and dark. When I am drawing skies I try to get the maximum effect of light and shade without overdoing it. Too strong an application of pencil, wax, charcoal or pastel, results in a dense mass which is not suggestive of light or the substance of cloud. Whatever drawing medium you use, the darkest tone of cloud or sky must not be made too dark, otherwise the drawing will look heavy.

I would not suggest smudging pencil to achieve gradations until more experience is gained – in inexperienced hands the result is dull and muddy. I normally put the darks in first when drawing to determine direction of light and also to clarify shape and form. I try to get all the tones right first time and seldom draw over an area twice, neither do I use a rubber, except for lifting out light areas. When I make a mistake I much prefer to start afresh.

Clouds can change shape and formation very quickly before there is time to finish a drawing. When this happens I don't try to make it up from memory but put down only what I see. Truth to nature when working outdoors is a good discipline; later on in the studio I can use my imagination and memory to interpret skies more freely.

Your first drawings need not be any larger than 7 × 5 in (178 × 127 mm); working to a small size enables you to have more control over the drawing, and visually it is compact. As you progress and your confidence builds up, the format can be increased in size.

Outline of Cloud

A dotted or hatched outline to indicate cloud shapes is lost when shaded, but a continuous line leaves a more clearly defined edge, as illustrations A and B show. Most of my drawings of clouds are done without any outline at all. I prefer to draw direct by shading, as in C.

A: Dotted line

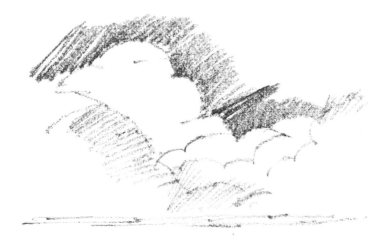

B: Continuous line

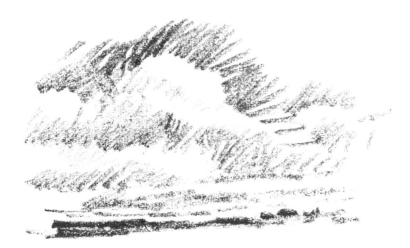

C: Direct. No outline

Sussex Downs

Size: 9 × 6 in (229 × 152 mm)
Medium: Carbon pencil
Paper: Drawing paper

This outdoor sketch shows the characteristic flat base and rounded top of heap cloud (cumuliform). Notice how the undersides appear closer together towards the horizon, adding to the illusion of recession. The central patch of dark cloud is a mistake, but sometimes poor composition and wrong tone values get overlooked when working outdoors.

Outdoor Sketch, Brighton

Size: 14 × 9 in (356 × 229 mm)
Medium: Soft black and white conté
Paper: Grey scrapbook

Coastal skies can be very exciting to draw or paint. Here I was interested in the way the high-rise development pushed into the sky to create block shapes.

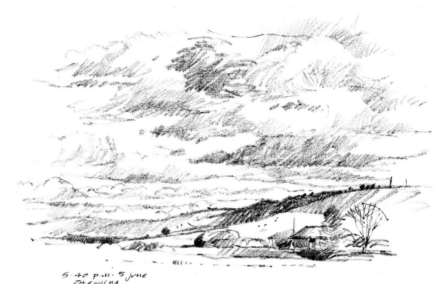

62 25 May '79 View from Sidmouth House. Devon p.m.

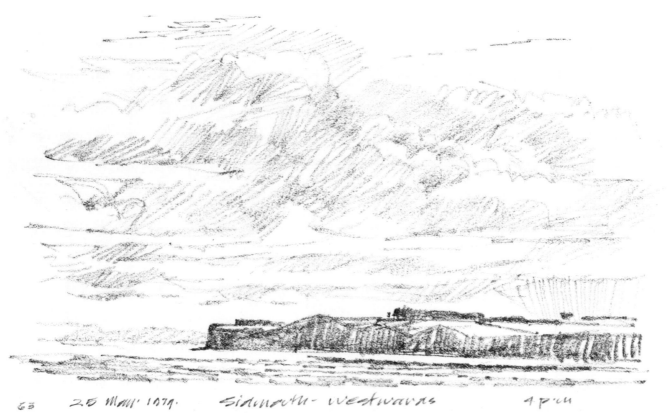

63 25 May' 1979. Sidmouth- westwards 4 p.m.

Four Sketchbook Pages

Size: $9\frac{1}{2} \times 6$ in (241 × 152 mm)
Medium: Carbon pencil

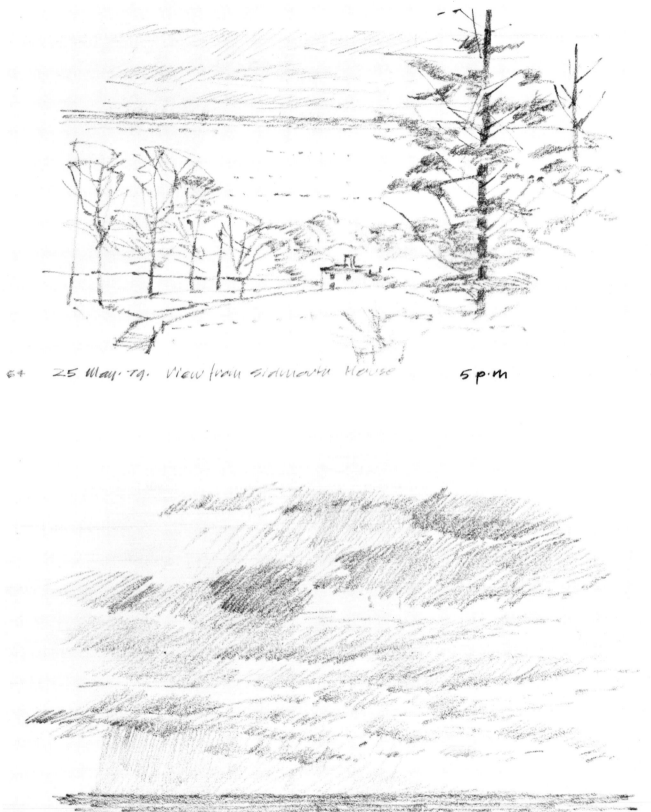

64 25 May. 79. View from Sidmouth House 5 p.m

65 25 May 79. Over Sidmouth.

CHARCOAL

I often use charcoal on white drawing paper; it has a sparkle and brightness that is ideal for cloud studies. I am careful not to overstate the darks, remembering that clouds are seldom darker than the landscape. It is very easy to brush off the charcoal gently with a small soft brush or paper tissue. If the clouds are against a background of blue sky I lightly rub in a medium tone all over the paper and then draw darks into the tone. To show the lighter parts of the clouds I lift out the areas by gently pressing with my fingers or with a kneaded putty rubber. This is a quick technique ideal for clouds. I also draw on grey scrapbook paper, which is very cheap and has just the

Cloud Shadow

Size: 6 × 5 in (152 × 127 mm)
Medium: Charcoal
Paper: Drawing paper

Because of the rounded form of heap cloud the gradation from light to dark is subtle. The darkest part may not be on the outer edge, but at the centre the formation. To the left of my sketch you can see the darkest part of the cloud with a lighter tone in front of it.

The principle of tonal contrast applies to cloud the same as it does to any other subject. The simplest way to learn about tone value of cloud is to make charcoal drawings.

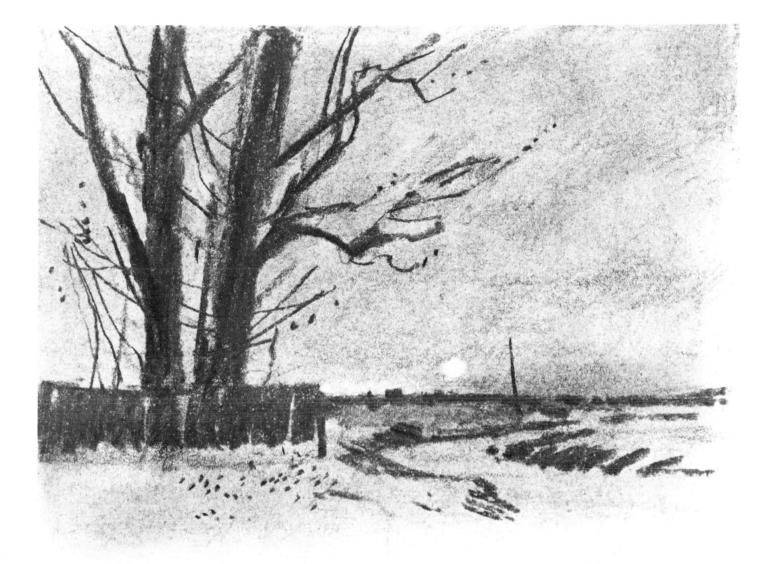

right surface for soft chalks or charcoal. Charcoal heightened with soft, silver-white chalk pastel is a good combination, but for the lightest parts of cloud it is better to leave the paper charcoal-free. If the charcoal drawing is fixed then pastel can be put on without it lifting. I don't fix my drawings if they are in a sketchbook because they are subjected to very little rubbing movement. Leave the charcoal marks showing if you can: they add vigour to a drawing – particularly to cloud studies.

Moonrise

Size: 7½ × 6 in (191 × 152 mm)
Medium: Charcoal
Paper: Drawing paper

My drawing is basically three tone values, light, middle and dark; tone was applied by lightly rubbing in charcoal. Into the background I drew the trees, fence and horizon. The path leads into the picture. I lifted out the moon shape with a small piece of kneaded rubber. The charcoal stains the paper if rubbed in very hard so the moon is not pure white, but for this subject it does not matter as white would be much too assertive.

Seascape

Size: 10 × 9 in
(254 × 229 mm)
Medium: Charcoal
Paper: Drawing paper

Step 1: First of all I
draw in the horizon
line, then the dark tone
to indicate cloud
shape.

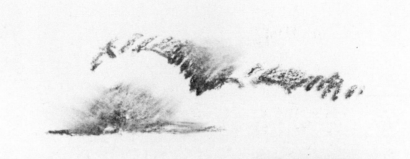

Step 1

Step 2: Paper tissue
blends the charcoal
and I now begin to
develop tone values.
The distant headland is
made larger and a
further strip of coastline
added to give recession.
A piece of putty
rubber takes out lighter
areas.

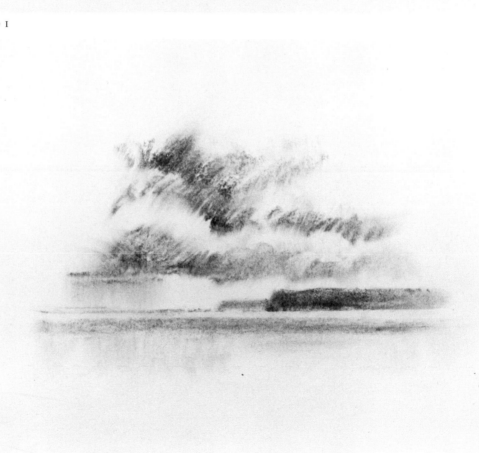

Step 2

Step 3: The drawing is now taking shape. I add more charcoal and blend to extend the foreground. The two figures are drawn-in with a carbon pencil. Notice how they add scale and recession to the sea and sky.

Step 3

Step 4: I decide to add a boat and more people to give some activity to the scene. These are drawn with a very thin charcoal stick. A putty rubber takes out the light reflections by the boat.

Step 4

4. Pastel Skies

*Grey alone reigns in Nature,
but it's frightfully difficult to catch.*

Paul Cézanne (1839–1906)

PASTEL MONOCHROME

Soft chalk pastel is the easiest and most expensive drawing medium, particularly for cloud studies, and is more versatile than either pencil or charcoal. Much can be learnt from tonal studies in monochrome: they are easier than colour because you need only be concerned with light and dark. Black pastel is much too dark for my monochrome drawings so I use three or four greys and one white from the George Rowney range on a middle-tone grey paper: Cool Grey Tint 1, Cool Grey Tint 2, Cool Grey Tint 4, Cool Grey Tint 5, and Silver White Blue Shade. With the paper serving as another tone, the range of values from these five pastels is quite adequate. If the paper gets overworked and loses its texture because too much pastel has been applied, I brush off the surplus with a small stiff brush and reinstate the area. A putty rubber can also be used to clean the mark right off, and for lifting out lighter parts.

Before I begin, I first of all decide which is the lightest and darkest tone of the area that I'm going to draw. Then I aim to get those two tones down on my paper as soon as I can. It is easy to get distracted by other cloud effects which are taking place at the same time, but I concentrate on the part I have selected.

When the light and dark areas of cloud are laid-in I blend them into a gradation of tone by lightly smudging with my fingers. A downward movement is preferable to haphazard smudging. I always carry a soft rag to keep my hands clean.

To achieve strong contrast of light, a dark-tone pastel is carried up to the edge of the lighter part. Remember that the sunlit outer part of cloud is always lighter than the blue of

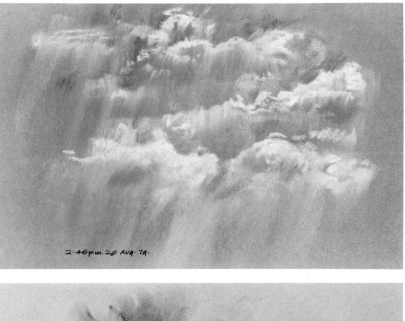

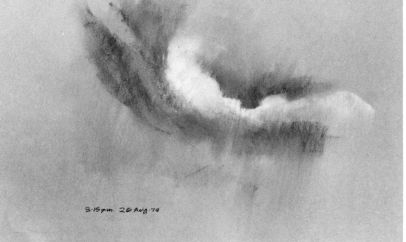

Five Outdoor Studies
Size: 15 × 8 in (381 × 203 mm)
Medium: Pastel – cool greys and silver white
Paper: Grey scrapbook

Five consecutive pastel studies done outdoors in a period of about 1½ hours. Cloud form and atmosphere constantly altered and presented an exciting challenge not to be missed.

When making cloud studies I do not do any preliminary drawing, but begin by laying-in the dark and light masses first. By this method the two major tone values are immediately established. Intermediate tones and detail then follow.

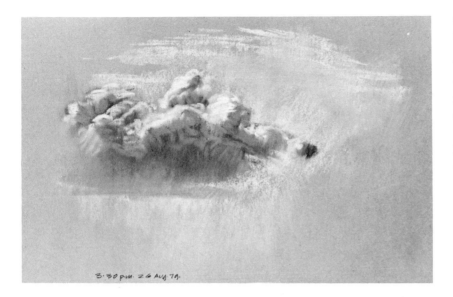

3.30 p.m. 26 Aug 79.

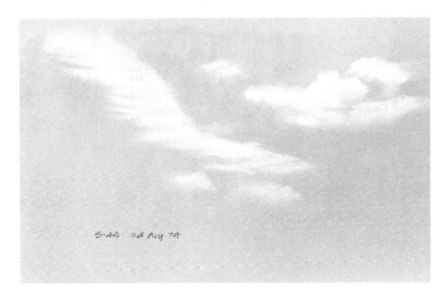

5.45. 26 Aug 79.

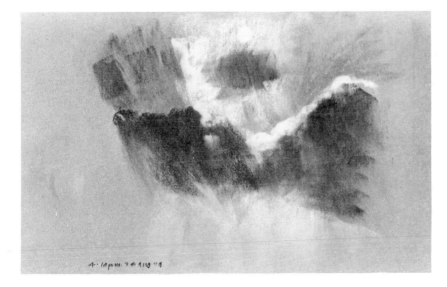

4.10 p.m. 26 Aug 79.

the sky and is brighter and more defined than the shadow side.

Here and there I soften and lose the edges by gently blending with my fingers. This technique achieves rapid results but take care not to make your smudging too pronounced or slick.

For all my pastel work I prefer to use a piece of pastel about $\frac{1}{2}$ in (13 mm) long. Broad marks are easily obtained with the side of the pastel. To retain a feeling of spontaneity try not to overwork or tidy up your outdoor sketch, especially when you get home; it is much better to use it as a reference for another painting. This applies to any work done outdoors.

Clouds often change shape so rapidly that there is no time to block-in with a preliminary drawing, so I start by indicating the landscape with a few lines and the darkest tones; then I put down the dark tone of the principal cloud shape, and also the lightest part with the grey paper serving as a middle tone. Sometimes I draw lightly over the paper surface with the darkest pastel, and then sweep over it with a ball of paper tissue. This gives me a transparent dark tone to draw on with lighter pastels. I also use the rubbing technique with tissue for softening edges and getting delicate cloud effects. Too much heavy rubbing destroys the textural surface of the paper; only the lightest touch is necessary.

I make as much use of the grey paper as possible, either by leaving areas untouched or letting it show through the pastel marks.

Working with pastel monochrome is much faster and more direct than any other medium. The technique proved of great value when I went to the magnificent Scottish Highlands in October to do some drawing and painting for this book. The weather presented some problems but produced exciting cloud effects. My equipment for working outdoors is conveniently minimal in quantity and weight. The most important item is a comfortable stool; a sketchbook is held on a piece of plywood by four bulldog clips; the pastels and tissue fit tidily into a small cardboard box; and the whole lot can comfortably be carried in an old army valise. There is no need to use a fixative because the sketchbook is firmly secured to the drawing-board to prevent the sketches from smudging in transit. As I only use a

few pastels outdoors it is not necessary to take ground rice for cleaning them. By keeping them separated in transit and when in use the pieces stay fairly clean; all they need is a wipe with tissue.

To develop a painting from a monochrome sketch many artists find it helpful to work from colour notes made while sketching, or from colour photographs. The latter is the most common practice but as discussed under a separate heading, there are pitfalls for the unwary. I recommend developing colour memory without the aid of photography until experience is gained. Atmospheric skies are more easily managed in greys than colour, and working in this medium we can learn to appreciate the importance of light and the value of tone.

If you have not already tried the soft chalk pastel monochrome method of working outdoors I am sure you will find it very expressive and simple. Don't make sketches too large. Most of mine are no larger than 15 × 10 in (381 × 254 mm) except for single studies which average about 6 in (152 mm) square; all are in book form.

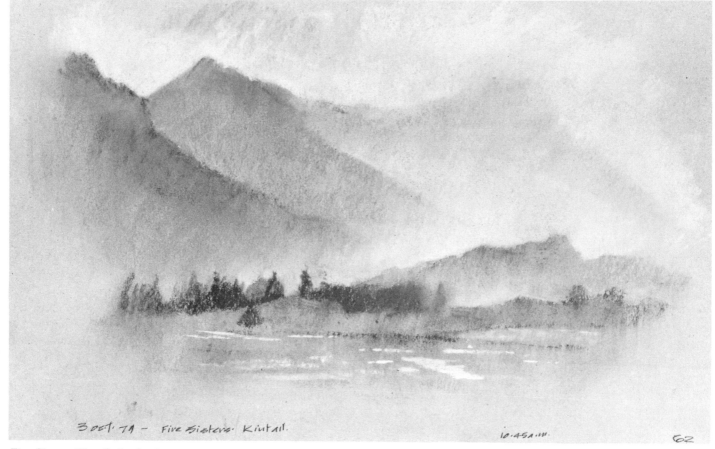

Five Sisters, Kintail, Scotland

Size: 12 × 7 in (305 × 178 mm)
Medium: Pastel – cool greys
Paper: Grey scrapbook

Magnificent Scottish scenery shrouded in mist is the subject of my outdoor sketch.

A great deal of softening and blending with a paper tissue was necessary to capture the atmosphere of this October morning. The mountains appeared and then became obliterated every few minutes. I began by roughing-in their shapes and then rubbed them over with medium grey pastel. Cutting out the left-hand mountain with silver white pastel gave me a tonal range of light to dark. I was then able to add the middle tones.

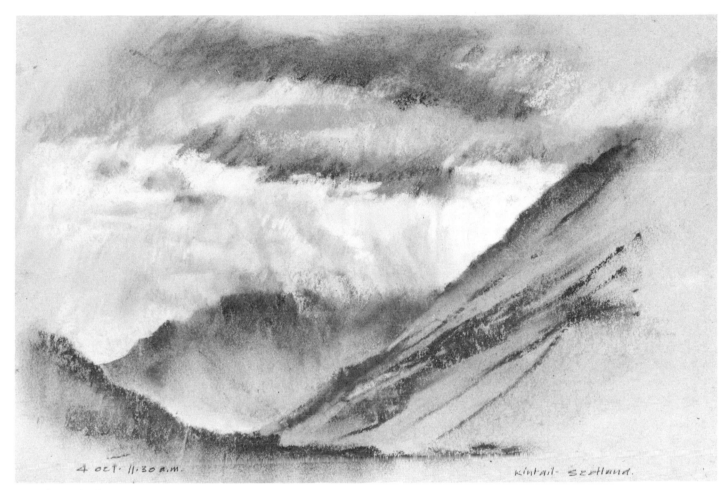

Kintail, Scotland

Size: 12 × 7 in (305 × 178 mm)
Medium: Pastel – cool greys
Paper: Grey scrapbook

I did this sketch outdoors on an October morning, and was enthralled by the dramatic cloud effects continuously changing as I watched. One moment the peaks were sharply silhouetted and the next, obliterated by swirling mist.

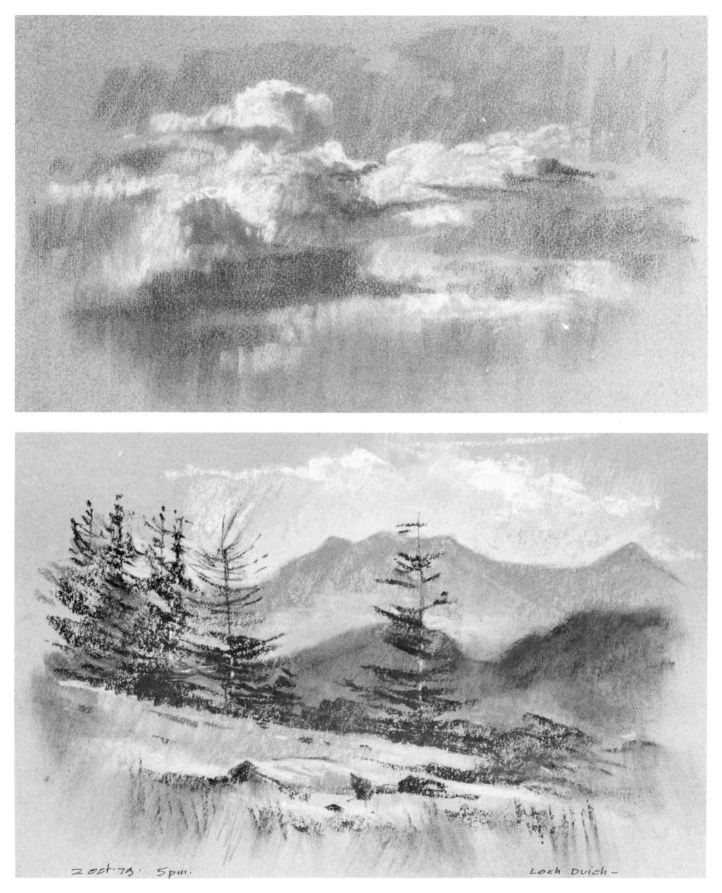

2 oct '79. 5pm. Loch Duich—

Outdoor Sketch

Size: 15 × 8 in (381 × 203 mm)
Medium: Pastel – cool greys and silver white
Paper: Ingres canson 52, Moonstone

For this outdoor study I was careful not to make the clouds too dark. The deeper tone was lightly put down, so that the texture and colour of the paper was not obliterated. Next came the lightest part of the clouds illuminated by the sun. On this light grey paper white pastel is not as pronounced as I would like it to be. To bring it out more, I put down mid-grey on the sky area, making sure it did not go into the white pastel. By cutting up to the edge the sunlit parts remain crisp and not overworked. On the lower part I lightly dragged a paper tissue downwards to get an effect of light and shade. Into this area I made positive marks with light grey pastel to increase the downward movement.

I started this study with the highest cumulus on the left and the dark cloud underneath. There is a certain amount of blending but I was careful not to overdo it.

Loch Duich, Scotland

Size: 12 × 7 in (305 × 178 mm)
Medium: Pastel – cool greys
Paper: Grey scrapbook

In contrast to my other outdoor sketches of Scotland this is a gentle placid sky. A few bits of fluffy cloud laze across the sky on a late October afternoon.

The landscape is divided into well-defined planes, broken by the trees. I made no preliminary drawing and began by placing the angle of the foreground. Next came the sky and mountains, and the trees were drawn last of all. The foreground was wiped with a paper tissue to soften and blend the dark pastel.

PASTEL COLOURS

The range of pastel colours is extensive and can be bought in sets specifically selected for landscape painting. Subtle colours are essential for painting skies. As with grey pastel, finer tones are obtained on tinted paper; neutral grey paper is a popular shade, or dull blue.

It is preferable not to use the number of colours you actually see in the sky and clouds as too many in one picture will result in confusion and destroy the effect of simplicity. As your sketch or pastel painting progresses put aside the pastels you use. This builds up a selection of colours with which to form your palette for the occasion.

Aim to work broadly with the minimum of layers of pastel – too many applications clog the textured paper giving a muddy finish. To clean pastel pieces shake them around in a container of ground rice or flour.

If you prefer to paint on separate sheets of pastel paper instead of a sketchbook, carry them interleaved with sheets of newspaper and fixed securely with strong spring clips between two pieces of same-size hardboard (Masonite).

When painting with pastels I first of all look for the general cloud and sky colour. I then lightly rub an approximation of the colour all over the area. On to this base I build up the principal colours, taking care to preserve some of the neutralizing tone of the paper colour which gives an underlying harmonizing shade. I have included a pastel painting, *Winter Sky, Cromer*, on page 41.

For making rapid colour notes of cloud, pastel is without equal. It is not necessary to do a complete colour sketch; you can draw the cloud in line, if the shape is sufficiently distinct, and just add small pastel marks of colour to the area concerned. At a later date the colour notes will serve as a useful reference.

Transposing a full-colour pastel painting into acrylic or oils in the studio does not present much difficulty with tone or colour as the density of pastel is similar to both mediums.

5. Painting Skies

OUTDOOR WORK

Pochade painting is a most convenient way of working outdoors. Although it limits the size of your work, a good small painting can be just as pleasing as a larger one. Turner used what must have been one of the first pochades, made for him by a friend who sometimes accompanied him on his painting trips. I often use a pochade and sometimes paint on sections of mounting board primed with Winsor & Newton acrylic primer. I have attached a webbing strap to the pochade, enabling me to carry it more conveniently slung from the shoulder. For your first painting studies of skies I would suggest working in 10 × 8 in (254 × 203 mm) format or 12 × 9 in (305 × 229 mm). Make sure you have all your gear before setting out. Even professional painters can have lapses of efficiency: inscribed on the back of an oil painting by Sir Alfred Munnings (1878–1959) is the cryptic note 'Bagsworthy Water, painted without brushes. Ten mile journey from Withypool – No brushes – left them behind – used pieces of wood, small fir-cones, paint rag – anything I could pick up.' It can happen to the best of us!

A few days before going out to paint, stain your painting surface with a diluted application of any of the following: yellow ochre, burnt sienna, burnt umber, ultramarine or pale grey. The stain takes away the glare of white priming, and also helps unify the painting.

Today when I went out to do some studies for this book the sky was very overcast with heavy cumulus cloud, and threatened rain, but I took the chance and luckily the weather stayed fine with some exciting cloud effects. If you always wait for warm sunny weather to come along you won't get much done. One of the pleasures of working outdoors is accepting the challenge of fickle weather conditions.

If possible, choose an open area for painting. The further you can see into the distance the better, because recession will add atmosphere to your painting of skies; you will also have a greater awareness of space. Before you begin painting it is a good idea to make some small preliminary pencil sketches, I would suggest about postcard size. This helps to establish an idea of what you are going to do. Any problems concerning composition are best solved at this stage.

When you are set up and ready to start, make a note of comparative tone values between landscape and sky. Be careful not to make the sky too dark. Establish the horizon line first and then lay-in the landscape broadly and with an approximation of tone. To do this I use a diluted mixture of light red and ultramarine. Still using the same colours, but with a touch of added white, block-in the dark areas to the main clouds. When this is done you can add more colours mixed with more white for the lighter parts. Keep your colours fresh and clean, using separate brushes for light and dark colours.

For your first attempt don't worry too much about the composition of clouds and remember that the main area of interest is generally placed towards the horizon to create an illusion of recession. If an interesting effect of light or cloud shape occurs while you are painting, immediately put it in. Trying to remember the effect after it has happened is not quite the same; but if the light changes drastically then you should stop painting. Clouds, shapes and light can change so rapidly it is tempting to state each one, repainting again and again. This is undesirable and invariably leads to muddy colours. If you must do it, take out the unsatisfactory thickly painted area rather than loading paint on to obliterate it.

Elms

Size: 10 × 8 in (254 × 203 mm)
Medium: Acrylic
Support: Hardboard (Masonite)

Sky seen through the tracery of trees is slightly darker than the sky itself. If the patches are too light they will appear as unconvincing cut-outs.

After painting a tree over a sky I repainted some of the patches with a slightly darker tone, adding new areas of light by cutting round the dark shapes.

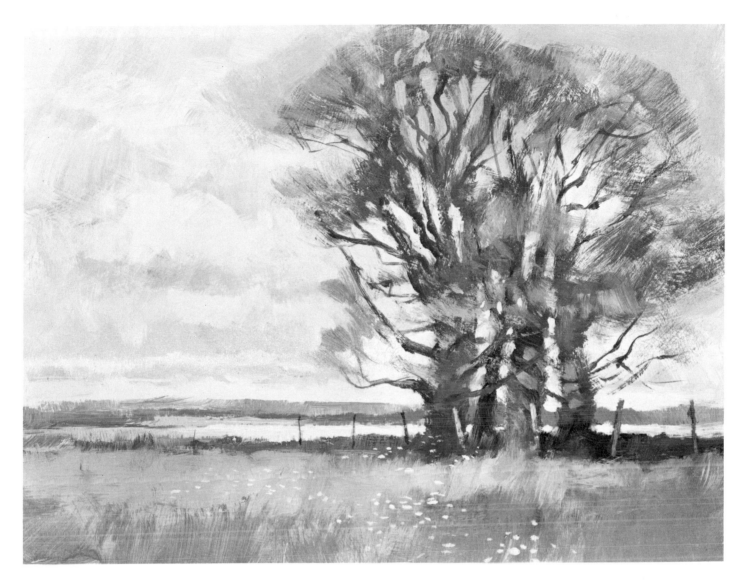

As your painting of the sky progresses bring the landscape along as well; both must be perfectly related and in harmony with each other. Alterations and modifications must obviously occur, that's part of painting, but resolve to leave a statement unaltered if you can: the effect will be compact, intimate and visually complete. A patched-up sky is seldom successful; profit by mistakes and resolve to apply what you have learnt to the next painting. It does not matter if you think your painting looks rough in execution, the chances are that you may well have captured an honest spontaneity of expression.

Try to get the feeling of space and depth into your sky painting; adopting the principle that clouds diminish in size towards the horizon will help to achieve this.

As a painting develops it is tempting to put thick paint on too soon. Try to retain translucency for as long as possible and remember that clouds are not solid lumps but floating ethereal mist. Blending and softening the shadow side of clouds will give roundness and atmosphere. The outline of clouds becomes softened by distance and you can achieve this by blending wet colour into wet, or into dry colour by brushing the top colour on to the dry colour underneath. Both are oil and acrylic painting techniques.

When I paint skies outdoors I always simplify the shape and number of clouds because trying to paint all that I see only leads to confusion. By selecting the principal shapes and tones the picture will have more strength because the statement is clear and uncluttered.

Step 1

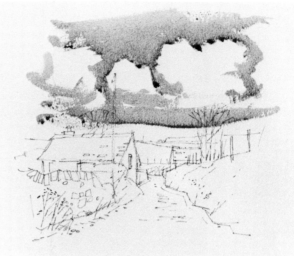

Step 2

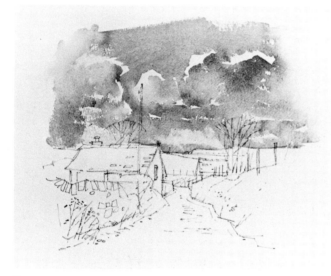

Step 3

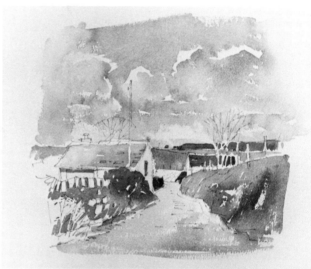

Step 4

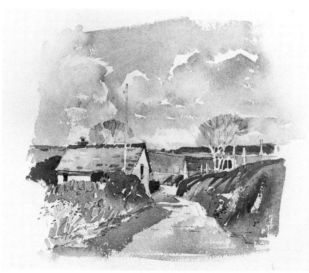

Step 5

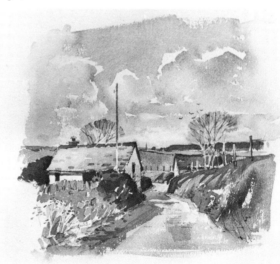

Step 6

Sunny Lane

Size: 9 × 8 in (229 × 203 mm)
Medium: Watercolour
Paper: Bockingford 140 lb (300 g/m²)

Step 1: For drawing-in the general composition I use a soft carbon pencil.

Step 2: A wash of Payne's grey and ultramarine is laid over the sky leaving the clouds as white paper.

Step 3: With a darker mixture of the same colours and some burnt umber I put in the shadow part of the clouds. The colour is thinned at the base of the clouds. I lift out some shapes on the horizon with blotting paper.

Step 4: The tone of the landscape adjacent to the sky must be darker. So I start with these areas first. In the next stage you will see the difference in tone to the cottage on the left.

Step 5: All the time I am painting I think about the relationship of landscape and sky, sunshine and shadow. The darks are more important than light tones. Sunlight on the clouds is hard; so too is the shadow on the road, both are related.

Step 6: The penultimate stage consists of drawing-in detail with a brush and pencil. Here and there my preliminary pencil drawing still shows but it is unobtrusive.

Step 7: One or two small details are added with a pencil, and the picture is finished.

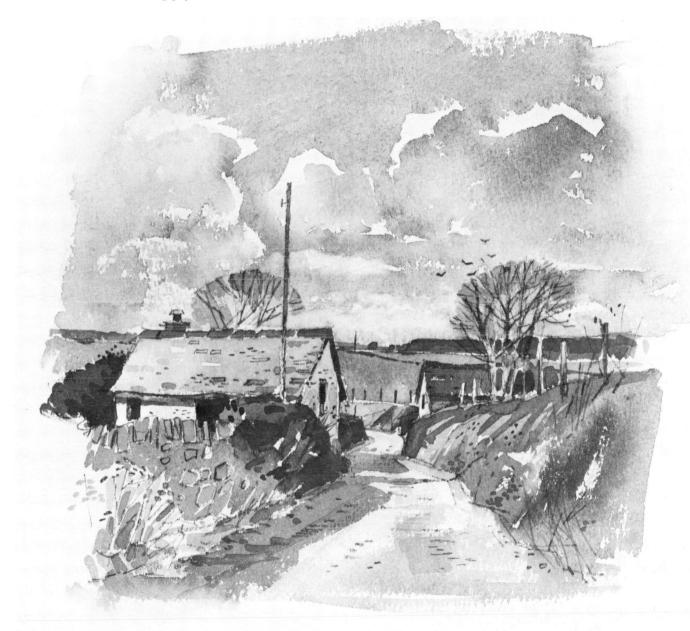

Step 7

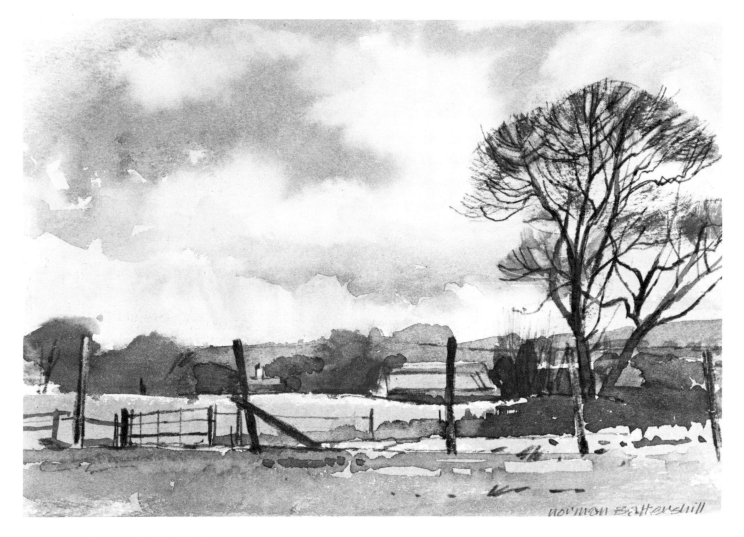

November Afternoon—Outdoor Study

Size: 10 × 7 in (254 × 178 mm)
Medium: Watercolour
Palette: Payne's grey, Winsor yellow, ultramarine,
light red, bright red, yellow ochre
Paper: Bockingford 140 lb (300 g/m²)
watercolour paper

After lightly sketching-in the composition I put a
very pale wash of yellow ochre over the sky area,
and then put in the dark tone using Payne's grey
and ultramarine. While still very wet the lighter
clouds were lifted with a clean sponge. After the
sky had dried the lower dark clouds were laid-in,
and the top edge was blended with clean water.

While the sky area was drying the fields were
washed-in with Winsor yellow, Payne's grey and
ultramarine, leaving some of the paper white. For
the distant hill I mixed ultramarine and bright red,
with a slight touch of Payne's grey. The large tree
went in last of all. To get the fine character of the
thin twigs I drew on top of the dry colour with a
soft carbon pencil.

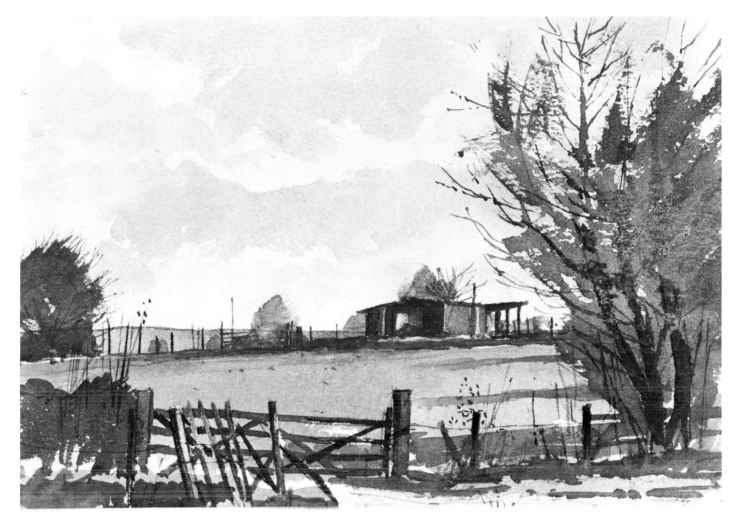

Cattle Shed, November Afternoon—Outdoor Study

Size: 10 × 7 in (254 × 178 mm)
Medium: Watercolour
Palette: Payne's grey, chrome deep, Prussian blue,
light red, yellow ochre, burnt umber, bright red,
ultramarine
Paper: Bockingford 140 lb (300 g/m²)
watercolour paper

The dark clouds were put in first, and when the
clouds were absolutely dry a pale wash of yellow
ochre was laid over the entire sky area to capture
the golden glow of the November afternoon. To
emphasize the effect I took care to get the tone of
the field exactly right. For it I mixed chrome deep
and Prussian blue, with a slight touch of Payne's
grey. Cutting round the fences and posts left white
paper, so when I put colour down it was not tinted
with green. Overlaying colours can result in a
dullness. When the sky and field were completely
dry the large tree was put in with the dry-brush
technique. I then drew into it while damp with a
fine brush. All the darker tones were put in last.

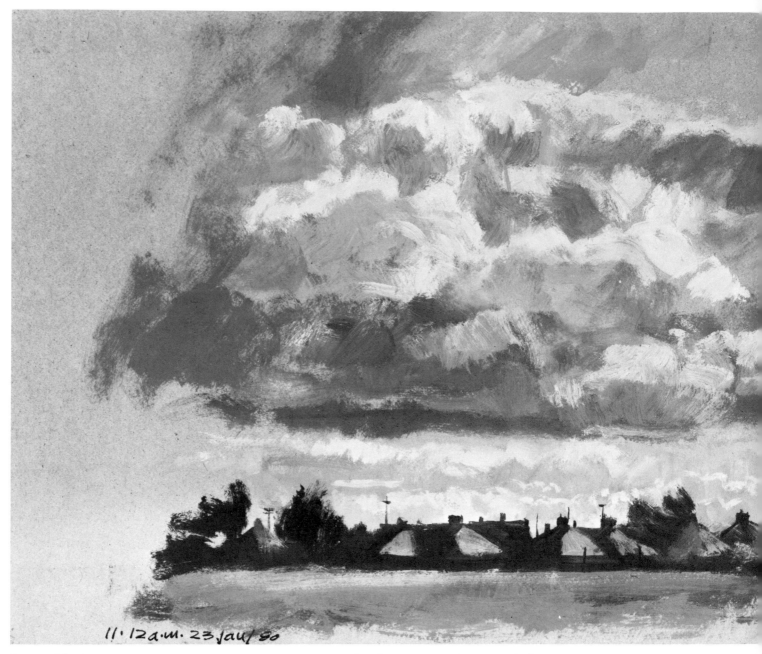

11·12 a.m. 23 Jan/80

January Morning

Size: 12 × 10 in (305 × 254 mm)
Medium: Oil
Paper: Unprimed grey paper

I enjoyed the challenge of this outdoor oil painting. The clouds moved fast so I painted direct without any preliminary drawing-in, putting in the lightest parts first. Working on a grey ground helped to arrive at tone values quickly.

On unprimed grey paper (the same as I often use for pastel studies) I used oil paint without medium and very little turps, to prevent the paint spreading out.

Although I put the bungalows in last, I was aware before I started that the sunlight on the roofs was important.

Recently I painted outdoors in Scotland during October and the weather varied from sunshine to heavy rain. The mountain tops were often shrouded by cloud, as can be seen in my acrylic paintings on pages 84 and 85, so instead of waiting to get a clear outline of the summit I started with the lower slopes. When the clouds moved away or thinned out, I quickly painted-in the wisps to get the impression intended. For this painting trip I used a pochade and acrylics. Acrylics dry quicker than oils which makes it easier to carry around a finished acrylic painting. For my palette I cut out a tear-off paper palette to fit inside the box and carried a separate water pot. Had the weather been warm I would have diluted the paint to a watercolour consistency.

Painting outdoors in oils allows a much greater flexibility with blending colours than acrylics. Oil colour dries more slowly, allowing the paint to be worked when wet. This is an advantage. Amorphous effects can be quickly achieved by wiping out with a rag, or painting wet-into-wet. However, as you can see from my acrylic paintings a similar technique is possible.

Some of my outdoor sketch paintings in oils and acrylics are not much larger than 12 × 10 in (305 × 254 mm). For both mediums at this size I use Nos. 2, 4 and 5 oil bristle brushes, and a small rigger for simple detail. When painting in watercolours or diluted acrylics I prefer a Bockingford 140 lb (300 g/m²) spiral-bound pad, and a good No. 10 sable watercolour brush.

Contrary to the standard method of watercolour painting I often paint from dark to light; I have found this a useful technique for painting skies outdoors, when time is of the essence. Drawing-in is not always necessary. I go straight away for the clouds, and lay-in the most important tones first.

When you have gained more confidence and technical ability you may wish to paint on a larger scale: the bigger the painting the greater the challenge. Sometimes, having painted only small pictures of a particular area, I return to the same spot and do a larger painting of a similar subject. One painting does not always produce the best out of a scene; the same subject seen under different light conditions will have variations of atmosphere. Light on the landscape creates many different moods, changing not only with the seasons but with almost every minute of the day.

I carry on painting outdoors through the winter months. There is often much more colour in a winter sky than summer. In November the sky can be striated with warm pinks and pastel blues, and the fields and trees can take on richly coloured hues. Even when the weather is dull and grey, by working outdoors in winter we can greatly extend our understanding of skies and light.

After a while we can re-create a painting with atmosphere in the studio, working from sketch notes, photographs or memory, but only after a long experience of painting outdoors.

Kintail, Scotland

Size: 12 × 9 in
(305 × 229 mm)
Medium: Acrylic
Support: Hardboard
(Masonite)

The acrylic colours
used in this painting of
Scottish mountains are:
cadmium red, burnt
umber, yellow ochre,
Winsor blue, and
titanium white.

The final stage is
illustrated in colour on
page 85.

Step 1: With a mixture
of Winsor blue and
cadmium red the main
shapes are laid-in very
broadly. Plenty of
water dilutes the acrylic
to a watercolour
consistency.

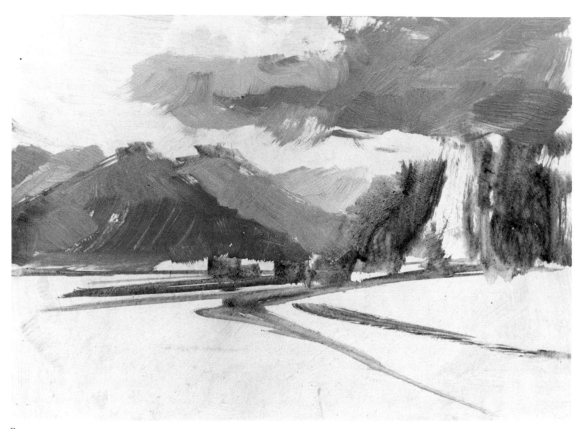

Step 1

Step 2: Next I get the
mountains painted-in
broadly. My concern is
to get the tone values
correct. While the paint
is still wet the sky goes
in next so that I can
blend the clouds into
the mountains.

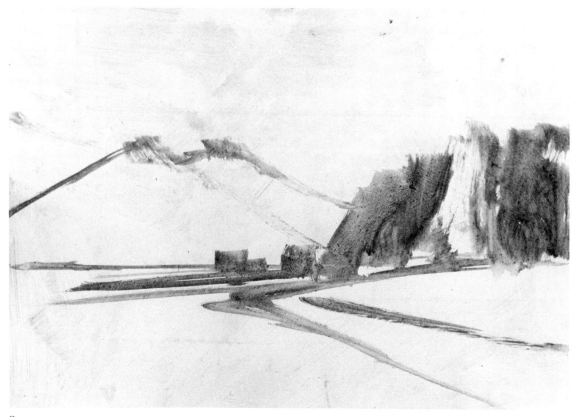

Step 2

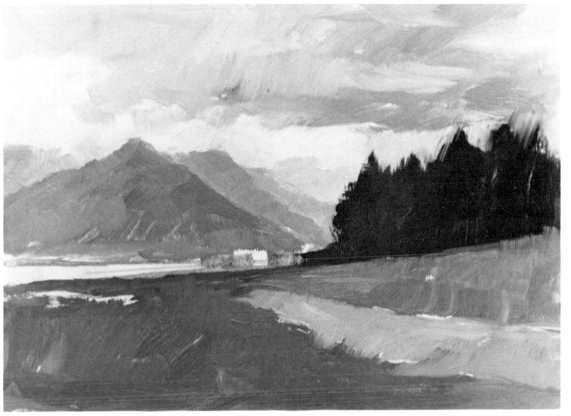

Step 3

Step 3: I paint fairly rapidly now to keep the paint moving and blending wet-into-wet. The rest of the big areas are laid-in to finalize the tone values.

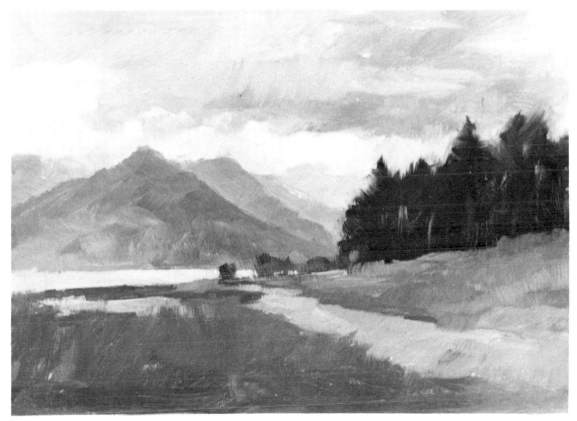

Step 4

Step 4: Now I can start pulling the painting together by accents such as light on the water. Detail is minimal, as I want to try and capture the sense of space. I do some more work on the sky while it is still wet.

The foreground needs to be broken up so I add further colour and bits of texture. Telegraph poles are added following the line of the track, and leading into the painting. I put more work into the sky, but it is now dry so I am careful not to lose the initial painting.

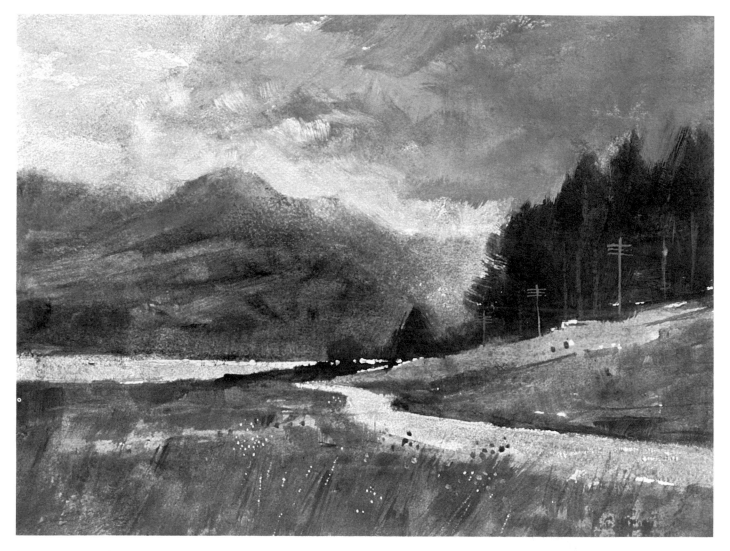

Morning at Kintail

Size: 12 × 9 in (305 × 229 mm)
Medium: Acrylic
Paper: Bockingford 140 lb (300 g/m²)
watercolour paper

This painting was done with the same acrylic
colours as the demonstration, but diluted to a
watercolour consistency.

 Apart from some areas in the sky, the path and
the poles, which have white added, the painting is
entirely painted with acrylics in the pure
watercolour style.

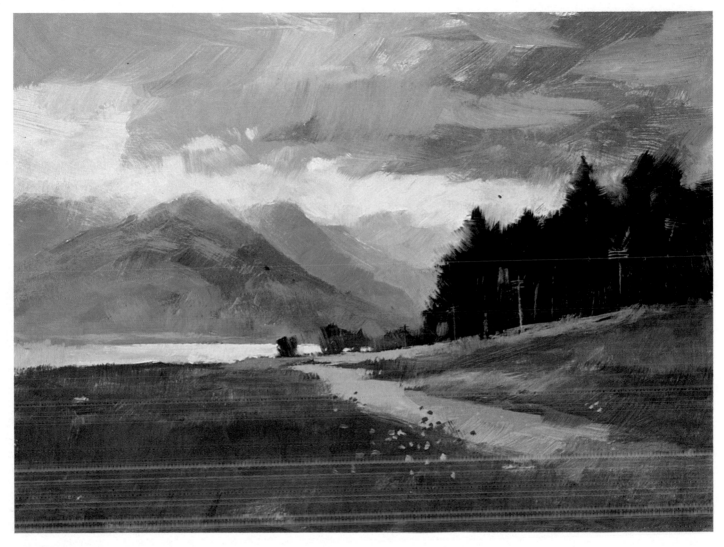

Kintail, Scotland

Size: 12 × 9 in (305 × 229 mm)
Medium: Acrylic
Support: Hardboard (Masonite)

This is the final stage of the step-by-step
demonstration illustrated on pages 82 and 83.

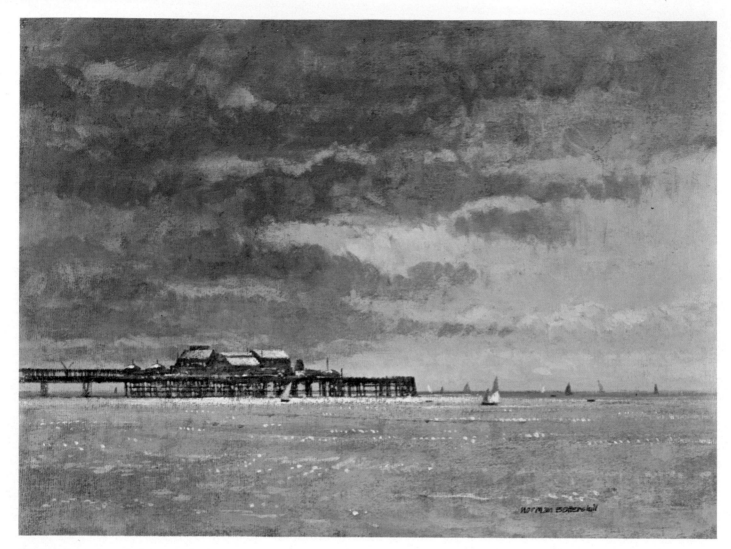

Brighton Pier

Size: 16 × 12 in (406 × 305 mm)
Medium: Acrylic
Support: Canvas on board

This studio painting is done from the outdoor drawing on page 31. First of all I washed a pale blue-grey acrylic stain all over the board to give a unifying tone and colour. Then the sky was begun, starting with the dark clouds. Recession is achieved by the clouds diminishing in size towards the horizon. Gradating tone values from dark to light also contributes to the effect of distance. Pier detail was added by drawing-in the darks with a fine brush. A few accents of light complete my painting. My palette was Winsor blue, ultramarine, cadmium red, yellow ochre, Winsor orange and titanium white

STUDIO WORK

Leonardo da Vinci (1452–1519) made this apt statement in his treatise on painting: 'If you do not rest on the good foundation of nature, you will labour with little honour and less profit – therefore, consult nature for everything.' Painting and drawing outdoors as often as possible builds the foundation for satisfactory studio painting that the da Vinci advises. I follow his dictum by working outdoors as often as possible, mostly several times a week.

Studio painting has the main advantage that we can consider at leisure the problems involved in the effects of light and shade on the sky and landscape, without having to give our attention to those fleeting moments that try our patience so much outdoors.

If you decide to paint from a drawing or colour sketch it is sometimes preferable not to copy it; using it as a basis for a fresh interpretation is a challenge. Perhaps you will find that the busy sky in your outdoor study does not suit the mood of your studio version, or your outdoor sketch may not have any sky at all. You then have to start from scratch and decide the sort of cloud and light effects which best express your own ideas. Jean-Baptiste Corot (1796–1875) said 'it is more logical to paint the sky last since it can be given its correct hue and tone when the landscape has been realised.' I sometimes adopt this practice outdoors and in the studio. The principle is certainly sound and works very successfully.

One of the advantages of doing a studio painting from a sketch is that the subject can be simplified by deleting unnecessary detail. Tone sketches of clouds and landscapes are a good basis to develop a painting from, or you may prefer, as I often do, to use several outdoor sketches and incorporate parts from each into one imaginary landscape painting. Even if we do not make a successful interpretation outdoors we can draw upon our visual experience and try for better results in the studio.

Dusk

Size: 24 × 20 in (610 × 508 mm)
Medium: Oil on hardboard (Masonite)

The main colour scheme of this oil painting is blue and grey with a very pale yellow in the sky. I wanted to achieve an effect of stillness which is apparent at dusk. I therefore kept to big flat shapes. Unnecessary detail would have made the painting too busy and have destroyed the illusion of tranquility. The layer of grey cloud on the horizon directs interest towards the light reflected in the water. Tone value plays a vital role in a subject such as this and horizontals are important in creating a feeling of repose.

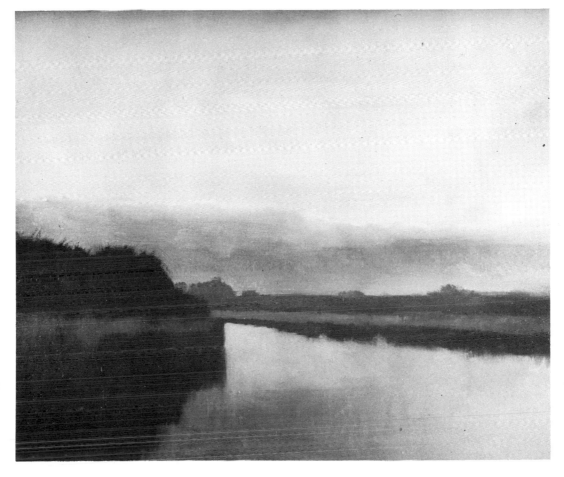

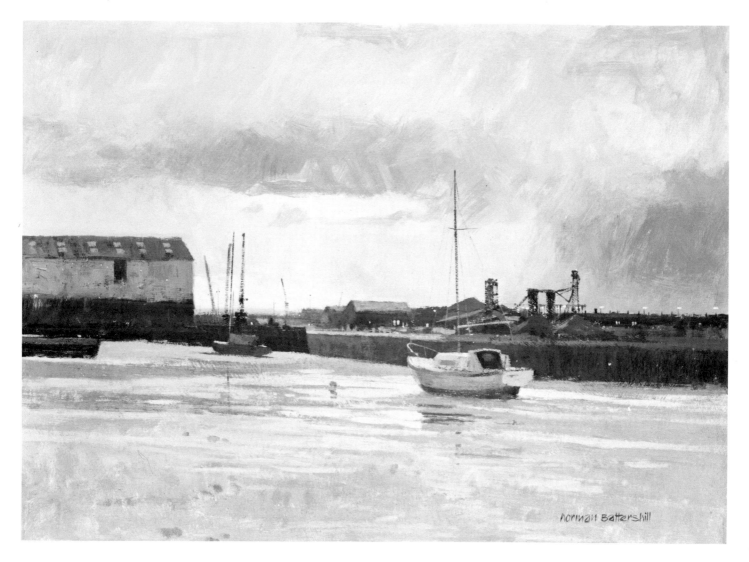

Dawn, Shoreham

Size: 24 × 18 in (610 × 457 mm)
Medium: Acrylic
Support: Hardboard (Masonite)

My theme for this studio painting is the moment when dawn is arriving and the street lamps are still on. Getting the correct tone of the middle distance is important because it determines the tone of the light in the sky. For this painting I used a limited palette of ultramarine, cadmium red, yellow ochre, burnt umber, and titanium white.

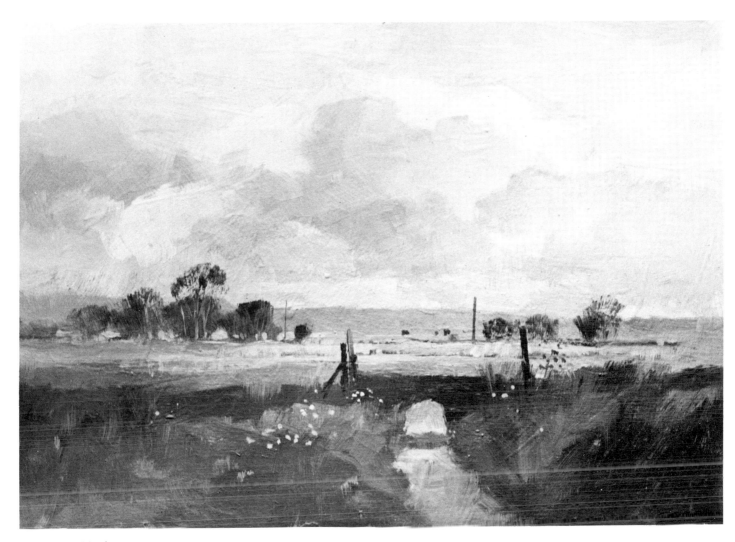

Stream and Meadow

Size: 10 × 7 in (254 × 178 mm)
Medium: Acrylic
Support: Hardboard (Masonite)

Although this is a small painting I have tried to achieve a feeling of space and recession.

The heap clouds are bold in shape so it is necessary to keep the overall tone light. A dark foreground aids recession by contrast to the effect of sunlight. Notice how the right-hand clouds are divided into three planes and simple tones.

The colours used for this acrylic painting are cobalt blue, ultramarine, Winsor lemon, yellow ochre, light red, cadmium red and titanium white.

BRUSHWORK

Empty sky painted with visible horizontal brush marks leads the eye towards the outer edge of a picture, whereas brush marks in different directions prevent this and add vitality and interest. When painting clouds, downward brush marks suggest movement and lightness, and subtle tone and colour will increase the effect. If you work while the paint is wet the vertical brush technique gives excellent results, especially with cumulus clouds. But if vertical brush marks are too pronounced the sky may appear to be falling out of the picture; softening and blending overcomes the problem. When the paint is still wet 'feather' the surface with a large, soft and clean dry brush. Following direction of form has a vigorous effect suitable for windswept cloudy skies, but again should not become too pronounced, unless painting skies after the style of Van Gogh. Whatever the method of brush style, consistency throughout a painting is desirable.

A contrast of impasto and thin areas makes the surface interesting. Towards the horizon, paint the sky with small touches, reserving

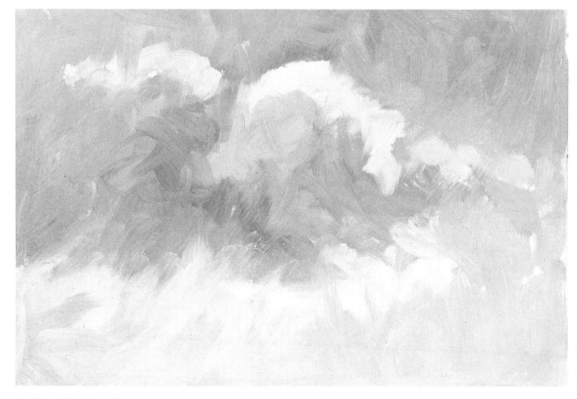

Outdoor Cloud Study

Size: 10 × 7 in (254 × 178 mm)
Medium: Oil
Support: Hardboard (Masonite)

This study almost defeated me. Cloud moving in front of cloud was so rapid I had no more than a few minutes to capture the effect.

I began with the upper sky and added the dark area of cloud, giving two tones. The sunlit part went between these tones. The blue sky above the cloud was darker than the yellow sky below, and the base of the heap cloud was dragged out in contrast to the well-defined top.

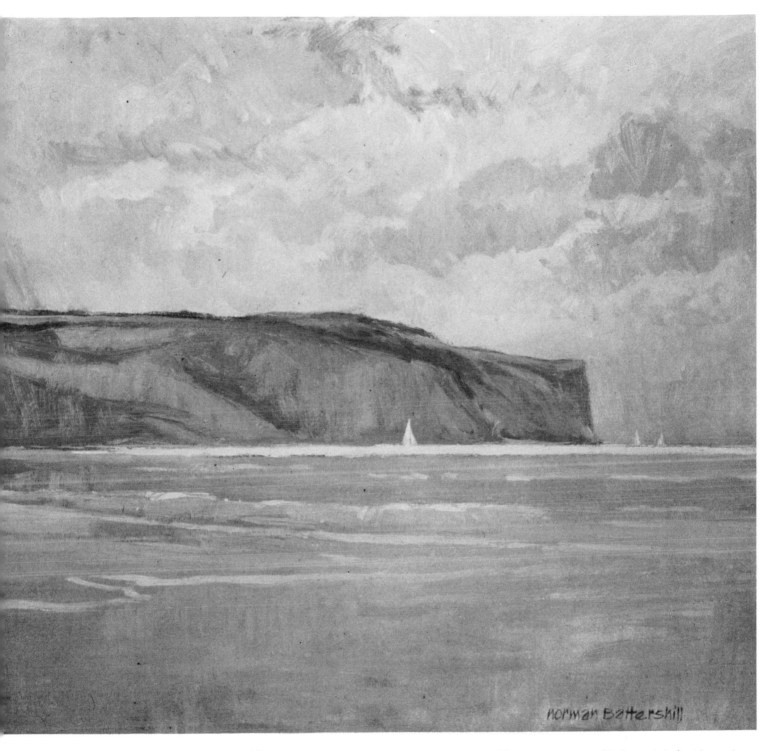

Summer Afternoon

Size: 24 × 20 in (610 × 508 mm)
Medium: Oil
Support: Canvas

Coastal skies often have a pearly quality of light, and this is the kind of atmosphere I have tried to capture. The subject was developed from a pencil sketch of an imaginary scene. Soft clouds blend without any accent of light and dark. Along the clifftop are patches of sunlight to show form, and add to the general atmosphere. Notice how the brush marks follow the contours of the clouds and cliffs.

Except for the sandy-coloured beach the colour scheme is warm blue-grey. My palette was cobalt blue, ultramarine, cadmium red, yellow ochre and titanium white.

larger brush marks for the foreground clouds and sky.

A palette should not be starved of colour. Be generous with the quantity you put out but bear in mind that too much blending of paint on the palette destroys the quality of the colour. Some painters do not completely mix colours on the palette and leave accidental blending on the canvas untouched. Long bristle brushes pick up the paint easily from the palette and give expressive brush marks.

How you hold a brush is important and has a bearing on the way the paint is put on. Using the brush vigorously does not mean pushing it through the canvas or smoothing the paint on as if ironing a shirt; developing lightness of touch is essential. The ability to lay a wet colour on top of another without the underneath colour lifting is a good test.

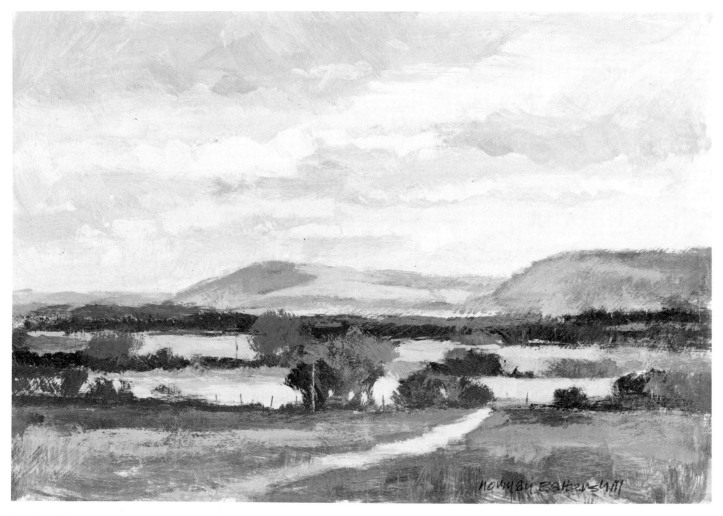

Outdoor Sketch

Size: 10 × 7 in (254 × 178 mm)
Medium: Acrylic
Support: Hardboard (Masonite)

The sky has many pearly colours in my outdoor painting ranging from pale lilac to a greeny blue, even the dark layer clouds are warm grey. High up to the right there is cirrus; to the left cumulus is building up, blending into the lilac colour of the aerial atmosphere.

I have been painting from this spot for many years, and always find a different effect of atmosphere. I don't need to drive for miles to search for variety – it is all here on my doorstep if I look for it.

MIXING SKY COLOURS

The most common colour of cloudy sky is grey. Not the colour resulting from mixing just black and white, but subtle pearly grey tinged with almost any colour from your paint box. If you are aware that colour exists in grey then your sky painting will have some truth to nature. Similarly, white straight from the tube cannot suggest the sunlit parts of cloud. There will be tints of warm colour such as yellow ochre, cadmium yellow, orange, light red or cadmium red, burnt sienna or burnt umber.

Learning to define colours in white and grey is essential to the landscape painter, particularly with regard to skies. Making written notes outdoors in conjunction with painting is a sure way to progress.

We can see the clouds are grey, but what kind of grey? Is the colour predominantly blue-grey, brown-grey, or yellow-grey? Having perhaps decided it is yellow-grey you must then determine the appropriate yellow. Is cadmium yellow too golden, or lemon yellow too green? Perhaps you need a less assertive colour, in which case yellow ochre would be the right choice. The easiest way to get a basic grey is by mixing black and white. Put some white on your palette, add a little black and mix them into a medium grey, then add a touch of yellow ochre. The grey now has a subtle tinge of colour. Experiment by adding one or two different colours to black and white, and make a note of them.

Some artists frown upon the use of black – I seldom use it myself – but it has a value. One company alone lists six different greys and blacks in oils, seven in watercolours, and one black in acrylic. The watercolourist may use Payne's grey instead of black and white.

If you have not painted clouds before, here are a few colour mixes which you may find useful:

1 Burnt umber + ultramarine + white
2 Cobalt blue + orange + white
3 Raw sienna + white
4 Cobalt blue + rose madder + white
5 Ultramarine + light red + white
6 Payne's grey + vermillion + white

Clouds rarely appear muddy even in the worst weather. You may have noticed that only two colours are mixed above. Three is the maximum, otherwise the colour becomes lifeless and dull. It is wise to add increasing touches of colour to white – that way you have control over colour mixing – and be generous in the quantity of paint you set out on the palette.

Grey influences the English landscape more than any other colour, and is influenced by the quality of light from the sky. A way to capture the subtle harmony and relationship of grey is to paint on a grey ground which may be either opaque or a stain. If I am painting on hardboard (Masonite) I may use a ground of good quality grey emulsion and paint on that with either acrylics or oils. For staining I prefer to use Winsor and Newton acrylic thinned with water and wiped on to Winsor and Newton white acrylic priming. It covers easily, dries quickly, and allows the white priming to shine through. For painting on canvas in oils or acrylic I also prefer a thin stain as a base tint.

Start your painting of cloud by selecting the lightest general colour and then paint a thin stain all over the cloud area. Middle tones and darks on this tinted ground are all held together by the unifying tint. Instead of working on an overall tinted ground, the colour is applied only to selected areas. Alternatively, the darks are selected and rendered first of all. This method applies to all painting mediums, including watercolour.

If a colour looks wrong on your painting it may well be that the tone is wrong. Is it too dark? Or too light? It is important to appreciate that every colour is affected by those which surround it. A blue sky painted with ultramarine has a warm influence on surrounding colours; deep blue has the effect of making sunlit cloud appear lighter and brighter; grey placed next to red will have a red influence. So, before you modify a colour on the palette check the surrounding tones and colour on the painting.

The colour and tone of clouds are never the same all over. My earlier suggestions for colour mixing are intended as a guide to defining their predominant colour. Intermixed should be other subtle tints and shades and the easiest way to achieve this is to paint wet-into-wet. Try not to push the paint around too much or loss of colour and muddiness will result. To retain clean colours use separate brushes for light and dark colours. If there are patches of blue sky showing through the clouds do not make

them too dark, otherwise they will be assertive and look like holes in your painting.

Sunlight on cumulus clouds can be accentuated by a deep-toned blue sky background, but the blue must be modified as I have already mentioned otherwise it becomes more important than the effect of sunlight. Corot's landscape paintings show how very subtle colour can be used to get a sunny effect. His *Dardagny, Morning* (below) in the National Gallery, London, is a fine example. Harmony is also achieved by adding touches of the sky colour to the landscape.

Landscape painters soon learn to avoid the cliché that a blue sky is a colour straight out of the tube. Observation and analysis reveal that the colour is not a neat blue at all: it may have a delicate tint of pink or yellow. Towards the horizon I often mix cobalt blue and cadmium red with lots of white. A faint blush of another colour is always evident in a blue sky, and whether it is green, red or yellow, a touch of the selected colour added to those of the clouds will add authentic atmosphere. The more attention we pay to the colours evident in nature, the more likely we are to develop good colour sense in our painting.

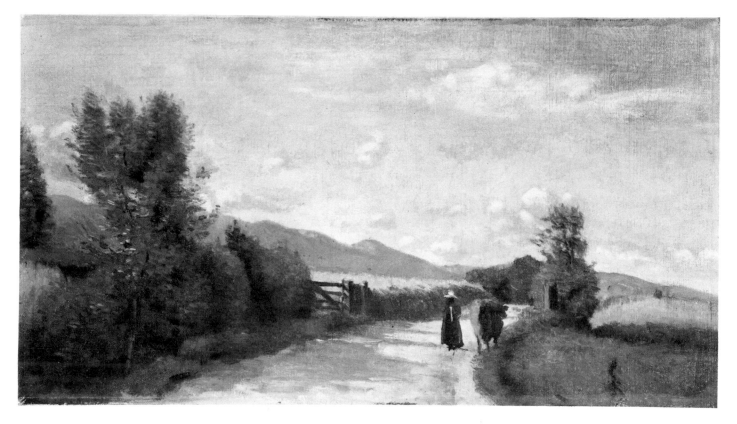

Dardagny, Morning Jean-Baptiste Corot (c 1853)
Size 10¼ × 18½ in (262 × 470 mm)
Medium Oil on canvas

Subtle tones and modulated colour typify Corot's pastoral gentleness. Of nearly 3,000 paintings the largest proportion is of small informal landscapes painted outdoors. He attached great importance to his sketches made direct from nature. Many of these were in preparation for his larger studio canvases.

Like Constable his advice was, 'One should go to the fields.'

Riverside Poplars

Size: 24 × 18 in (610 × 457 mm)
Medium: Acrylic
Support: Hardboard (Masonite)

I used a limited palette for this painting: cadmium
red, ultramarine, burnt umber, yellow ochre and
titanium white.

Cloud shapes are echoed in the shapes of the
middle-distance trees, and this links sky to
landscape in a subtle way. The water is darker than
the sky and reflects cloud. The clouds in the
distance lose definition and blend into the mistiness
of aerial atmosphere. The deep colour of the trees
contrasts against the sky and gives an impression of
space beyond them. Creating a feeling of distance
and space in a painting is considerably enhanced
by the contrast of tone – of light against dark.

Norfolk Sky

Size: 24 × 20 in (610 × 508 mm)
Medium: Alkyd
Support: Hardboard (Masonite)

I began with the sky, taking care not to make it too dark. Apart from a few accents, I wanted the landscape to be the deepest tone in the painting. I laid this in next so I could judge overall tone values more easily. The sky was painted vigorously to suggest movement.

About half way through I added the accent of light across the field and on the church. By doing this the lightest part determines the extent of the tonal range: except for a few spots of flowers no other colour is lighter in tone. My palette was yellow ochre, ultramarine, cadmium red, cadmium yellow, light red and titanium white.

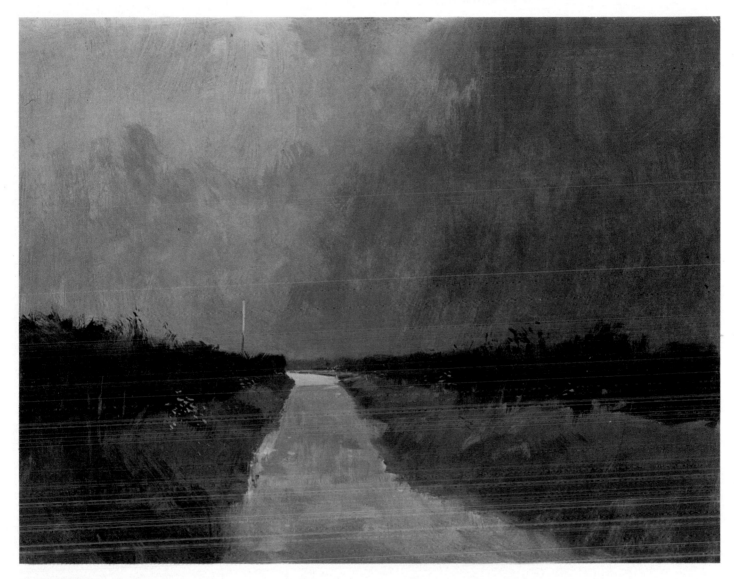

Passing Rain

Size: 24 × 18 in (610 × 457 mm)
Medium: Acrylic
Support: Hardboard (Masonite)

A simple subject but one which set tone value problems. The key to the painting is the patch of sunlight at the end of the lane. It is tempting to overstate the effect by making it too bright.

The rain cloud was painted rapidly wet-in-wet and left untouched; painting an effect such as this benefits from spontancity. Before I began the painting I had a very clear idea as to the atmospheric effect I hoped to achieve.

This painting is almost monochromatic and an exercise in tone value and colour harmony.

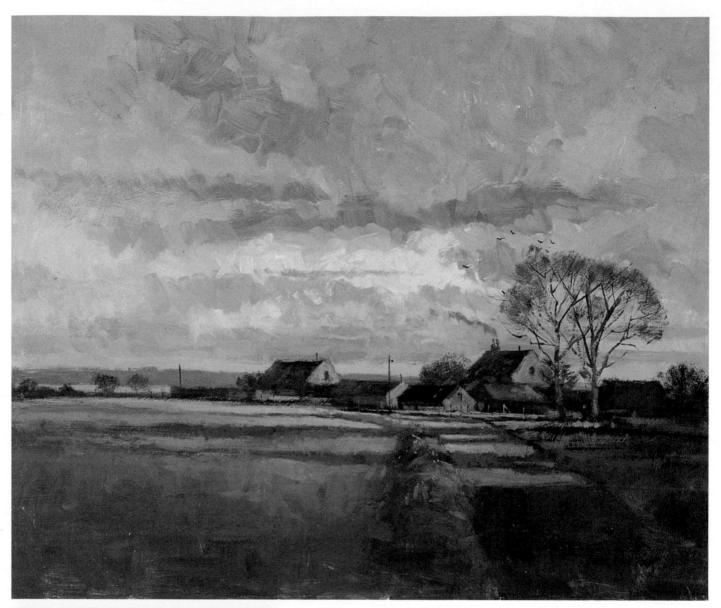

Norfolk Landscape

Size: 24 × 20 in (610 × 508 mm)
Medium: Oil
Support: Hardboard (Masonite)

The sky is a major part of this studio painting, and establishes the mood of light and atmosphere. The low winter sun throws long shadows across the lane and field. Repetition of these horizontals occur again in the middle-distance hedge, far away hills, and the sky.

The clouds are vigorous in shape and brushwork suggests movement. For this painting I started the clouds first to establish atmosphere. Next came the middle tones and shadows on the buildings and fields. These were altered in colour and tone as the painting progressed.

The enlarged cloud detail (left) shows the effect of vigorous brush marks. As far as possible the paint was put down and left untouched. Success depends on getting the tone and colour correct on the palette; and, of course, knowing the effect you want to get in your painting before the paint touches the canvas. But success is not always immediate.

6. Cloud Studies

Now clouds are not as solid as flour-sacks: but, on the other hand, they are neither spongy nor flat. They are definite and very beautiful forms of sculptured mist.

John Ruskin (1819–1900)

DRAWING CLOUDS

Landscape and sky are inseparable, but an approach I would suggest is to start by drawing only the sky; interest is then focussed on the subject of clouds. Later on, after a number of cloud studies, you can start to relate the sky to landscape by drawing both together. But at first concentrate on a confined area of the sky unless you are drawing low cloud capping a mountain where the slopes disappear into the mist.

Charcoal and pastel are the best mediums for interpreting amorphous cloud masses. I use paper tissue or my fingers to blend and soften edges to get a desired effect. Pencil is probably the best medium to start off with but smudged pencil does not have the same quality or texture as charcoal or pastel, nor is the effect as immediate.

When feathery cloud is above a formation of cumulus, draw-in the higher cloud first,

Outdoor Sketch (above)

Size: 12 × 9 in (305 × 229 mm)
Medium: Pastel – cool greys and silver white
Paper: Grey scrapbook

'Mackerel' clouds sweep across a blue sky high above the large cumulus. I did both outdoor sketches on this page on an August afternoon near my studio in Steyning.

Cumulus-outdoor study (right)

Size: 15 × 8 in (381 × 203 mm)
Medium: Pastel cool greys and silver white
Paper: Grey scrapbook

4 pm. 26 AUG '79

taking it right across the paper. Then draw-in the heap cloud over the top, lifting off areas of charcoal or pastel with a putty rubber where necessary.

Drawing clouds in a blue sky can be tackled in several ways. Rubbing-in pastel or charcoal creates a tonal background representing the blue sky, lighter areas can then be lifted out with a piece of kneaded putty rubber.

To get a fresher tone, take the sky up to the cloud edge leaving the paper untouched within the cloud area and then apply lighter pastel to the cloud. Drawing clouds against a blue sky with pencil is best done as directly as possible, without too much smudging and rubbing out, otherwise a tired and overworked drawing will result.

When I am outdoors drawing or painting skies I look all around me before starting.

This is not only to become acquainted with what I see, but also to take in the feeling of being there at that moment. Getting the sense of open air and space is important to the landscape artist. Even if I am only going to make cloud studies just a few inches square for future reference, I adopt this method every time. It's all part of the close and intimate relationship between environment and artist.

Drawing skies outdoors has the same immediacy as painting. Trying to tidy up a drawing at home away from the subject is something I avoid—spontaneity is so easily lost. When working in the studio a small monochrome drawing is enough to give me a starting point of tone, light direction, and cloud formation. I indicate with a kind of shorthand the texture of the different clouds so they can be identified for future paintings.

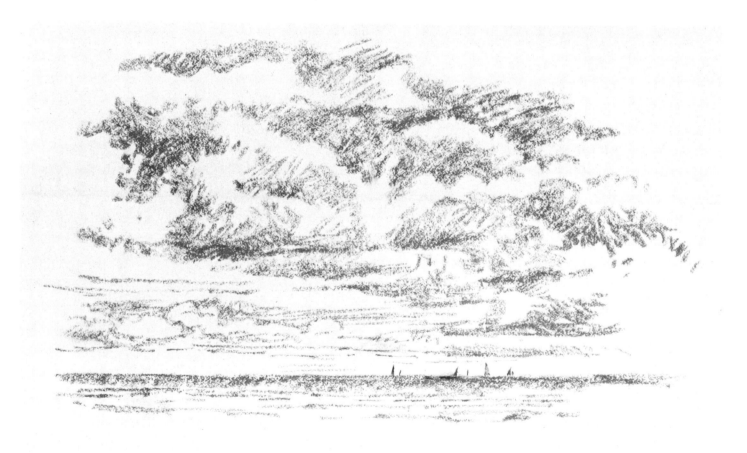

11·40 30 June Brighton

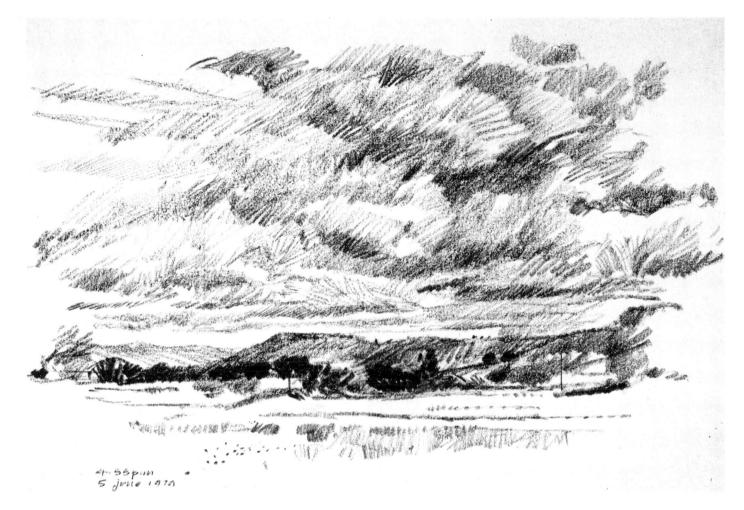

4.55pm
5 June 1910

Afternoon clouds (above)

Size: 12½ × 8 in (318 × 203 mm)
Medium: Conté
Paper: Grey scrapbook

This scene is a short walk from my studio and I have painted or drawn within the area for many years, never tiring of it.

The drawing was done outdoors while low, dark rain clouds threatened rain. First of all I blocked-in the distant hills without any shading. The clouds were then established with vigorous open lines. When I had the overall tone correct the dark hills were more easily assessed for tone value. Conté has a wide tonal range ideal for subjects like this. Foreground grass aids the feeling of distance to the trees and hills.

Cloud study (opposite)

Size: 12 × 8 in (305 × 203 mm)
Medium: Soft chalk pastel cool grey tint 4
Paper: Grey sugar paper

In this outdoor study the sea occupies a small part of the subject giving emphasis to the clouds. I have not smudged the pastel at all and drawn direct. The sailing boats add scale and further movement.

DEPICTING DIFFERENT CLOUD TYPES

'Mackerel' Sky (Altocumulus)

These closely grouped clouds of globular texture straddle the sky in great sweeps or patches. Sometimes a 'mackerel' sky may appear in conjunction with high cirrocumulus. The lower cloud will have a broader texture than the other which gives the painter an opportunity to suggest aerial perspective. On the horizon other cloud types may be forming. Large heap clouds on the horizon make an interesting contrast and are an aid for directing interest into the painting.

Sharp definition of a 'mackerel' sky may present compositional problems: if it is pronounced and at an acute angle, the emphasis will be unacceptably strong. Light

'Mackerel' Sky

Size: $3\frac{3}{4} \times 2\frac{1}{2}$ in (95 × 64 mm)
Medium: Charcoal
Paper: Drawing paper

Except for a slight rubbing-in towards the horizon the charcoal is direct. I have used a photograph as a general guide to the cloud form, but for the greater part the scene is imaginary. The suggestion of a house and trees gives immediate scale and recession. I have placed the emphasis of cloud texture towards the lower part of the sky area to take interest to the horizon.

Positioning accents of landscape and sky is an essential part of picture making. Small sketches like this require as much careful consideration as paintings.

on the lower cloud should only be suggested; to define each globular shape clearly in terms of light and shade is almost impossible. Here and there indicate globular forms more closely grouped to avoid conformity of texture, and break up edges by blending to lose any hardness.

Surface texture is essential if the dry-brush technique is to be used. Making sure the sky colour is absolutely dry before putting in the clouds means that you can wipe out an unsuccessful attempt. Practise on a similar surface to gain confidence and get the desired result.

A 'mackerel' sky is one of the most difficult to paint and requires careful handling and building up. Tonally it must not be too pronounced otherwise it will stand away from the sky and have little relationship to it. Try to contain the lightest parts of the cloud formation within the centre of interest.

Fair-weather Heap Clouds (Cumulus)

Scattered or ranked cumulus in a blue sky indicates fair weather with no immediate change: ideal conditions for a day's painting outdoors. This type of sky is featured in many paintings and recalls warm summer days, cornfields, and sea breezes. Cumulus cloud formation is well defined and shows marked perspective by the recession of single clouds and clouds in rows or 'streets'.

Separated clouds require arranging and balancing into a suitable composition, particularly if strong sunlight emphasizes shape. Softened and blended edges of the nearest clouds take interest into the painting and towards the horizon.

Fair-weather skies often have a degree of sharp contrast overhead stretching to middle distance, from there to the horizon clouds and sky become affected by aerial atmosphere; a soft lavender grey unifies them, giving a wonderfully delicate feeling of space and air. Careful handling is needed to achieve the right balance of colour and tone.

The upper part of cumulus cloud in bright sunlight has a well-defined edge, and the underside is grey and ragged, specially in the morning or in showers when there is little contrast between it and the blue sky. This difference of light and dark between the upper and lower parts of cloud emphasizes its form and adds interest, but the contrast

5.10 p.m. 5 June

Afternoon Clouds

Size: 12 × 9½ in
(305 × 241 mm)
Medium: Conté
Paper: Grey scrapbook

Cumuliform clouds
show characteristic
heap form and move
rapidly across the
windy sky. My method
of drawing skies is to
establish the horizon
and big shapes first to
get a basic composition
of the landscape. The
fence poles were added
last so that I could
judge how dark they
needed to be.

Although the subject
is very simple it has
interest. My main
concern was to achieve
a feeling of space and
moving cloud.

should be less pronounced with recession and
the greying of atmosphere; partially blending
shadow edges of cloud into sky gives the
necessary roundness.

Towards the horizon, grey cloud and blue
sky may show some influence of red, a slight
touch of cadmium red or alizarin is enough to
give the correct colour cast. Yellow ochre too
may be evident but much greyed. If your
blue is too intense add a touch of burnt
umber or raw umber, the horizon scarcely
shows any blue and is likely to be a warm
tint.

Cumulus clouds undergo diurnal variations
which are easy to observe. During the
morning their bases may be a few hundred
feet above the ground and are often ragged or
ill formed. As daytime heating increases
they rise and their bases become more
uniform. By mid- to late afternoon the bases
are quite flat and may be several thousand feet
above the ground. If precipitation emerges
from the base of cloud in any great quantity
the cloud base will sink and ragged stratus
clouds may form in the precipitation.

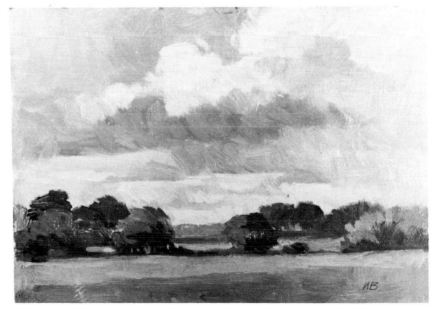

Cumulus – Outdoor Study

Size: 15 × 10 in (381 × 254 mm)
Medium: Oil
Support: Hardboard (Masonite)

There is too much emphasis on the horizontals here and the trees are lumpy.
However, it was the sky which interested me most.

The colours I used were cadmium red, cobalt blue, ultramarine, yellow
ochre, light red and titanium white.

Cumulus

Size: 3¾ × 2½ in (95 × 64 mm)
Medium: Charcoal
Paper: Drawing paper

An imaginary cumulus subject.

Diminishing shapes give an impression of distance. The characteristic rounded tops and flat horizontal bases also aid recession, and lead to the silhouetted distance.

The numerous small sketches throughout this book are not intended for use as future paintings; they were drawn to develop my ideas and techniques of charcoal drawing.

Detail (right)

This greatly enlarged detail of my charcoal drawing above shows how the dark areas in the sky were drawn-in direct. Blending was done by lightly brushing with a paper tissue. Some of this was softened still further by taking the edges off with a kneaded putty rubber.

Firm pressure with the rubber lifted out the light running across the horizon. I then drew-in the house and poles with a sharpened carbon pencil. Slight smudging in the foreground creates texture and softened hard edges

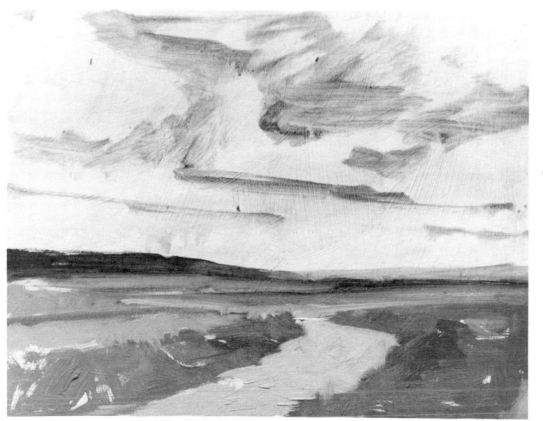

Step 1

Step 2

Cumulus

Size: 12 × 10 in
(305 × 254 mm)
Medium: Oil
Support: Hardboard
(Masonite)

Step 1: The basic
composition is
drawn-in with
ultramarine and
cadmium orange
mixed to give a
grey-blue colour. The
paint is well diluted
with turps.

Step 2. To establish the
tone of the landscape I
block-in the general
colours. Darks are kept
towards the horizon to
give a contrast against
the sky. Of course, the
tones and colours will
be adjusted as the
painting progresses.

(Continued overleaf)

Step 3: Now the dark clouds are indicated. The bases are flat so this helps to give a sense of recession. Light and middle tones are next, working wet-in-wet and keeping the paint fluid.

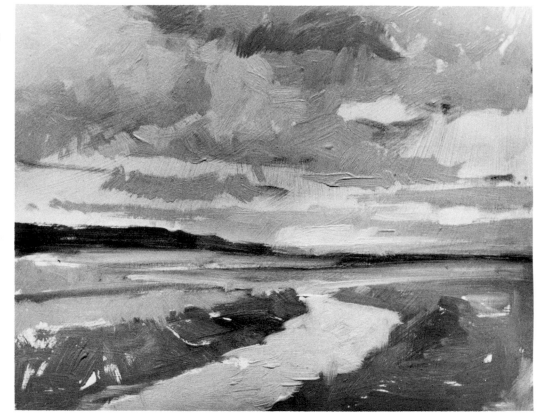

Step 3

Step 4: Brush marks become smaller towards the horizon, and the cloud bases closer together. The light patch of sky in the distance is lowered in tone by overpainting with pale blue-grey.

At this stage I will leave the sky and do some more to the landscape. I prefer to finish both at the same time.

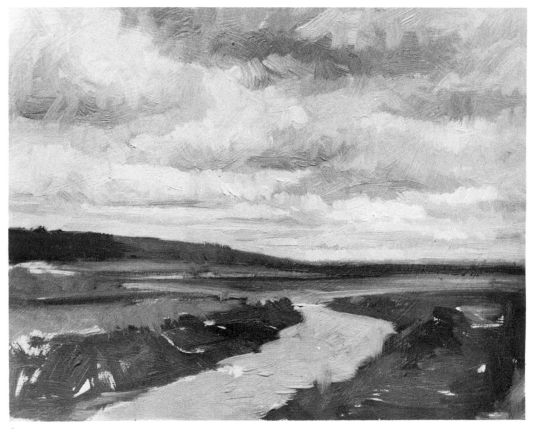

Step 4

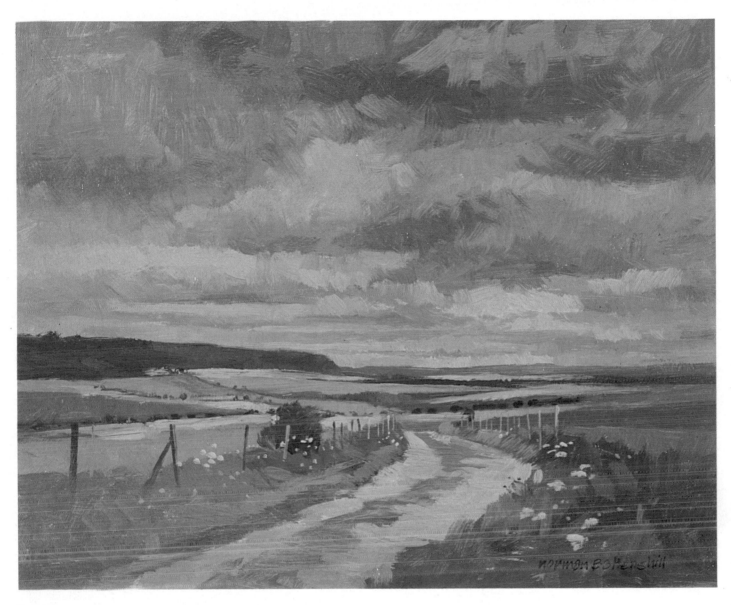

Step 5

Step 5: I have now completed the landscape, making sure it is neither too dark nor too light in relation to the sky.

The distance is modified to create further recession. I do this by adding more blue to put another plane beyond the dark hill on the left.

Final touches are the cow parsley and fence posts. The sky is lowered in tone on the left to keep interest within the painting.

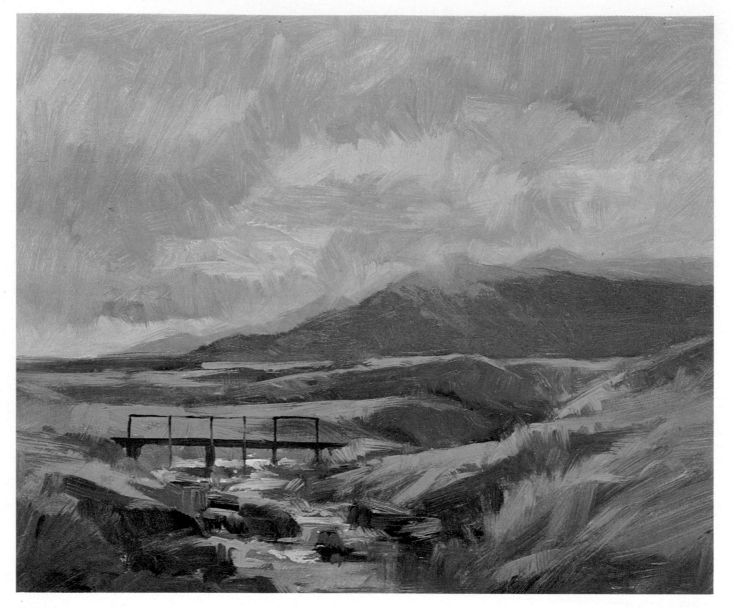

Stratus

Size: 12 × 10 in (305 × 254 mm)
Medium: Oil
Support: Hardboard

The step-by-step demonstration for this painting of
stratus clouds over Ben Lawers is on pages
115–117.

Ben Lawers is designated an area of outstanding
beauty by the National Trust of Scotland. I visited
it for the first time in the depths of winter. The
atmosphere was magical.

Cloud Study – Cumulus

Size: 10 × 7 in (254 × 178 mm)
Medium: Watercolour
Paper: Bockingford 140 lb (300 g/m²) watercolour paper

Step 1: The paper is first wet with clean water and a No. 12 brush. Then I sweep in a mixture of Payne's grey and ultramarine with the same brush while the paper is still very wet. The lower part is brushed-in with fresh colour.

Step 1

Step 2: Using a piece of soft paper tissue the cloud shapes are lifted out.

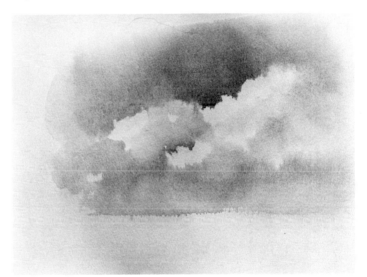

Step 2

Step 3: While the paper is still damp a pale colour of ultramarine and Payne's grey is brushed into the shadow side of the cloud, softened and blended with clean water. Darker colour is dropped into the sky near the edge of the clouds for greater contrast. More cloud shapes are lifted out with clean paper tissue.

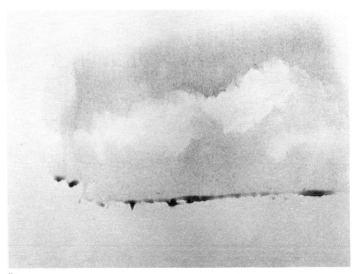

Step 3

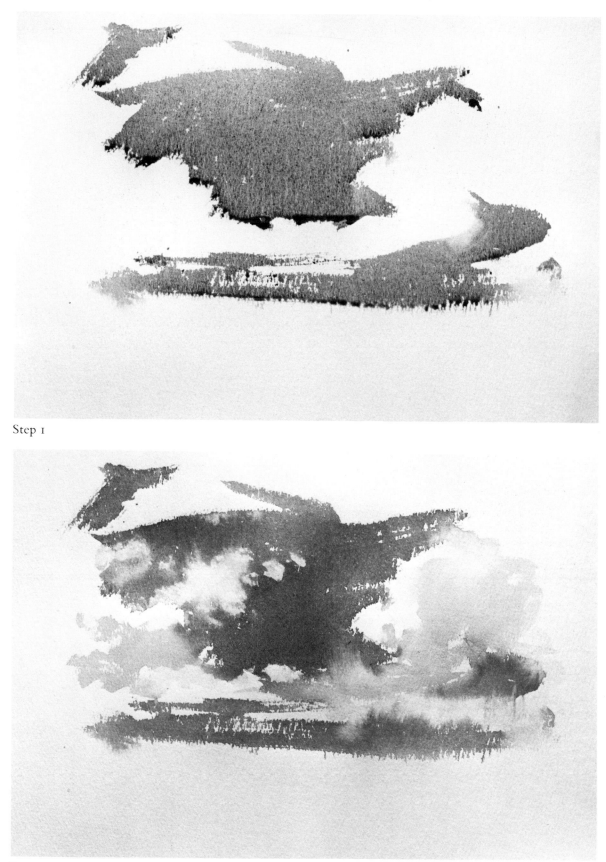

Step 1

Step 2

Step 3

Cloud Study—Cumulus

Size: 10 × 7 in (254 × 178 mm)
Medium: Watercolour
Paper: Bockingford 140 lb (300 g/m²) watercolour paper

Step 1: A wash of ultramarine and Payne's grey is laid on to dry paper, leaving white paper for cloud shapes.

Step 2: Now I put in a paler wash to the shadow side of the clouds. Working quickly I lift out further cloud shapes with soft paper tissue.

Step 3: The shape at the top is too forceful so it is taken out with a sponge and then blotted to prevent the water spreading.

The subject is imaginary and built up from the way the colour flows, and the pattern is created by lifting out with tissue.

Anvil Cloud

Size: $3\frac{3}{4} \times 2\frac{1}{4}$ in (95×57 mm)
Medium: Charcoal
Paper: Drawing paper

The top of the cumulonimbus is becoming swept off by high-level winds to form the exciting anvil shape. At a lower level, layer cloud dark in contrast gives scale and adds distance to the flat landscape. The sky area is rubbed-in fairly hard but the texture of the paper is not lost. Compare it to the foreground field where the charcoal is put down and left untouched. For the cloud I lift out the edges with a kneaded putty rubber, taking care to keep the marks as positive statements. If charcoal is rubbed too hard it leaves a stain on the paper that is difficult to remove.

Storm Clouds (Cumulonimbus)

Bad weather often heralds spectacular effects with low rain cloud dark against a distant break in the sky, or the gathering up of heap clouds into a cauldron of rain and thunder. Time for painting is limited with the possibility of heavy rain or hail but the opportunity should not be missed. A charcoal drawing or pastel study is the quickest method of capturing fleeting impressions, but an attempt to paint should be made if possible. When time is short use a limited palette of the principal colours, and start at the point of interest. Cloud forms in bad weather may appear pronounced in tone, colour and shape, but when working outdoors it is pointless to lose valuable moments by thinking about composition. A studio painting of the same subject can be corrected at leisure and with greater thought.

A medium grey ground is a useful middle tone when painting in oil or acrylic, and by adding dark grey and light grey a three tone value can be established very quickly. Having painted in the main tonal contrasts it is then an easier task to bring the subject into colour. I prefer to paint direct, any underpainting of tone values consists of thinned colour.

Dark rain clouds need careful tonal selection. Take care not to make your sky too dark otherwise the landscape will finish up black. Lightening the tone of dark cloud when you start a painting will allow a greater flexibility of values. If you have over-emphasized some dark rain clouds, instead of repainting the whole area wait until the paint is dry to touch, then lightly scumble a lighter colour over the top leaving some of the underpainting showing through.

A sky associated with rain or storm does not necessarily have a total covering of dark cloud; blue sky may stretch overhead to the middle distance where light coloured creamy clouds rise upwards. Impressive in shape and catching sunlight on their peaks, cumulo-nimbus clouds against a blue sky are a subject of great beauty.

Layer Clouds (Stratiform)

Low layer clouds have shallow horizontal forms sometimes extending overhead to the horizon. Victorian artists delighted in depicting such skies for their sunset and dawn paintings, often adding a streak of orange and yellow in the distance for romantic measure. Confining emphasis of light to the horizon produces a dramatic effect, but to achieve it the landscape must be darker in tone than the sky. A shaft of light through gaps in the clouds intensifies the dramatic atmosphere, but this stage effect is a much loved and well tried theme and needs careful handling to prevent mediocrity. Although only a small amount of light may penetrate the thick layer of cloud its source must be indicated. A low light on the horizon can be reflected on to the underside of nearer layers. Warm pale tints reflected into cool grey cloud give a harmony of opposites. Subtlety is achieved by low tones and blending colour into colour,

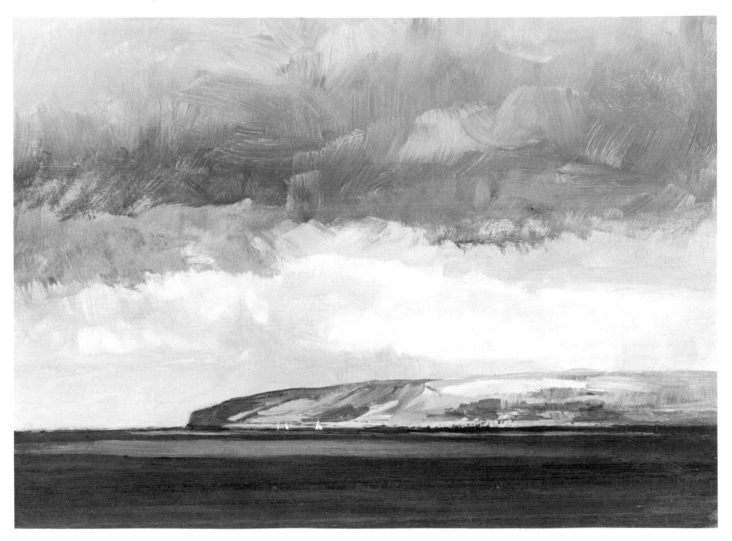

Distant Sunlight

Size: 12 × 9 in (305 × 229 mm)
Medium: Acrylic
Support: Hardboard (Masonite)

Low stratus cloud with ragged fragments, and distant cumulus often result in a dramatic contrast of light and dark as in this painting.

Although the nearest cloud is dark it is not as dark as the sea. The sea is a deep indigo. For this colour I mixed burnt umber, light red, ultramarine, a touch of cadmium red, and titanium white. The dark cloud is burnt umber, ultramarine, yellow ochre, light red and titanium white.

I painted most of the sky first, and the sea last of all.

with the greater emphasis on the far distant strip of sunlit sky.

Low heap–layer clouds (stratocumulus) have a basic shape of flattened curves, fitting together like a loose jigsaw. Horizontal emphasis is more pronounced than diminishing recession, and the artist must make more of recession, or interest will be forced to the edges of the picture. As I have said before, the focal point is best placed off centre.

Cumulus clouds may appear on the horizon, and the contrast of flat layer clouds leading towards them creates exciting contrast and a feeling of space.

Devon Coast

Size: $9\frac{1}{2} \times 7$ in (241 × 178 mm)
Medium: Watercolour
Paper: Bockingford 140 lb (300 g/m²) watercolour paper

This is a monochrome watercolour using Payne's grey.

The layer clouds were painted on to dry paper. I ran a brushful of clean water around the edges of the clouds; the paint reacts by spreading out into the water. Here and there some hard edges have been left untouched. When the sky was absolutely dry the sea and cliffs were put in. Notice the dry-brush effect in the foreground. Finally, I added distant cumulus cloud and the figures on the wet sand.

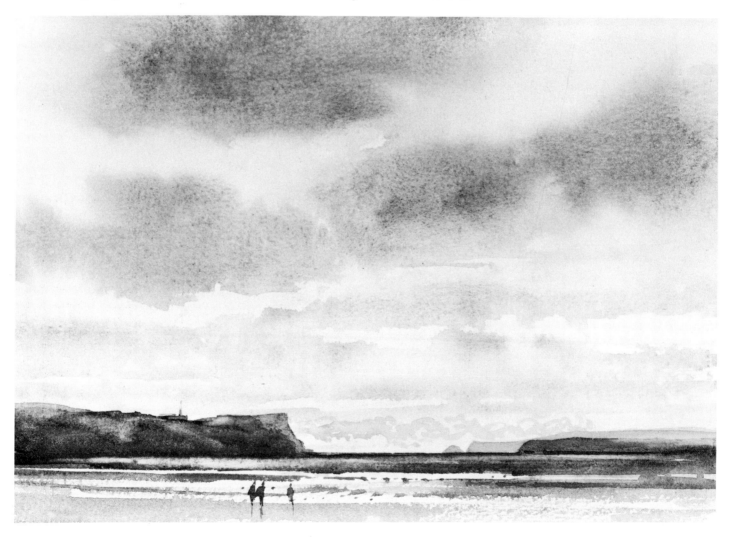

Step 1

Step 2

Stratus

Size: 12 × 10 in
(305 × 254 mm)
Medium. Oil
Support: Hardboard
(Masonite)

Step 1: My subject is
Ben Lawers in Scotland.
The general com-
position is indicated
with a mixture of
cobalt blue and light
red, diluted with plenty
of turps. Next I
establish the tone
values broadly, leaving
the sky until later on.

Step 2: Most of the
landscape is stated, but
still only in a broad
manner. My main
concern is to build up
the painting gradually,
without concentrating
on any particular part.
Now I can start
painting the sky.

(*Continued overleaf*)

Step 3: The right-hand side of the sky shows how I lay it in with the darks first. To the left you can see how I am building up the tones. Brushwork is bold to give vitality and movement to the cloud.

Step 3

Step 4: The colours I use for the clouds are light red, cadmium red, yellow ochre, cobalt blue, and titanium white. Stratus cloud is often formless, I try to get this characteristic by painting wet-into-wet and blending with a dry brush.

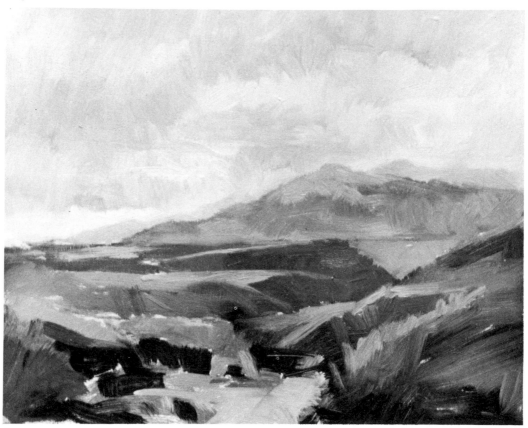

Step 4

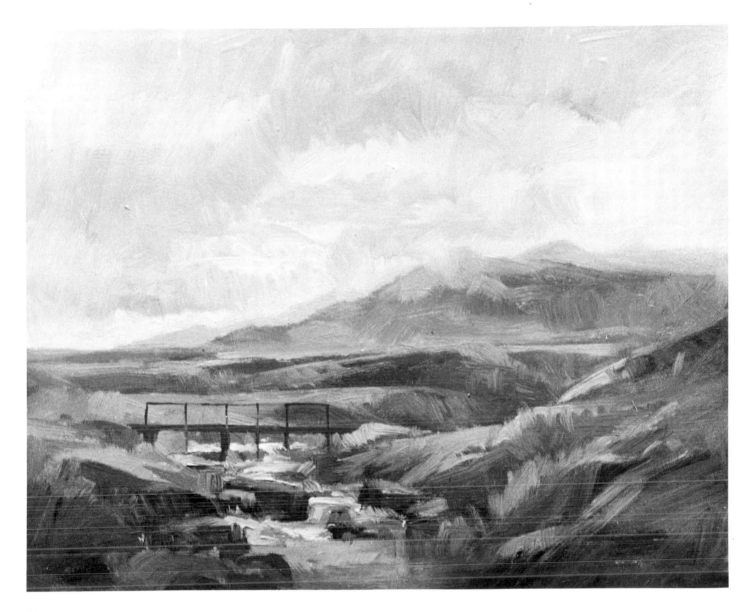

Step 5

Step 5: The bridge is put
in with a rigger brush,
followed by the
highlight on the water.
More detail is added to
the stream. A little
more softening in the
sky around the
mountains helps to
create atmosphere. The
diffused broken light
on the landscape is
consistent with the type
of cloud.

See page 108 for
colour reproduction.

Hazy Cloud (Cirrostratus)

The veil of cirrostratus or altostratus often entirely covers the sky, diffusing the sun's light and weakening the shadow definition. Although the landscape is reduced to an even tone, the soft halo around the sun in a flat, translucent grey sky makes a subject full of mystical atmosphere.

The problem is not to detract from the sky by making the landscape too dark: it is necessary to lighten its tone by several shades to arrive at a harmonious balance.

Daybreak

Size: 9½ × 7 in (241 × 178 mm)
Medium: Watercolour
Paper: Bockingford 140 lb (300 g/m²) watercolour paper

For my painting of cirrostratus cloud I mixed Payne's grey and ultramarine and laid a very liquid wash across the sky. Towards the horizon the colours are ultramarine with a slight touch of light red.

While the sky was still very wet the clouds were lifted out with a damp sponge. Too much movement of the sponge would have lifted the softened paper surface, so I took care not to overdo it. When the paper was absolutely dry I put in the silhouettes of the trees and houses, mixing Prussian blue, Payne's grey and burnt umber. To get the effect of light in the windows I lifted off the damp paint with a wet brush. I did the same for the washing on the line but let the loosened colour stay on the paper.

Feathery Clouds (Cirrus)

Clouds with the familiar feathery streaks high in a blue sky are flat and are stretched by narrow ribbons of fast-flowing air at around 30,000 ft (9,100 m) called jet streams whose speeds can approach 200 knots (370 k. p. h.). Near these jet streams attractive bands of cirrus may be observed which appear to converge towards the horizon – this is of course an optical illusion. These bands of cirrus flow with the jet stream and may have striations, fallstreaks and wave-like formations.

Ever since aircraft have attained altitudes in excess of 20,000 ft (6,100 m) it has been possible for them to produce clouds. Their exhaust gases contain much water vapour and if environmental conditions are suitable this water may produce a condensation trail. Some trails are short-lived while others may persist for many hours. The longer-lived trails may spread in the jet streams to form clouds similar to cirrus or cirrostratus. A widening aircraft trail indicates the direction of a cross-wind aloft.

Sometimes referred to as mares' tails, cirrus clouds feature in many paintings of serene summer landscapes. Simple as this cloud form may appear, streakiness in a painting should be avoided especially if it is diagonally placed. Oblique angles require both careful consideration and placing to obviate distracting directional interest. Soften and blend edges into the blue sky, but first determine whether the cloud has one side softer than the other. Contrast them with lower layer or heap clouds; the difference of texture will make your sky painting more interesting.

Varied Cloud

Different types of cloud shown together in one painting have an interesting contrast of form and perspective. Medium-height dark cloud against pale higher cloud and a blue sky is a combination depicted in many paintings and requires a knowledge of cloud types to make it convincing. Good composition is necessary to balance light and dark shapes into a truthful and natural arrangement of cloud and space.

Laying-in the sky roughly to the final pattern is preferable to starting a painting without any preconceived idea, particularly when the sky consists of several cloud types. Compose your sky with textured clouds and flat clouds, contrast height levels too. You may depict medium-level heap clouds (altocumulus) against the higher, flat mares' tails (cirrus). Other cloud forms of contrasting texture and height make a fascinating combination against a grey-blue sky.

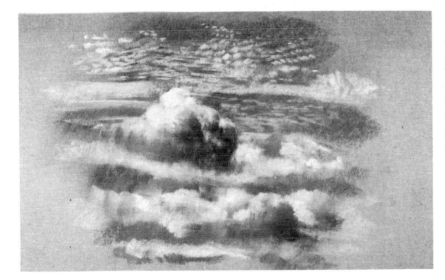

Varied Cloud

Size. 12 × 9 in (309 × 229 mm)
Medium: Pastel
Paper: Grey paper

This is an outdoor pastel monochrome sketch. The cloud formation was beautiful: great rafts of 'mackerel' cloud dusted the blue sky in broad sweeps, and at a lower level, cumulus clouds constantly altered shape with the winds.

Cirrus

Size: 12 × 10 in
(305 × 254 mm)
Medium: Oil
Support: Hardboard
(Masonite)

Step 1: I indicate the
horizon line and basic
composition. Next I
start laying-in the
landscape, using broad
brush strokes. My first
consideration is to
establish tone values
not colour. The
priming is left showing
in the sky at this stage.

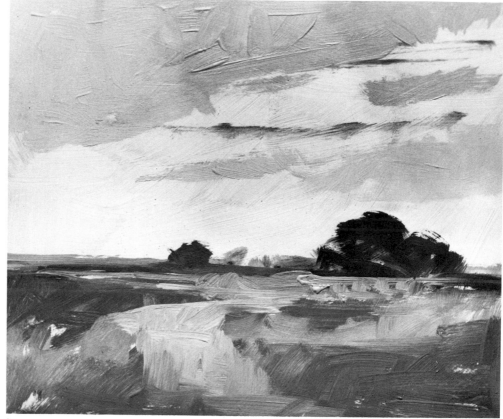

Step 1

Step 2: The landscape
becomes more defined
but still broad in
treatment. Laying-in
the sky is next, from
dark blue at the top to
pale, yellowy blue on
the horizon. I mix a
slight touch of Winsor
lemon to cobalt blue
deep to get this subtle
tint.

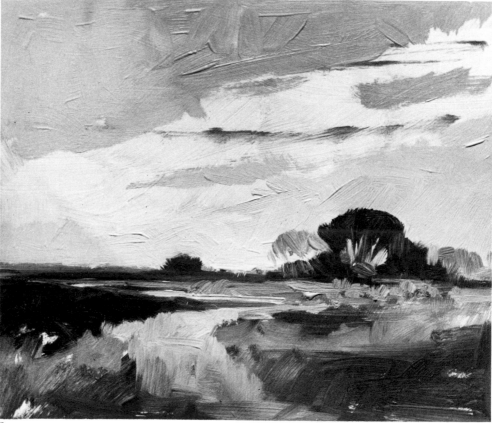

Step 2

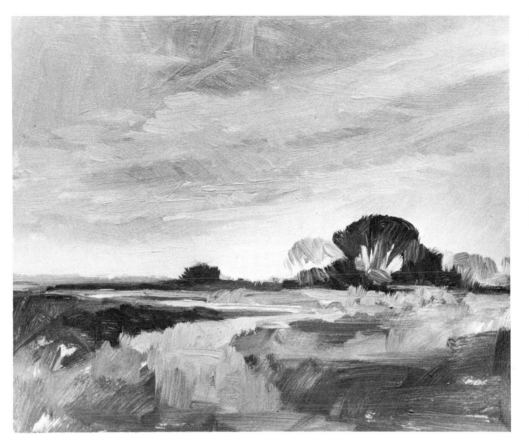

Step 3

Step 3: Now comes the feathery cirrus cloud. Yellow ochre, cadmium red, and titanium white are the colours mixed to get the pale sweep of cloud. The blue is wet so I blend and soften the pale colour into it.

If you compare the tone of the cloud with the white of this page, you can see how low toned the cloud is.

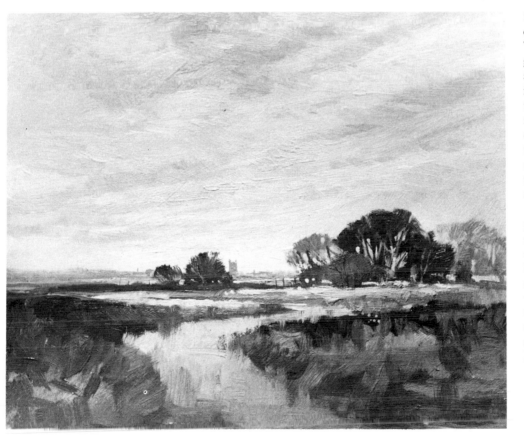

Step 4

Step 4: Now I can add detail and some accents. The distant church gives scale to the sky, and also recession. I put in some more cloud at the top of the painting, making sure it is not obtrusive. Here and there sky colour is overlaid on the cloud to define its wispy form.

The colours on my palette are cadmium red, cadmium orange deep, light red, cobalt blue, ultramarine, cadmium yellow, yellow ochre and titanium white. To my usual palette I have added yellow ochre and light red.

REFLECTED LIGHT

The colour of clouds is not only affected by the atmosphere and the brightness of the sun but also by reflected light from adjacent clouds. If we put two white objects close together one will reflect light into the other. Similarly heap clouds of distinct form will in bright sunlight cast a strong reflected light on to clouds nearby.

Still-life painting teaches us to look for the light reflected on objects, and the consequent influence of local colour. Landscape painters must also acquaint themselves with the same principle applied to clouds. How intense the light is depends on the brightness of the sun. On a sharp, clear day, heap clouds against a blue sky may show a silver quality in the shadows. Reflected into this blue-grey are several colours, but warm yellow

predominates. You will find in the shadows pale tints of lavender, cobalt blue, pink, and pearly white. A predominance of colour that is too strong does not have the appearance of reflected light; subtly blended colours are truer to nature and guarantee harmony. Care must also be taken with your interpretation of the different tone values of cloud shadow.

As clouds recede towards the horizon the divisions between smaller shapes become less apparent so we cannot clearly see either colour reflected from one cloud to another, or the intermediate tones. Distance has the effect of softening and blending closely related tone values and colours. An underpainting of pale yellow or lavender colour can be retained in the final stages of painting for the colour of reflected light and a thin glaze of white or pale grey applied to the clouds nearest the horizon will enhance the recession.

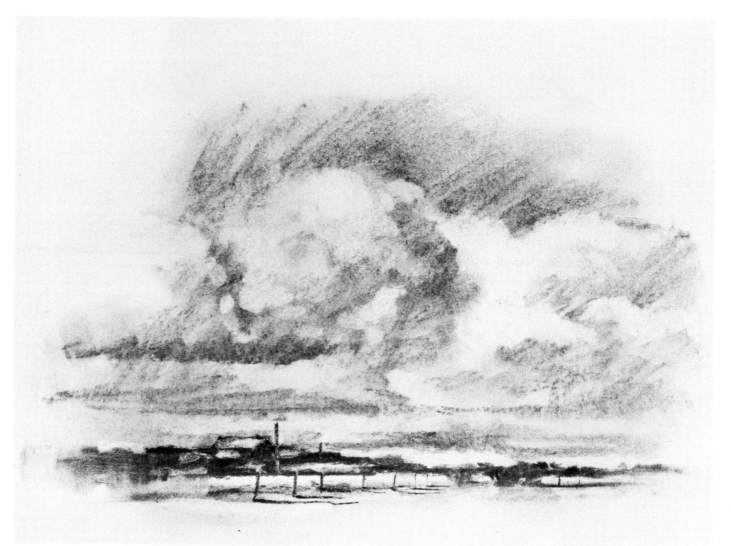

GROUND SHADOW

I made notes for this section on a summer morning while watching shadow chasing shadow across the ripe corn and rich green fields of the South Downs in Sussex.

Dramatic effects happen so swiftly it is impossible to paint them as you see them, but shadow patterns are repetitive and occur over the same areas. If the weather is likely to remain with little change you stand a good chance of getting down some interesting cloud shadows. First of all the landscape must be blocked-in, and then the shadows stated. There will always be a part of your subject which has the most impact: like shadow straddling the brow of a hill, or moving across a group of farm buildings. It is essential to get the focal point balanced with the composition; and to avoid rearranging

Direction of Light (below left and right)

Size: 7 × 6 in (178 × 152 mm)
Medium: Charcoal
Paper: Drawing paper

Shadows cast on the landscape must obviously relate to the position of the sun. Shadows also indicate the degree of light. An overcast sky may filter the light to such an extent that there are no positive shadows on the landscape. These drawings show the effect that sunlight has on clouds and landscape from different directions.

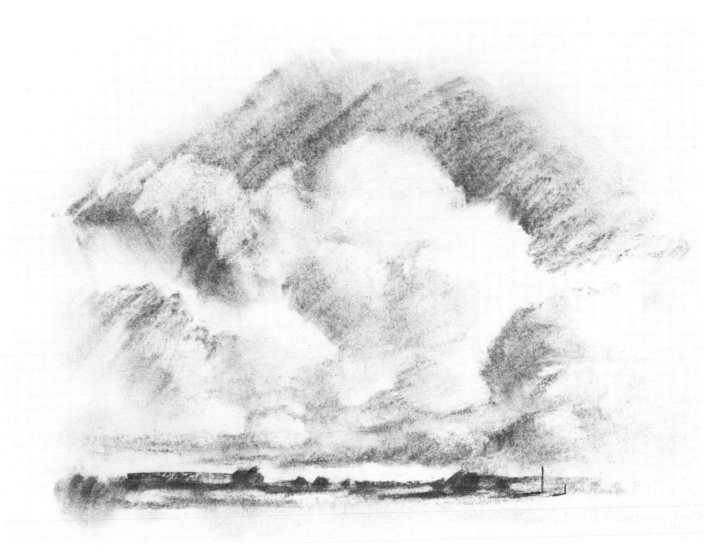

things at a later stage, this must be decided before you begin to paint.

Because clouds vary in density, ground shadows are not all the same tone. Where cloud is thin, shadows cast on the ground are light in tone. Dense cloud casts dense shadow, and cloud dark in the middle and light at the outer edges throws a similar varied shadow on the ground. Within all the shadows there is reflected light from the sky; I have noticed this even on an overcast day.

Somewhere on the outer edge of ground shadow the sun strikes more brilliantly than elsewhere. Look carefully and you will see an area of sunshine next to the shadow slightly brighter than other parts. By emphasizing the colour and tone we get an impact of light meeting dark, but the area must be small. If too much emphasis is made over a large area the effect is hard, and small accents are nullified.

Cloud shadows on the ground are elongated and diminish in size with recession into the distance and the further away they are, the greyer they appear. If you can capture the subtlety of these greys, you will add a convincing impression of distance and depth to your sky and landscapes.

Sky and Fields

Size: 12 × 9 in (305 × 229 mm)
Medium: Acrylic
Support: Hardboard (Masonite)

I began with the sky, having a preconceived idea of the effect I wanted. I used burnt umber, ultramarine, yellow ochre, and titanium white.

The patch of light cloud relates to the sunlit fields, and the dark clouds relate to the shadows on the ground. This relationship of tone values between the sky and the landscape is important: it creates a harmonious link.

If the foreground in the painting were much lighter then emphasis would be directed towards the dark clouds. As it is, your interest stays on the ground.

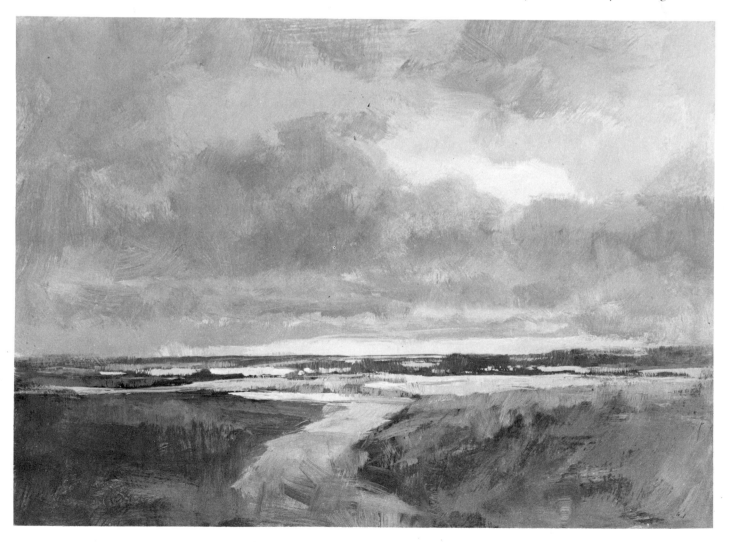

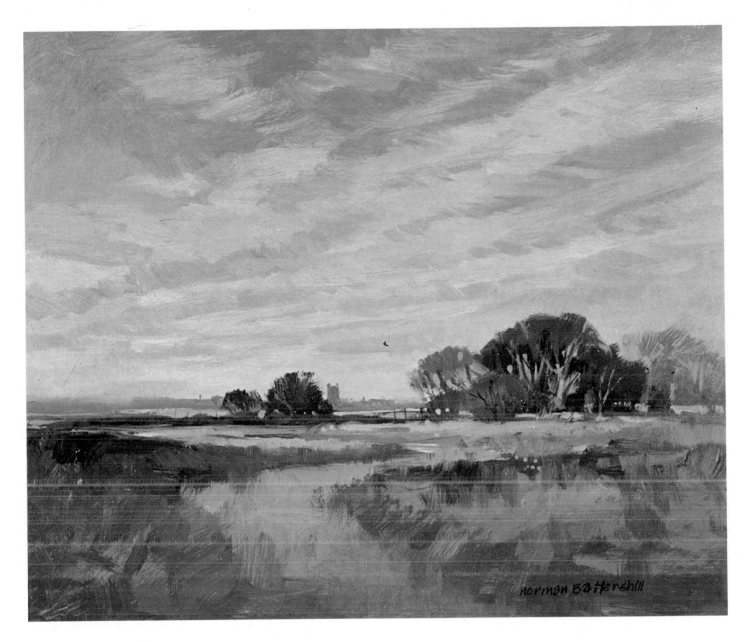

Church across the Meadows

Size: 24 × 20 in (610 × 508 mm)
Medium: Oil
Support: Hardboard (Masonite)

Cirrus cloud at an acute angle across the sky can cause problems of composition. By keeping the tone of the sky light and introducing darks into the landscape, the sky is not obtrusive.

My palette for this picture was cobalt blue, ultramarine, raw umber, cadmium yellow, yellow ochre, light red, cadmium red and titanium white.

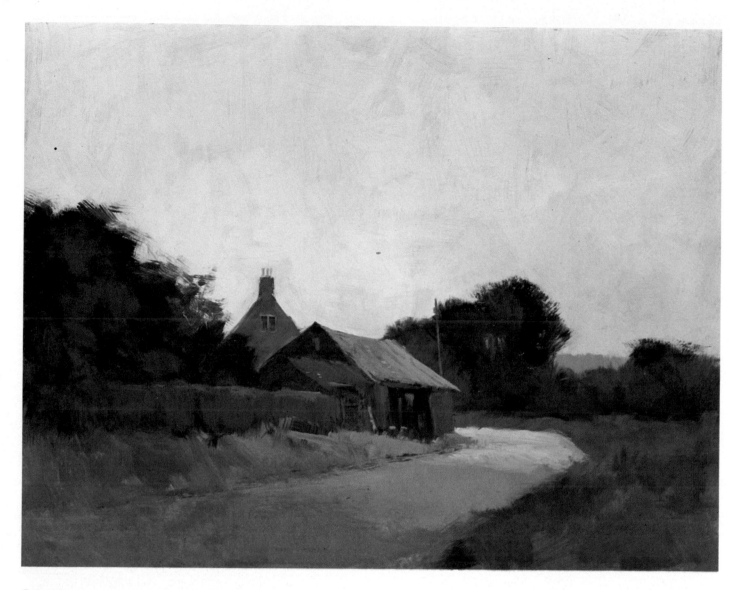

Sussex Lane

Size: 24 × 18 in (610 × 457 mm)
Medium: Acrylic
Support: Hardboard (Masonite)

The effect I was after here was a soft diffused light from a flat sky. Shapes against the sky were almost silhouetted and needed thoughtful planning for tone and composition.

The russet colour scheme has a foil of blue in the road and in the distance. I paint the sky last so that I can judge exactly the tonal pitch against the rest of the painting. Some of the landscape colours are tinted in the sky to give unity.

For this subject I worked from my own black-and-white photograph.

CLOUD PHOTOGRAPHY

Because fleeting weather conditions almost impossible to paint outdoors can be captured in a fraction of a second with a camera, photography can be invaluable for artists wishing to build up references of different cloud types.

If you use colour it is worth noting that the contrast ratio of a transparency is about 40 : 1 while that of a colour print is only about 14 : 1, and that colour prints made from colour transparencies may well show loss of detail in shadows and highlights. Correct exposure times are essential to get optimum results so you will need a built-in or separate exposure meter. Even if the colours appear bright in the processed print or transparency, it will give a useful colour reference as a starting point for a painting.

Black-and-white pictures of clouds are best taken with fine-grain film which gives the best definition of detail. A red filter renders blue sky almost black and sharpens the tonal contrasts in clouds. If you don't use a red filter on your camera lens for black-and-white photography you may be disappointed to find that clouds do not show up very well on the print; your eye will see subtle cloud tones that will not register on the film. Choose a clear, bright, sunny day if possible, when there is good tonal contrast between light and dark. I personally find 35 mm black-and-white photographs a lot easier to use as a reference than colour prints. Despite their superior quality I don't use colour transparencies at all because they appear too bright when seen in a hand-held viewer.

If you are photographing clouds near the sun either use a lens hood to mask out unnecessary brightness and prevent flare, or position the sun behind a telegraph pole, building or tree. You don't have to include landscape when photographing clouds for reference but it will give an indication of scale and distance.

To avoid 'burned-out' highlights in cumulus and cumulonimbus clouds calculate exposure for the brightest parts of the cloud. If you expose at this value the landscape will be dark and foreground features will become silhouettes. A compromise can be achieved by averaging the exposure. Take a reading for the bright highlights and then another reading for the landscape then expose using the average of these two readings. For example if the exposure for the highlights should be 1/250 sec. at f 16, and for the landscape 1/250 sec. at f 8, the average will be 1/250 sec. at f 11.

Your photographic cloud studies can be classified by the cloud type, direction of wind, position of the sun, time and place of origin, and camera exposure details. Always write lightly on the back of a photograph, preferably with a soft chinagraph pencil as ball-point pens or hard pencils will indent the photograph.

7. Perspective and Composition

It is the greys that make a painting.
Jacques Louis David (1748–1825)

PERSPECTIVE

Perspective is applicable to the sky just as it is to landscape. Aerial perspective concerns the effect distance has on colour and is discussed separately in the next section 'Aerial Atmosphere'. Here I want to discuss diminishing perspective.

Clouds appear smaller and closer together as they recede towards the horizon and this is particularly noticeable with layer and heap cloud. Fair-weather cumulus clouds in rank or street formation are a good example of how clouds appear to diminish in size by recession. The clouds nearest to us show full shape but further away they merge into a continuous veil like the side-on view of a ploughed field.

Layer cloud that is parallel to the horizon and spans the sky will not have a vanishing point because its expanse is too wide, but convergence of layers is clearly definable. In all landscape work it is unnecessary to plot vanishing points with geometric accuracy; a rough guide is quite sufficient.

Different cloud types may be present at the same time, angled across the sky. When painting this type of formation make the acute-angled cloud of secondary importance because such angles are assertive and disrupt the balance of recession towards the horizon. If they conflict they create havoc with composition unless carefully planned.

Fibrous cirrus cloud often presents a powerful diagonal pattern with hooked strands that taper towards the horizon, diminishing with perspective. Sometimes the filaments lie horizontally on an angled 'raft'.

Cumulus clouds can show considerable vertical development, rising in great billowy towers. They have no vertical vanishing point but being at right angles to the horizon gives

Recession

Size: 9 × 7 in (229 × 178 mm)
Medium: Charcoal
Paper: Drawing paper

Recession is achieved by bringing the base of the clouds closer together towards the horizon. The darkest cloud is nearer to add to the illusion of perspective.

I have added telegraph poles to give scale to the clouds and increase the impression of distance. Notice how the distant trees on the left of the dark horizon appear miles away. Light smudging of the charcoal in the area adds atmosphere and a suggestion of rain.

an impression of their height. Well-defined and shaded bases will clearly indicate recession, but with such strong vertical and horizontal shapes we have to decide which are to be of major interest. If equal emphasis is given to the rising towers and their bases, the conflict of angles will distract the eye and produce an unsatisfying composition. Cumulus towers are a powerful and

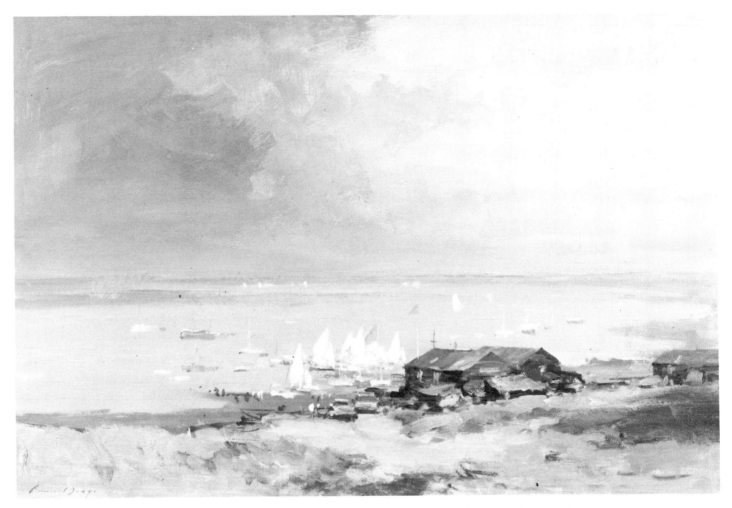

The Sailing Club Edward Seago (c 1955)
Size: 30 × 20 in (762 × 508 mm)
Medium: Oil
Support: Board

challenging subject which could be the main theme for a painting.

If you are aware that clouds appear closer together and diminish in size towards the horizon then perspective will not be a problem. When clouds are flat and featureless the effect of recession is accomplished by colour and tone. Sky must always relate to the landscape and reflect mood and atmosphere. Edward Seago's (1910–1974) oil painting *The Sailing Club* (above) has a dark storm cloud on the left from the top of the picture to the horizon. Directly beneath the cloud are distant sailing boats showing up light against the dark sky. Cover them up and the cloud has very little recession within itself. Seago has made masterly use of the yachts to suggest miles of distance on the seascape and in the sky. Any attempt at pronounced perspective of the storm cloud would have destroyed the dramatic atmosphere.

Many cloud formations lie parallel to the horizon. Nature has a subtle way of breaking up the horizontal lines with an uneven or ragged cloud base. The flat base of heap cloud in the afternoon is sufficiently distinct not to need emphasis. If made too obvious by tone then our interest is diverted from the rest of the painting to follow the rows of parallel lines directly to the horizon.

Similarly, feathery cloud such as cirrus tends to lie in parallel bands across the sky. If the cloud is low in tone against the blue sky then the impact of recession is not so pronounced. The convergence of parallel lines is sufficient to create a sense of depth.

Stratocumulus is another cloud type often arranged in regular and almost parallel rows converging into the distance. The underside

of each row may appear less ragged with recession. Although flat cloud base aids recession, horizontal rows are static; you may prefer to angle them slightly to avoid monotony.

Sometimes cloud may appear irregular and devoid of perspective even though the formation may have shape. To achieve recession without linear perspective depends entirely on aerial atmosphere. Towards the horizon clouds exhibit subtle shades of colour, perhaps dusty grey or pale lavender, while nearer to us their colour is not influenced by the intervening atmosphere.

A featureless blue sky is made to recede in a painting by the subtle gradation of pure colour overhead to muted blue on the horizon.

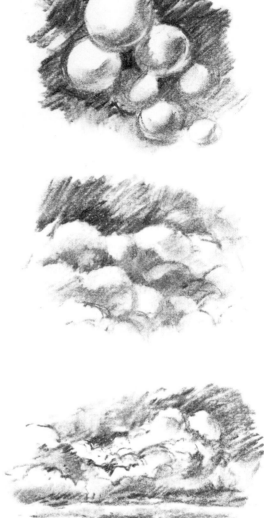

Recession

Size: 10 × 7 in (254 × 178 mm)
Medium: Carbon pencil
Paper: Drawing paper

A very basic diagram to show you how tone aids recession. But Nature can be very contrary and place the darkest cloud in the distance.

Diminishing cloud shapes, lighter tone values, and aerial atmosphere are the factors governing the principles of aerial perspective.

Practise these diagrams so that you are able to gain a basic understanding.

Cloud Form

Size: 9 × 7 in (229 × 178 mm)
Medium: Charcoal
Paper: Drawing paper

These greatly simplified drawings illustrate the basic form of heap cloud in the afternoon and show how the round shapes flow into each other. The diagram also illustrates the effect of light source and shadow. The last illustration shows the flat base of heap cloud which helps to increase the illusion of recession towards the horizon.

It is not intended that you should draw or paint heap clouds in this manner. The illustrations are only diagrammatic.

AERIAL ATMOSPHERE

Creating space and recession in landscape painting relies on modifying colour by greying and on the principle of diminishing perspective. The sky overhead is clearer than at the horizon because we see through less atmosphere. Towards the horizon, atmosphere gradually greys the landscape and sky with a thin veil. We often see bright, sunlit heap clouds on the horizon, but although it may not be visible the veil is still there. Every colour in the distance has a touch of neutralizing grey – not a pure grey but with a tinge of added colour – perhaps a purple-grey, blue-grey, or pink-grey. Aerial atmosphere should convey the effect of space. Flying brings us in proximity with the thrill of limitless space. Recently I had the golden opportunity of flying in a vintage Tiger Moth

aeroplane. Even though we flew well below the clouds I experienced great exhilaration of being in space and feeling part of it. Travelling at high altitude in a jet reveals the true wonder of clouds: some stretching into the far distance like snow-packed ice-fields, others towering in great rounded forms. Flying through cloud is the best way to see how light reflects, and permeates these misty forms.

Sky is not merely a backcloth to a painting but an inseparable part of it. The landscape artist must both appreciate that sky is infinite space, and understand the importance of aerial atmosphere and its relationship to the landscape. Have you noticed on a warm summer's day that not only can you feel the warmth around you but often see and sense it far into the distance? It is easily talked about but difficult to paint. To create overall colour harmony and to achieve aerial atmosphere

Above Cloud

A graphic illustration of cumulus seen from 20,000 ft (6,100 m), stretching into the distance like vast snowfields.

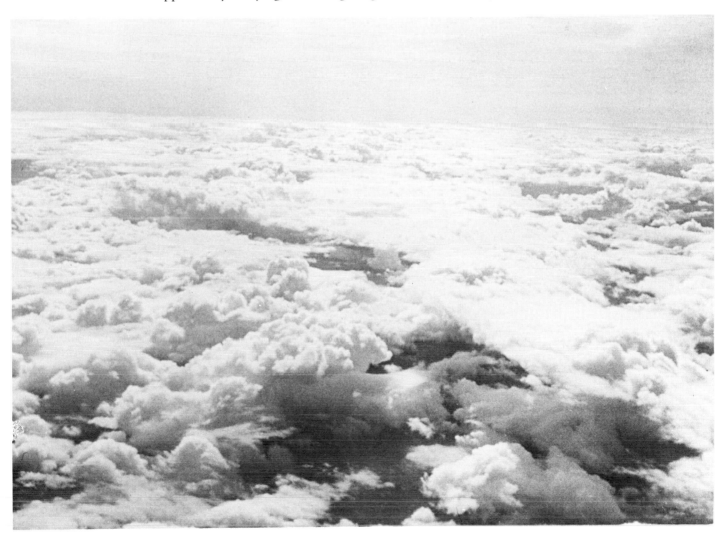

Cloud Study

Size: $3\frac{3}{4} \times 2\frac{1}{4}$ in
(95×57 mm)
Medium: Charcoal
Paper: Drawing paper

An imaginary subject sketched-in direct. Tone values are important. The sky is dark but the landscape is much deeper in tone. This aids recession and adds to the sense of atmosphere. The sky was drawn-in first without over-emphasizing the darks.

mix some sky colour into the landscape, or paint the sky below the horizon and then paint the landscape into the wet colour. Another method is to let the sky colour dry and then paint the landscape over the top, allowing some of the sky colour underneath to show through. This technique is applicable to all painting mediums.

SKY COMPOSITION

Arranging the clouds of a landscape study into a satisfactory composition requires a great deal of thought: an ill-conceived balance of colours, tones and shapes will all contribute to the failure of a picture. But a natural balance must be aimed for rather than geometric accuracy which can produce contrived results. If you observe a few simple rules then there should not be too much difficulty in arriving at a pleasing sky composition. Here are some guidelines:

1 Don't put the largest cloud in the middle or at the edges of your picture.
2 Placing an emphasis of cloud to one side of the painting requires a balance on the other, but not necessarily another smaller cloud. The balance can be created by an accent on the landscape.
3 A group of trees similar to the shape of cumulus clouds creates visual harmony and balance.

4 Don't make sky between clouds too dark otherwise the patches look like holes.
5 Diagonal clouds create strong directional lines.

A sure way of checking that your sky composition is satisfactory is to look at it in a mirror, or turn it upside down; this will make any imbalance immediately apparent.

I start with only the main shapes to determine the basic composition and then build up the pattern by introducing smaller clouds as the painting progresses. A haphazard approach invariably creates difficulties only realized at a critical stage of painting. By then radical changes are inadvisable and it is wiser to begin again. After you have blocked-in the sky the basic composition should be assessed for any major adjustment. Further stages during painting must also have critical consideration. Rough sketches or preliminary paintings will give you some idea of the composition of the sky in relation to the landscape.

There are points of interest in the sky as on the landscape and you must decide which one is to be emphasized. Its position should normally be off-centre; if placed too near the edge the composition will be unbalanced and the eye will be drawn off the edge of the painting. If an effect of light, colour, or tone is centred on the horizon then the eye is taken into the picture. Exactly where it is placed is critical to the composition of your painting. Symmetry of cloud masses is not the answer

Thumb-nail Sketches
(opposite)

Size: $2\frac{1}{2} \times 2$ in
(64×51 mm)
Medium: Carbon pencil
Paper: Drawing paper

These small drawings help to work out composition ideas. It is much simpler to use this method for establishing the elements of a painting, before you put brush to canvas.

Tone contrasts are also determined in a broad manner, leaving out small details.

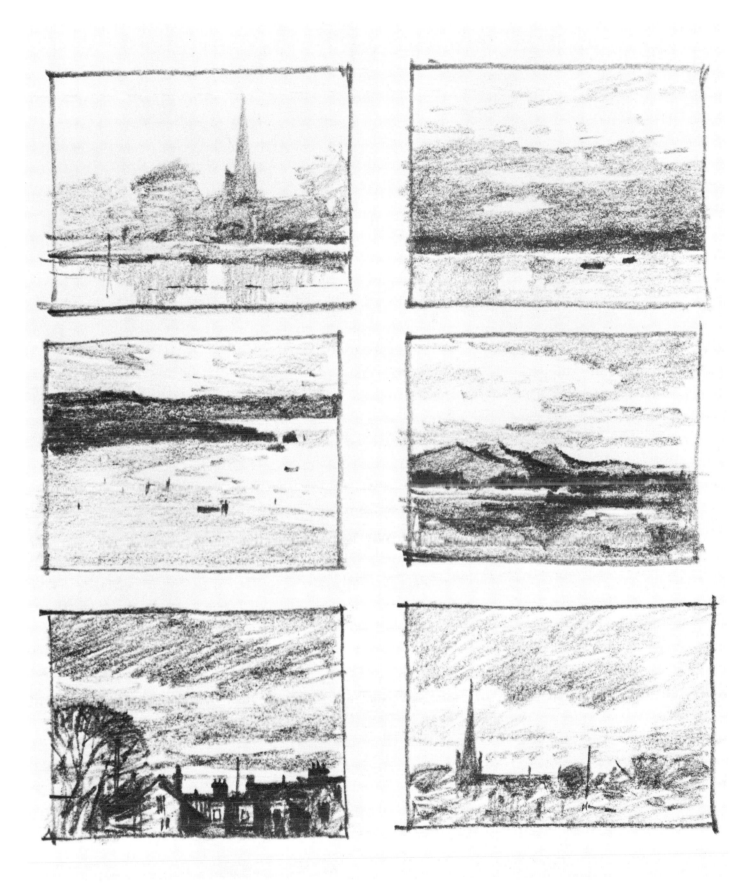

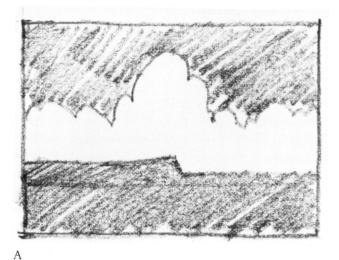

A

B

C

D

Composition

Diagram A: The main cloud shape is in the middle of the picture, so is the point of the distant hill. Both are incorrectly placed. The subject of main interest should be either the hill *or* the cloud, and placed to the left or right of centre.

Diagram B: There is a shape in each of the top corners and another in between. The interest is diverted to these three shapes to the detriment of the rest of the subject. It is better to rearrange the shapes so their position is not as assertive as in the diagram.

Diagram C: The diagonal is too strong geometrically and tonally. If the angled cloud is made low in tone then it will be less assertive. Softening and blending the edges will also help to make the angle harmonious.

Diagram D: A large shape can be balanced by a smaller shape. The interest is not then concentrated on the large one. By darkening the cloud on the left more attention is directed to the small shape.

to balancing a composition, because it will look contrived. A much subtler technique is to counterbalance a dark cloud with a smaller, lighter toned cloud, or a patch of sky. To have a number of strong focal areas in the sky is distracting and divides interest.

If you are painting cumulus cloud then probably the masses will be more prominent than any part of the landscape. To prevent the picture looking top-heavy the tone of the clouds must not appear too dark. The amount of cloud area is not so important as its tone.

Acute angles are dynamic and help to focus attention, so you must consider carefully the lines of angled clouds. Streaks of cirrus clouds across a blue summer sky may look attractive, but if the tone is wrong the angle will be over-emphasized and will upset the composition. As a general rule an angle moving from left to right is more pleasing than an angle in the opposite direction – this is because we are accustomed to reading and writing from left to right. Cumulus clouds do not present similar problems because the

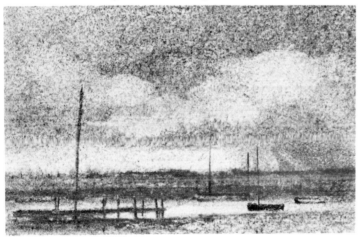

Estuary

Size: $3\frac{3}{4} \times 2\frac{1}{4}$ in (95 × 57 mm)
Medium: Charcoal
Paper: Drawing paper

My favourite subject is distance in landscape. Here, with just a few essentials to make a simple composition I have emphasized the sky and recession. The mooring poles are a useful device to contrast with horizontals.

The sky was put in first by lightly rubbing-in charcoal and then lifting out cloud shapes with a putty rubber. Over on the left-hand side the marks in the sky add vigour and interest. Distant headland dark against the sky aids recession and emphasizes the light on the river.

shapes roughly repeat the shape of trees, and create a unison between landscape and sky.

As I have mentioned before, an emphasis of horizontal cloud layers in a predominantly horizontal landscape takes visual interest off the edge of a composition. Some verticals are necessary to counterbalance the lateral lines, and keep interest focussed within the picture.

If the focal point of your painting is a group of buildings or trees, it may help to have a secondary accent in the sky which may consist of colour, contrast of tone, or an atmospheric effect. I often use secondary accents myself.

A few scattered clouds require more careful compositional planning than a totally cloudy sky. The point to remember about composition is that you should try and get a natural order in your landscape painting, but this does not entirely concern the placing of shapes. For example, blending a distant line of hills into the sky not only creates aerial perspective and distance, but joins the land and sky into a harmonious composition.

When you are making sketches outdoors either in monochrome or colour there is not always time to consider composition. The main essential is to capture a mood. Simplifying composition by the deletion of unnecessary detail adds strength to a picture, and a simple method of determining what to leave out is by covering up the questionable area with your fingers. If you decide to delete a prominent part then something less obtrusive must take its place. With a low horizon and the landscape full of interest a simple sky creates a balance.

When you paint clouds it is necessary to think not only of their shape but also the pattern created between them. The space of blue sky between clouds is an assertive shape and can easily become more predominant than the clouds themselves. Lightening the sky will render it less positive and will help to harmonize composition. Remember that everything you paint has two shapes: the inside and the outside. Both must be considered with equal attention. Cirrus clouds form soft and feathery abstract patterns less predominant than cumulus so their directional movement is more important to composition than their background shapes. But quite often a sky painting fails not because the cloud form is unconvincing, but because the shapes

in between are poorly considered. Look carefully to see that these shapes are an integral part of the main composition. When you have completed your painting you may be surprised to discover that a patch of blue sky between the clouds remarkably resembles a head in profile or a turned-up boot. Again, looking at your painting in a mirror as it progresses prevents such unintentional shapes, or you can turn the painting upside down.

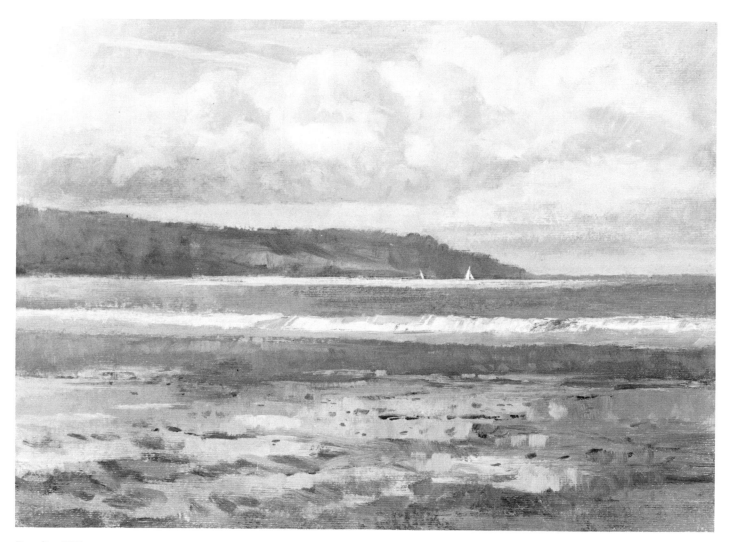

Receding Tide

Size: 16 × 12 in (406 × 305 mm)
Medium: Acrylic
Support: Canvas on board

I had three colours and white on my palette for this painting: cadmium red, yellow ochre, and cobalt blue.

The cumulus cloud is large and bulky. As I wanted the interest to be in the lower half I pushed the clouds back by greying them. In the top left is a patch of blue sky with a streak of feathery cirrus cloud. This also had to be made unobtrusive, otherwise it would have created interest in the wrong place.

The colours mixed for the lightest part of the clouds were cadmium red, a slight touch of yellow ochre and lots of white.

In the studio there is time to consider composition more carefully than when outdoors. Conscious arrangement of cloud shapes when drawing and painting outdoors may result in a poor composition.

To sum up then: compositional rhythm between sky and landscape is affected by tone, colour, shape and perspective, all of which, used correctly, aid in unifying the whole.

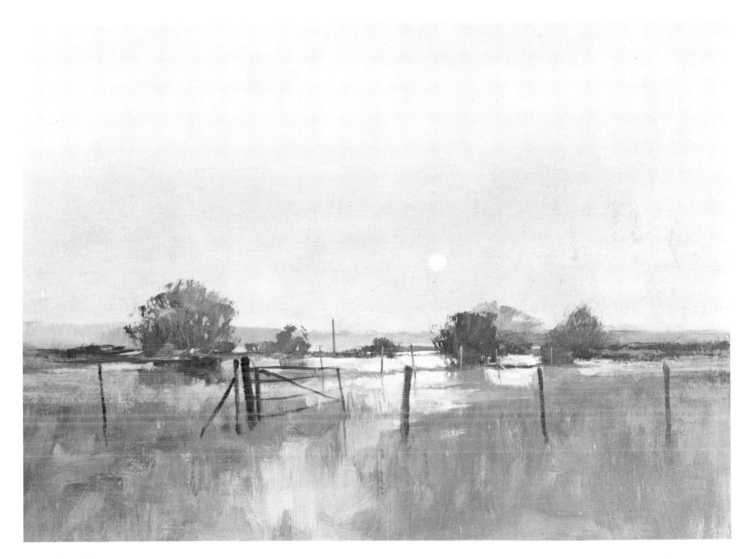

Flooded Fields

Size: 16 × 12 in (406 × 305 mm)
Medium: Acrylic
Support: Hardboard (Masonite)

My acrylic painting is in muted tones of greys. The colours I mixed were cadmium red, burnt umber, yellow ochre, light red, ultramarine and titanium white.

To achieve a feeling of stillness I painted the sky almost flat, with close tones of warm greys. I painted it first to establish the tonal key of the subject. After the landscape had been laid-in I added the moon shape. It then gave me a starting point for the atmosphere I wished to create.

A flat sky and busy landscape can be effective counterfoils of contrast. The subject is imaginary and was developed as I went along.

8. Special Effects

There are painters who transform the sun into a yellow spot, but there are others who, thanks to their art and intelligence, transform a yellow spot into the sun.

Pablo Picasso (1881–1973)

SUNSETS

Sunset has been a popular theme for centuries. Claude (1600–1682) and Turner are two painters whose sky subjects live in the memory as outstanding representations of evening and morning light. James Whistler (1834–1903) also captured the poetry of such skies with his studies of evening. Unashamedly romantic, the Victorians lovingly depicted the last orange glow of sunset in quiet pastoral landscapes. A stretch of water reflecting evening light can make a beautiful subject to paint, but without attention to subtle atmosphere it can easily become hackneyed and clichéd.

Two main problems emerge when painting sunset outdoors or in the studio: the rendering of glowing light and colour. The colour of the sun itself is important; an orb of pale, light colour will look subtler and more evocative than one painted garishly bright. The brightest part of the sky may not be around the sun but immediately above it, and it is this area where the glow of light becomes predominant. Surrounding the sun with a darker tone than the lighter area above makes a good focal point.

Painting a sunset outdoors is extremely difficult due to the rapid fading of light, brilliancy, and transparency of colour. To save time work with just a few principal colours on a dark-toned ground, in this way the lightest parts are instantly rendered with comparative tonal accuracy.

Silhouettes from middle distance to the horizon are extremely dark against the light of the fading sun but never a dead colour although they may appear so. The predominant colours of silhouettes in a red or orange dusk are ultramarine with cadmium red or alizarin crimson; if you need a duller colour use light red mixed with ultramarine. Silhouette colours will vary according to the

Windmill (left)

Size: $3\frac{3}{4} \times 2\frac{1}{4}$ in (95 × 57 mm)
Medium: Charcoal
Paper: Drawing paper

For this sketch I lightly rubbed charcoal all over the picture area. Then I lifted out the streaks of light in the sky and water. The windmill went in next, and I took care not to make it too dark. There is just enough light in the sky to show a subtle difference of tone value on the windmill.

Evening Landscape

Size: 16 × 12 in (406 × 305 mm)
Medium: Acrylic
Support: Canvas textured board

I began this acrylic painting with the sky, to create the mood and atmosphere of the subject.

When you paint a sky like this it is tempting to overstate the effect of light, and make it too bright. Look at the white paper of this page, and you will see how low in tone the light in the sky is in comparison. The colours mixed for the sky were yellow ochre, light red, cadmium red, burnt umber, yellow ochre, ultramarine and titanium white. Basically, the resulting colours are warm greys.

For the landscape I mixed ultramarine, light red, yellow ochre, burnt umber and titanium white.

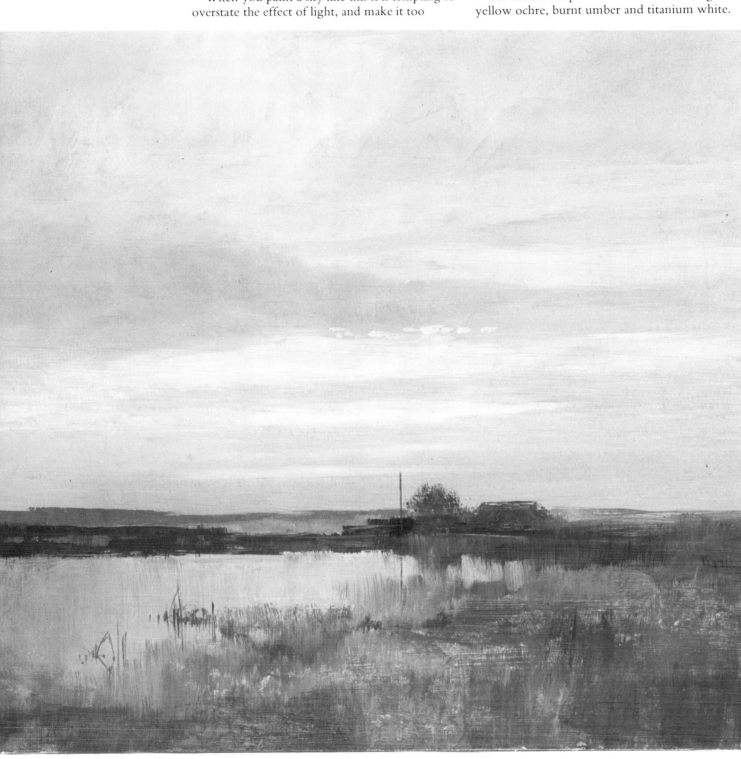

colour of the sky, but red is sure to be evident in the darks. Too much mixed with ultramarine brings the silhouettes forward and it may be necessary to modify the colour by greying to aid recession. Skies with a complicated colour scheme are best completed before adding silhouettes, especially if they are trees – trying to paint round complex silhouettes and yet maintain continuity in the sky will present problems to the inexperienced painter. But cutting round a dark colour with a light one has much more interest than painting dark on to light, so if the silhouette shapes are simple or your skill is sufficiently developed, try this method. If you are painting outdoors in oils on a dark grey priming, wiping out the rough shapes of silhouettes with a clean rag is a useful method of establishing shapes quickly. Silhouette

colour then painted in has a fresher quality because the sky colours are not picked up with the brush.

Not all sunsets are dramatic displays of vivid colours. Subtle lavender tints blending into warm grey with creamy coloured upper clouds is a beautiful variation. A pink sun veiled by evening mists was a subject much loved by Turner. Light from the evening sky influences colour on the landscape with an infinite range of shades, sometimes as subtle as the tones of a grey day.

Recently I was drawing and painting along the Norfolk coast one late December afternoon and had the chance of making some pastel studies of subtly lit clouds at sunset. You have probably seen one of these, *Winter Sky, Cromer*, already; it appears in colour on page 41.

Dusk (below)

Size: 11 × 8 in (279 × 203 mm)
Medium: Pastel – monochrome
Paper: Grey scrapbook

I have based my monochrome sketch on The Royal Meteorological Society photograph reproduced opposite. Working this way in grey and silver-white pastel is a very good exercise in tone value.

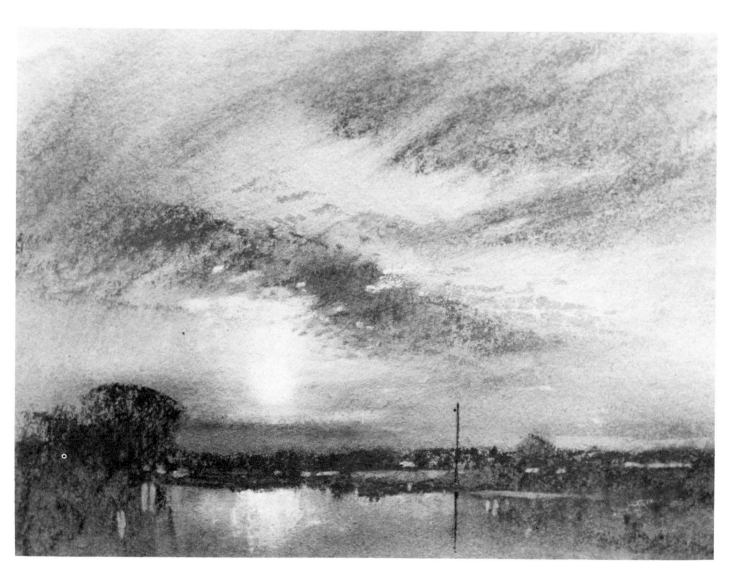

Evening (step-by-step, below and overleaf)

Size: 11 × 8 in (279 × 203 mm)
Medium: Pastel – cool greys and silver white
Paper: Fabriano Ingres Mid-grey

For my step-by-step demonstration I will again use the black-and-white photograph (left) as a reference. It is not my intention to make a copy but to develop the atmosphere into a simple subject. The sky effect is the main theme of my proposed painting. I am also aiming for the sense of aerial space.

Step 1

Step 1: The first application of pastel is the middle tone. Roughly indicating the clouds I then drag a paper tissue across, leaving some of the pastel untouched. The horizon also is a middle tone, and I blend this into the lighter part of the sky, again with tissue.

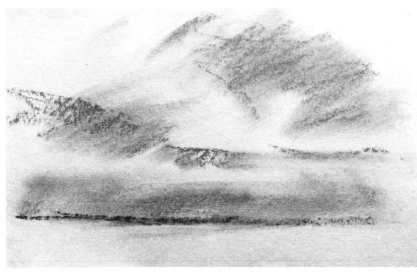

Step 2

Step 2: The darkest tone is used next, to indicate the landscape. This is blended with a tissue to vary the tone and suggest atmosphere. So far I have only used two grey pastels – cool grey No. 4 and No. 5.

(Continued overleaf)

Step 3: Now I add the sun with silver-white pastel, first of all blending it into the sky, then adding more pastel with some pressure to get contrast. The lightest grey is touched on the paper for the reflection of the sun.

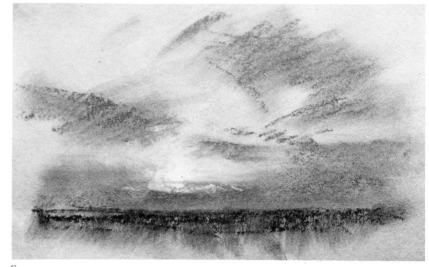

Step 3

Step 4: Now I can add detail and accents. The central cloud has some detail added to give it the texture of a 'mackerel' sky.

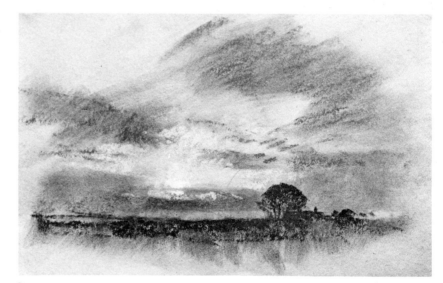

Step 4

Step 5: Finally, the pole and foreground grass give recession and scale.

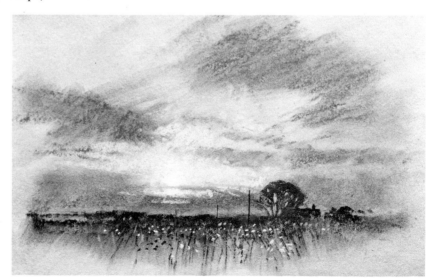

Step 5

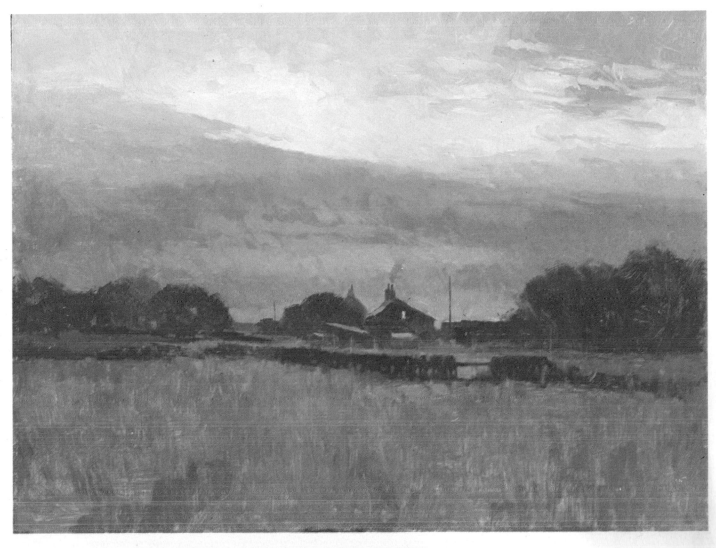

Evening

Size: 24 × 20 in (610 × 508 mm)
Medium: Oil
Support: Hardboard (Masonite)

The time of dusk is magical but presents a number of painting problems. Tone value and the subduing of colour are the principal considerations. Rarely is it possible to make more than a colour sketch outdoors of such a fleeting moment as dusk or sunrise. I did this oil painting in the studio.

To determine the tone value of the sky I laid-in the landscape first. Contrary to the usual method of painting the darks first, I painted a very thin wash of pale yellow over the sky. Transparency and clean colour is essential to get the impression of evening glow. Throughout the painting all colours and tones were judged against the yellow glow. The final touch was to repeat the sky colour in the lit window of the house.

The enlarged detail (*left*) shows brushmarks and blending of colour.

Winter Snow

Size: 24 × 18 in (610 × 457 mm)
Medium: Oil
Support: Hardboard (Masonite)

A studio painting. Some of the colours in the trees and winter shrubs are
carried into the sky. This creates the harmony and a warmth which I
particularly wanted to get.

Snow scenes are not always the traditional cold blue, so often depicted.
Staining the support all over with pale burnt sienna or yellow ochre is a
warm ground to work on, and harmonizes a painting. Painting snow tempts
the use of white straight from the tube, but this is not always successful. In
this painting the tonal key is restrained, and warm and cool colours are
contrasted to good effect.

The colours are cadmium red, yellow ochre, ultramarine, light red,
cobalt blue, cadmium yellow and titanium white.

WINTER SKIES

Cold, sharp days of winter make it tough for painting outdoors, but if you can manage to brave the weather the effort is worth while. Sitting to paint or draw in the cold soon becomes uncomfortable. Providing my feet are well insulated, I find standing at an easel more tolerable even in snow conditions. I personally cannot paint wearing mittens, but many artists do.

Winter skies can be exciting, their strong purples and deep blues influencing the colours of the landscape and clouds. Atmospheric light is the theme of many winter paintings.

Generally the tone of winter landscape is much deeper than at any other time of the year. A priming of grey or burnt sienna is a satisfactory basis to work on. Estimate your lightest and darkest tone first of all, and keep

December Afternoon

Size: 10 × 7 in (254 × 178 mm)
Medium: Watercolour
Paper: Bockingford 140 lb (300 g/m²) watercolour paper

While painting this watercolour outdoors I was oblivious to the chilly December afternoon.

Grey layer cloud moved fast, and continuously altered shape. By the time I had finished, it had changed to individual cumulus with patches of blue sky. However, my first interest was the rich tone of the winter landscape and a grey sky, and it was the sky I started first. A grey wash went all over the distant hills and darkest trees. When it was dry I added the dark clouds mixing Payne's grey, ultramarine and burnt umber. After the sky dried, the distant hills were painted-in with a fluid wash of ultramarine, cadmium red and burnt umber. I had to wait a long time for the colours to dry, so I could build up the sequence of washes; but patience is part of watercolour painting.

Back in the studio I flicked out touches of light from the paper with the point of a knife. You can see the effect on the gate and trunks of the silver birches.

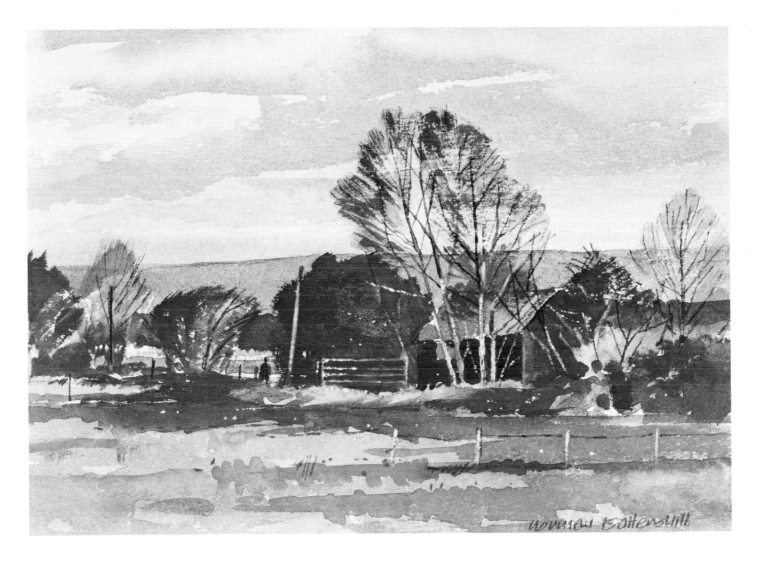

within that range. If the weather makes it impossible to work for a long time, establishing principal tones is enough for future reference. You are more likely to finish a pochade than a larger painting, but a broad lay-in on a 20 × 24 in (508 × 610 mm) canvas for example can be developed and finished in the studio.

I have previously stressed the importance of trying to get a sky effect as soon as possible when time is short. In the winter, clouds may dominate the landscape's colour and tonal contrast; but of equal priority when trying to capture a quick impression is to get the right relationship between sky and landscape. The tinted or opaque ground will be a great help in this respect.

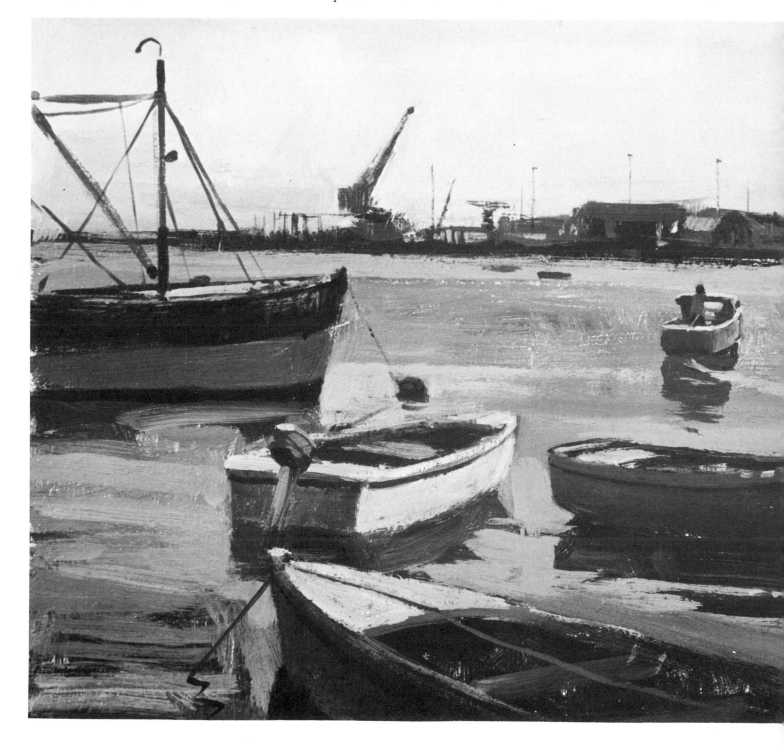

BLUE SKY

Blue sky is transparent space and in paintings should look recessive; if it is painted in the wrong tone or colour it comes forward like a wall. The correct tone and choice of blue is essential if recession is to be achieved. It is tempting to overstate the blue of sky and make it much too bright, resulting in hardness and loss of quality; also if it is too bright or deep in tone the spaces between clouds will look like holes in your painting.

First of all we must be able to recognize the different blues and know how they look when mixed with other colours. One company alone sells thirteen different blues in oil colours, five in acrylics and thirteen in watercolours. The blues I would recommend for your palette to start with are ultramarine, a rich warm colour; and cobalt blue, a paler and cooler colour. Some artists use Prussian blue but I personally find it a bit too green for skies. Whatever your choice it is inadvisable to use a colour direct from the tube because it cannot represent nature; a blue sky has many subtle variations of intermixed colours, and the landscape painter must be able to define them. The sky near the sun has an influence of warm yellow, which at times may appear devoid of any blue. On the opposite horizon a subtle gradation from yellow to blue is clearly visible. When I use cobalt blue I may add a hint of rose madder, cadmium red or alizarin crimson to give a warm tint.

If you are trying to depict a sunny day, painting blue into a wet underpainting of yellow is a good idea. Alternatively, leave an underpainting to dry, and then scumble the blue over the top. This technique can be used with both oils and acrylics.

A transparent wash of colour as a preliminary stain imparts an interesting quality. You may choose to use pink, pale green, raw umber, lemon yellow or yellow ochre. Experiment with different under-painting tints on scraps of primed hardboard or paper to see the effect when you apply blue over the top.

Every changing light condition in the blue sky has an immediate effect upon the landscape. Dust in the atmosphere greys distant sky and landscape, and produces a wonderful range of shades. A clear blue sky at dusk, particularly if it has recently rained, has many fine and beautiful gradations of subtle colours. Bright sunlight casts strong hard shadows on the landscape and within these shadows are broken colours of reflected light from adjacent features and the sky.

The landscapes of Corot are well worth studying. His gentle pastoral subjects and blue-grey skies are object lessons in tone and colour control. Soft light permeates his paintings with a memorable romantic atmosphere

Poole Harbour

Size: 12 × 10 in (305 × 254 mm)
Medium: Acrylic
Support: Hardboard (Masonite)

Clear sky and calm water is my theme for this painting. A slight touch of red in the sky makes it warm against the blue water.

The foreground boat leads the eye into the painting by directionally linking the other boats. I was particularly interested in the silhouettes created against the sky by industrial wharves.

MIST

Painting mists outdoors is a strange experience with an element of the unreal. Shapes appear and disappear in diffused half-light as if by a trick of the imagination. The experience is unforgettable. One of the greatest masters to depict misty subjects was Turner. In an astonishingly small area he created beautiful effects, particularly of coastal subjects. His later works give no feeling of paint – only of space and light. Some paintings by the Victorian Romantics of sunsets veiled with mist seem clichéd in retrospect but nevertheless show technical skill.

Painting in the studio is much easier than painting mist outdoors, but if you have the opportunity of working out in the open then do not miss it. Fascinating tricks of the light occur when the sun strikes through thin mist, brightly illuminating roof-tops or water. Tone values must be absolutely right in this sort of subject to make it work; colour is of less importance and a good plan is to do some preparatory tonal sketches. Objects tend to resolve into flat shapes with minimal tonal contrast and detail. Dividing your painting into a few gradated planes of flat shapes will have more contrast than a series of closely gradated tones. Keep your impression simple: too much detail destroys the illusion of mist.

In diffused light all colours are modified by grey, but the grey of mist is not a mixture of black and white only: the predominant colour cast may be lavender-grey, yellow-grey, blue-grey, or brown-grey. A simple method of mixing colour is to begin with black-and-white and then add the appropriate colour.

Mist does not always totally shroud the landscape. Evening or morning mist can lie across the landscape in the distance like a horizontal veil, or cover just the tops of hills, or lie in streaks across inland water – another subject popular with the Victorian artists.

A cloud layer covering the sky like a featureless mist is stratus, which may be transparent enough for the sun to shine weakly through. At times it is dense and obscures the sun or moon. Thin stratus in a single layer will allow strong light to permeate on to the landscape, the effect being flat and even, without much contrast of light and shade. I often paint such a sky: it has the soft light that I like to get into my paintings. By building up layers of thin paint in the sky, easier with acrylics than oils, it is possible to achieve translucency rather than solid paint.

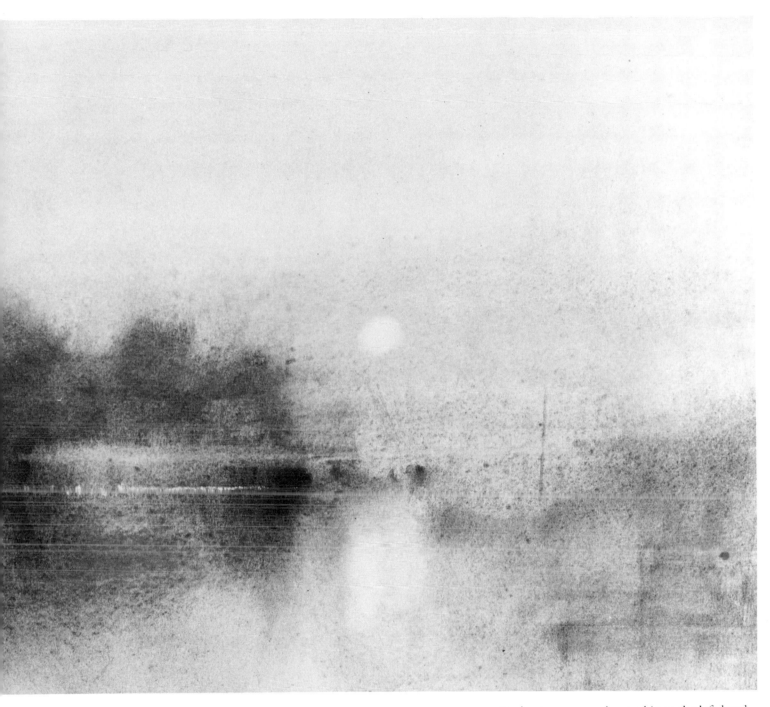

Morning Mist

Size: 12 × 8½ in (305 × 216 mm)
Medium: Watercolour
Paper: 'Not' surface watercolour paper

A wash of pale yellow ochre was laid all over the paper first. While the wetness had a shine, pale Payne's grey was washed into the top of the sky. Having turned the board upside down, a wash of ultramarine was taken across. As the colour spread I turned the board back again to let it run down to the bottom of the picture.

Darker tones were dropped in to the left-hand side. While the sky was still wet I lifted out the sun shape with paper tissue. The moisture was taken off the surface so the surrounding wet colour would not spread into it. A flick with the point of a sharp knife rendered highlights across the water.

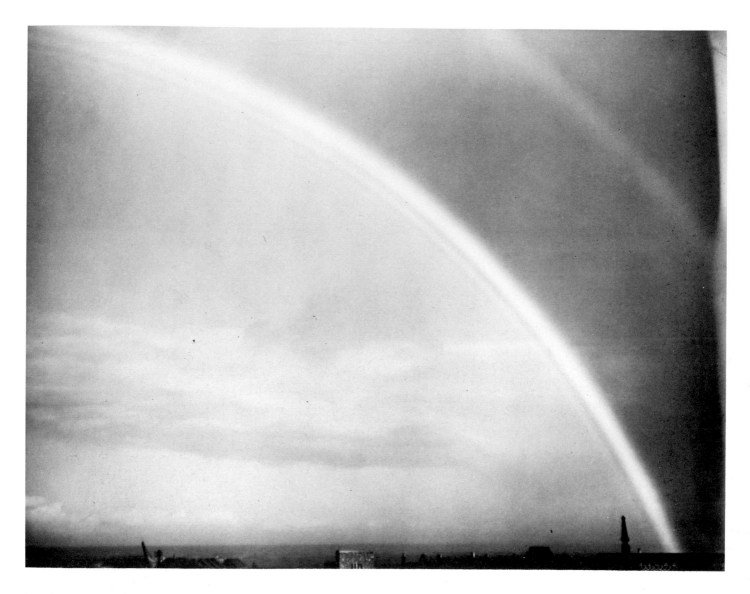

Rainbow

When we see a rainbow it is the dramatic effect and colour which holds our attention. This black-and-white photograph reveals the subtleties of a rainbow's tone; note that the sky appears lighter under the bow than above it. Layer clouds in the middle distance have the appearance of passing behind a dark translucent filter.

The secondary rainbow caused by reflection is also modified in tone. It is interesting to note the tapering of the rainbow towards its base.

The rainbow is caused by the refraction and reflection of the sun's rays in drops of rain. It is always seen opposite the sun, often when there are showers.

RAINBOWS

Remember when painting rainbows that red is on the outside and violet on the inside of the primary bow. The position of colours is reversed in secondary bows. Remember too that the background sky within the primary rainbow is noticeably lighter than the sky outside the bow; this is because no refracted light is received from outside the bow to add to the background illumination.

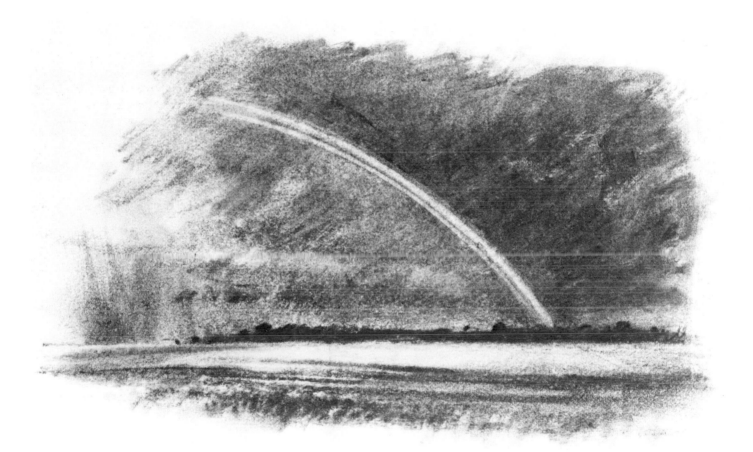

Rainbow, Norfolk

Size: 8 × 5 in (203 × 127 mm)
Medium: Charcoal
Paper: Drawing paper

This charcoal drawing is a reconstruction of a dramatic effect I saw on a November afternoon in Norfolk. The sky became deep indigo showing the momentary rainbow in all its brilliance. At the same time a strong beam of light illuminated the field in front of it, casting deep shadows across the foreground.

SEA SKIES

I have lived on the Sussex coast for some years and have become aware of the difference between sea skies and the sky inland. Even on the dullest days clouds over the sea have a luminosity; in summer the air glitters like silver and skies are the purest cobalt blue blending through to cerulean blue; and a sunset over the sea can produce an extraordinary brilliance and luminosity of colour. This fine quality of light is not confined to the Sussex coast, I have noticed it in other areas. Two factors contribute to the cause of this pearly light: firstly, away from industrial areas, particularly at sea, the air is free of pollution and therefore clearer; and secondly, light shining on to a surface of water is reflected back into the invisible moisture suspended in the air – each tiny drop is like a mirror and reflects the light reflected from the sea. Sea skies were of particular interest to Turner who painted dramatic storms and ethereal light at sea. His later paintings evoked many unjust criticisms: among them William Hazlitt's ludicrous assertion, made in 1816, to the effect that Turner's paintings were 'too much abstractions of aerial perspective and representations not properly of the objects of nature.... They are pictures of the elements of air, earth and water.'

Folkstone from the Sea J. M. W. Turner (c 1822)

Size: 19½ × 27½ in (487 × 691 mm)
Medium: Watercolour

Turner made no less than sixty-five watercolour studies of clouds in his sketchbook dated 1816–1818. Less complete sketches are annotated pencil scribbles. From 1817 onwards the sky assumed greater importance in his work. His outdoor sky studies in watercolour display verve and spontaneity quite remarkable in technique and expression.

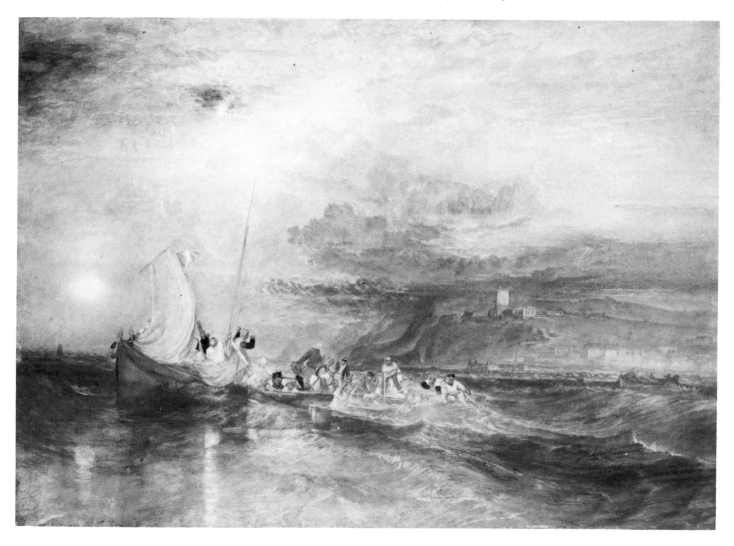

Making for Home
(left)

Size: 5 × 3 in
(127 × 76 mm)
Medium: Charcoal
Paper: Drawing
paper

To get a feeling of
nature's forces in this
imaginary sketch I kept
the drawing vigorous
with open lines. The
darkest mass is focused
on the boat. Direction
of line also adds vigour
and a sense of
movement.

The drawing was
done direct without
preliminary drawing-in.

Putting out to Sea
(below)

Size: 10 × 6 in
(254 × 152 mm)
Medium: Charcoal
Paper: Drawing paper

Another direct charcoal
sketch without any
preliminary drawing-in.

These sketches are
fun to do and develop
imagination and a
sureness of touch.

Turner said that 'no painter, in history, probably has loved water more than I.' I would include skies as well: whatever the effect of light and atmosphere, his skies are perfectly related to land and sea. Study Turner; study all the masters of landscape and seascape. Their paintings will inspire you; but let Nature be your main source of inspiration. My final advice is that you should strive to improve your skies by painting and drawing outdoors as often as you can.

The school of the self-taught is a slow, hard school, with only yourself to say where you go wrong. I am of that school. What knowledge I have is, and always shall be, gathered from Nature herself. Writing this book has made the bond closer. I hope the pleasure may be yours also.

10·30a.m 20 Jan·80

Outdoor Sketch

Size: 14 × 10 in (356 × 254 mm)
Medium: Pastel
Paper: Grey paper

This cloud effect is characteristic of coastal skies.
Three cool grey pastels and silver white were
used to capture it.

High above the cumulus is cirrus against a pale
blue sky. Notice the direction of light on the cloud.

Further Reading

American Artist, New York

The *Artist*, Tenterden, Kent

Association of Clouds and Weather, Clouds 2 (Wallchart), BP Educational Service

BATTERSHILL, Norman, *Draw Landscapes*, Pitman, London, and Taplinger, New York (1980)

BATTERSHILL, Norman, *Draw Seascapes*, Pitman, London (1981) and Taplinger, New York (1980)

BATTERSHILL, Norman, *Draw Trees*, Pitman, London, and Taplinger, New York (1980)

BATTERSHILL, Norman, *Light on the Landscape*, Pitman, London, and Watson-Guptill, New York (1977)

BAZIN, Germain, *Impressionist Paintings in the Louvre*, Thames & Hudson, London (1958)

BLOCKLEY, John, *The Challenge of Watercolour*, Pitman, London, and Watson-Guptill, New York (1980)

Constable: Paintings, Watercolours and Drawings, Tate Gallery, London (1976)

COURTHION, Pierre, *Impressionism*, Harry N. Abrams Inc, New York (1971)

DUNSTAN, Bernard, *Learning to Paint*, Pitman, London, and Watson-Guptill, New York (1970)

FISHER, Stanley W., *English Water-colours*, Ward Lock, London (1970)

The Formation and Types of Cloud, Clouds 1 (Wallchart), BP Educational Service

GRUPPÉ, Emile A., ed. C. Movalli and J. Lavin, *Gruppé on Painting*, Pitman, London, and Watson-Guptill, New York (1976)

Leisure Painter, Tenterden, Kent

MASON, B. J., *Clouds, Rain and Rainmaking*, Cambridge University Press (1971)

MERRIOTT, Jack, ed. E. Savage, *Discovering Watercolour*, Pitman, London, and Watson-Guptill, New York (1973)

PEACOCK, Carlos, *John Constable: The Man and His Work*, John Baker, London (1965)

PELLEW, John C., *Acrylic Landscape Painting*, Watson-Guptill, New York (1968) and Pitman, London (1976)

RICHMOND, Leonard, and LITTLEJOHNS, J., *Fundamentals of Pastel Painting*, Pitman, London (1978)

RUSKIN, John, *The Elements of Drawing*, Dover, New York (1971)

SAVAGE, Ernest, *Painting Landscapes in Pastel*, Pitman, London, and Watson-Guptill, New York (1974)

Turner 1775–1851, Tate Gallery, London (1974)

Turner in the British Museum, British Museum, London (1975)

WATTS, Alan, *Instant Weather Forecasting*, Adlard Coles, St Albans, Hertfordshire (1968)

Weather, Royal Meteorological Society, Bracknell, Berkshire

WILKINSON, Gerald, *The Sketches of Turner, R.A. 1802–20*, Barrie & Jenkins, London (1975)

WILKINSON, Gerald, *Turner's Early Sketchbooks 1789–1802*, Barrie & Jenkins, London (1975)

List of Suppliers

General materials and equipment
Frank Herring & Sons, 27 High West Street,
 Dorchester, Dorset
A. Ludwig and Sons, Ltd, 71 Parkway,
 London NW1
E. Ploton Sundries, 273 Archway Road,
 London N6
George Rowney and Co., Bracknell, Berkshire
Winsor and Newton Ltd, Wealdstone, Harrow,
 Middlesex

Canvases
As above and:
Russell & Chapple Ltd, 23 Monmouth Street,
 Shaftesbury Avenue, London, WC2

Easels
As above and:
Guys Art Products Ltd, Longbridge Meadow,
 Cullompton, Devon

Pastel papers
As above and:
Interprovincial Sales Ltd, BEPA House,
 Rectory Lane, Edgware, Middlesex
Italian pastel papers are generally available from
 art shops

Pochades
The Mendip Painting Centre, Rickford,
 Burrington, near Bristol

For American readers comprehensive mail order
 catalogs are available from:
Arthur Brown and Bros. Inc, 2 West 46th St,
 New York, NY 10036
Sam Flax Inc, 25 East 28th St, New York
 NY 10016
A. I. Friedman Inc, 25 West 45th St, New York,
 NY 10036

Index